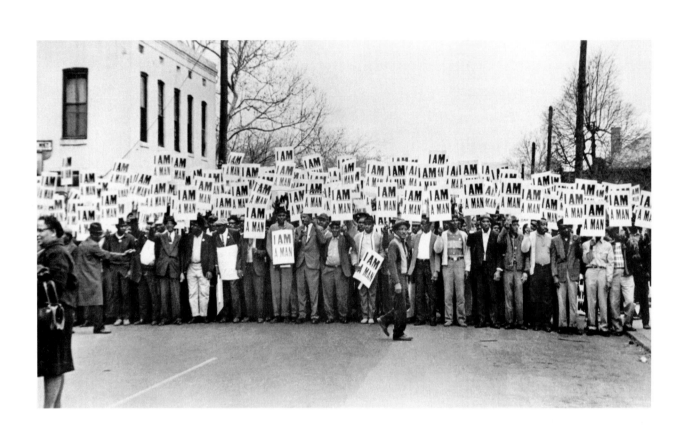

FOR ALL THE WORLD TO SEE

FOR ALL THE WORLD TO SEE

MAURICE BERGER

FOREWORD BY THULANI DAVIS

VISUAL CULTURE AND THE STRUGGLE FOR CIVIL RIGHTS

Yale UNIVERSITY PRESS
New Haven & London

In collaboration with:

Center for Art, Design and Visual Culture
University of Maryland Baltimore County

National Museum
of African American History and Culture
Smithsonian Institution
Washington, D.C.

NATIONAL
ENDOWMENT
FOR THE ARTS

the People

For
the brave men and women
who fought for racial justice
and
equality in America

CONTENTS

FOREWORD BY THULANI DAVIS

What if history granted white America only one or two individuals in each era to stand as its representative, the summation of its character, accomplishments, and perhaps all that the world would know of white America? Take the 1960s—who would be chosen—John F. Kennedy and Doris Day? Lyndon Johnson and Abbie Hoffman? When I put this question to a white friend, he asked what I meant by "represent." This is a logical question for anyone whose culture is known to have many facets. White America doesn't have representatives—it has people who represent the United States as a whole, Olympic athletes, for example. My friend could well have also asked, "represent white America to whom?"

When I asked this same question of several African-Americans, people who grew up with exactly this sort of selective representation, they simply answered that the most nationally prominent Negroes in the sixties were probably Rev. Martin Luther King, Jr., and Sidney Poitier. Though they all volunteered that Malcolm X was an icon for African-Americans, and King was often denounced, they saw King and Poitier as acceptable black Americans for white America.

In every decade since escaped slaves began to produce narratives of their lives in bondage, there have been one or two African-Americans whose lives and images have appeared in the mainstream and have been characterized as representing our experience. Take the era from 1900–1910: Despite some of the incredible souls building African-American culture during that time, it is easy to claim that the names of educator Booker T. Washington (lionized and accepted) and boxing champion Jack Johnson (demonized and criminalized) may have summed up general knowledge of the race. Who similarly embodied white America? Theodore Roosevelt? Lillian Gish? It's an impossible parallel to make because we have all been taught the complexity of white America.

The representation of African-Americans in the cultural mainstream, however, has been so selective, narrowly conceived, and determined by anticipation of white reception that widely accessible black images also became iconic. Most of them still exist in a shorthand of African-American fame rather than history: Frederick Douglass, Booker T. Washington, Paul Laurence Dunbar, Bessie Smith, George Washington Carver, Joe Louis, Jackie Robinson, Martin Luther King, Muhammad Ali, Michael Jackson, Michael Jordan, Oprah Winfrey. We have a list of demonized figures too, captured in names like Marcus Garvey, "the Scottsboro Boys," and Malcolm X.

What existed around these icons? What took the place of all the unknown and unseen in stories, folklore, and imagery of all kinds from advertising to photography? Standing in for real African-Americans and their stories was a world of fictional constructs uncannily similar in all forms. These were friendly African-American servants doing work of every kind—Negroes depicted in ways

viewed as comfortable to most white Americans. Even if this is not news, it is still obvious by our continued reluctance to look at the role of race in the entire visual field that most Americans have never learned to discern the dominant presence of imagery constructed to address white audiences from imagery that realistically reflects the complexity of African-Americans.

Maurice Berger, in this vital and important work, *For All the World to See: Visual Culture and the Struggle for Civil Rights*, takes us on a journey through the development of both the narrow field of African-American icons and the broadly influential legacy of blackface and other stereotypical imagery. Berger's text and a superb collection of images spanning the second half of the twentieth century give us a guide to visual literacy in African-American representation. He explores the modern visual myths of blackness and the ways in which African-Americans publicly and privately responded and resisted.

Berger, Senior Research Scholar at the Center for Art, Design and Visual Culture at the University of Maryland Baltimore County, and Senior Fellow at the Vera List Center for Art and Politics at the New School University in New York, is also author of a revealing and incisive memoir, *White Lies: Race and the Myths of Whiteness*, which illuminates the ways in which one is taught how *not* to see.

In *For All the World to See*, he introduces figures who waged the "epic battle against invisibility," and shows how the southern civil rights movement in particular shocked white America (and the world) into seeing by deploying photographic or televised evidence of the brutal realities of segregation (Intro, 7). This was necessary, Berger observes, because African-Americans felt "ill-served" by a mainstream media that skirted the issue of prejudice and catered to the interests and allayed the racial anxieties of its white audience. In the decades of legal segregation there were two separate and contradictory sets of black icons such that Berger could write of many black activists as he writes of Paul Robeson: "The very gifts and attributes that made Robeson a great man placed him in opposition to the acceptable image of African-Americans in mainstream culture" (ch. 1, 15). One could even say that only widespread integration made it possible for white America to valorize black America's activist icons, though usually only after the deaths of these civic troublemakers.

African-Americans of a certain age can recall exactly when and how they came to learn of important events affecting the race that were not broadcast over mainstream media. The 1955 murder of fourteen-year-old Emmett Till, for instance, was known only after his mother, Mamie Till Bradley, showed his mangled body to black citizens in Chicago and allowed photographic documentation (that only the black press agreed to publish). As Berger writes, the murder is one of the events of the era that left a generational mark. One of my friends recalls his parents returning home shaken from seeing Till's body.

As a six-year-old, I found Till's battered face in *Jet* magazine. Most white Americans were completely unaware that simply seeing that photograph was a trauma for thousands of African-Americans.

The warning Till's murderers may have wished to issue to blacks in Money, Mississippi was dwarfed by the effect of the photograph's publication. That single image recruited many young people Till's age (and thousands of others) into the civil rights and black power movements to come. Rev. Jesse Jackson, who joined King and the Southern Christian Leadership Conference (SCLC), and Stokely Carmichael, a chairman of the Student Nonviolent Coordinating Committee (SNCC), were also fourteen-year-olds when Till was killed. Many in SNCC were Till's peers, among them Congressman John Lewis, Julian Bond, now Chairman of the National Association for the Advancement of Colored People (NAACP), H. Rap Brown, also a SNCC chairman, and Doris Ruby Smith Robinson, a SNCC executive secretary. Almost exactly his age were the four college students who set off the sit-in movement at a Greensboro, North Carolina lunch counter, and Huey Newton, a founder and leader of the Black Panther Party.

In 1955, though many of us heard about the Montgomery, Alabama bus boycott through the black press or by word of mouth, television had begun to bring the southern struggles to the public eye. In 1957, millions watched the desegregation of Central High in Little Rock, Arkansas, with its mobs meeting the first nine students outside the school. A single photo of Elizabeth Eckford surrounded by screaming white women stayed with me. Several years later when an integration plan was made in my hometown, the image asked of me whether I could serve my community in that way. We didn't need a lone icon facing abuse for all of us; we needed more bodies than could be captured in one image. We wouldn't merely be represented; we would be there.

Activists realized early on the power of images to awaken public outrage. Journalists got it too. The first sit-ins of the era began in February 1960 in Greensboro, and were caught by a single local photographer. Those images showed powerfully the absurdity of segregation, the pains taken by protesters to refute with their appearance any charges that protestors were troublemaking thugs, and they showed college students across the Southeast what to do. In the 1980s when I went to Virginia to do research on the 1960 sit-ins there, a local newspaper editor informed me that there were no articles in the archives because editors in the state had met and decided not to print stories on the movement in an attempt to stop it from spreading.

For All the World to See shows the fruits of these insights as they played out in photojournalism, advertising, film, and television. As each battle won brought another attempt to maintain control of an expanding story of African-American self-definition, the sights and sounds of real events rewrote

fictional claims of who we were and what we wanted. The pictures of the March on Washington, or protestors attacked with fire hoses, female members of the Nation of Islam, or the organized sanitation men of Memphis, belied representations meant to scorn grassroots mobilization. Berger gives us the point-counterpoint of this struggle for the country's moral center.

It is hard to spend time with Berger's history of African-American imagery without reflecting on the almost sudden emergence in the twenty-first century of the one person whose face will for a long time to come be the most powerful and influential African-American image ever. What perhaps will set Barack Obama apart from the iconic African-American figures before him is that he literally represents the country itself.

The campaign and election of Barack Obama to the presidency of the United States made his image the most well known African-American face in history. Obama the candidate had his own logo and slogans—"Yes, We Can" and "Change We Can Believe In"—adopted as catchphrases in vernacular culture everywhere. As president he will be the subject of untold official imagery, perhaps even as a face on a coin of U. S. currency, despite jokes made during the primaries that he was posing for such commemoration. He is the focus of a host of books and periodicals consisting purely of photographs and other visuals, as well as scores of music videos, YouTube tributes, ads, gags, and documentary footage. A *New York Times* issue reprinted paintings of Obama across the front page for a story on a rising Internet presence of Obama art. A pundit described a recent speech by using the adjective "Obamesque."

The man and his media image embody the global ties that are common in contemporary life, mixed with the qualities most often replicated in "acceptable" African-American representations. While black voters often remarked on the echoes of Malcolm's tone in Obama's voice or the lines quoted from Ntozake Shange's *For Colored Girls . . .* in his memoir *Dreams from My Father*, white voters were won over by the blend of Sidney Poitier charm, Martin Luther King earnestness, Thurgood Marshall brains, Michael Jordan cool, and Oprah Winfrey–style bootstrap triumph. It goes without saying that any African-American destined to have an era named after him would have to deploy all of the culture's accumulated savvy on managing black representation.

Reading *For All the World to See* will make clear why Michelle Obama is perhaps an even more stunning icon for this country, given our past and her heritage as a descendant of enslaved people. As one will easily spot in this book, iconic African-American images have rarely been female. Despite attempts to paint her as a latter-day angry black nationalist (disturbing to mainstream whites), she defies that stereotype and the older female types, whether mammies, vixens, or a Julia, living outside of the black world. We recognize her instead as one of

those familiar women of unassuming beauty captured in the black photographers' studios—our sisters, classmates, colleagues, daughters, and sweethearts.

As Maurice Berger shows in *For All the World to See*, the discourse around African-American images, especially the consistent efforts of African-Americans themselves to shape and influence their representation, made possible a shift in the national body politic that has been seismic. We may all need this book as a guide to the confusing, sometimes homemade representations of our larger than life president rising in awkward hand-painted clouds, fist bumping with his wife in pseudo Muslim garb, pointing at you as a bobble-head doll, growing water-melons on the White House lawn, emerging bare-chested from the Pacific Ocean, staring back from the face of a watch, or dominating the front of a rather cool tee shirt that reads, "Black Man Running—but Not from the Police."

The black world must fight for freedom.
It must fight with the weapons of truth,
with the sword of the intrepid,
uncompromising spirit, with organization
in boycott, propaganda and mob frenzy.

W. E. B. Du Bois

Dusk of Dawn (1940)

INTRODUCTION: WEAPONS OF CHOICE

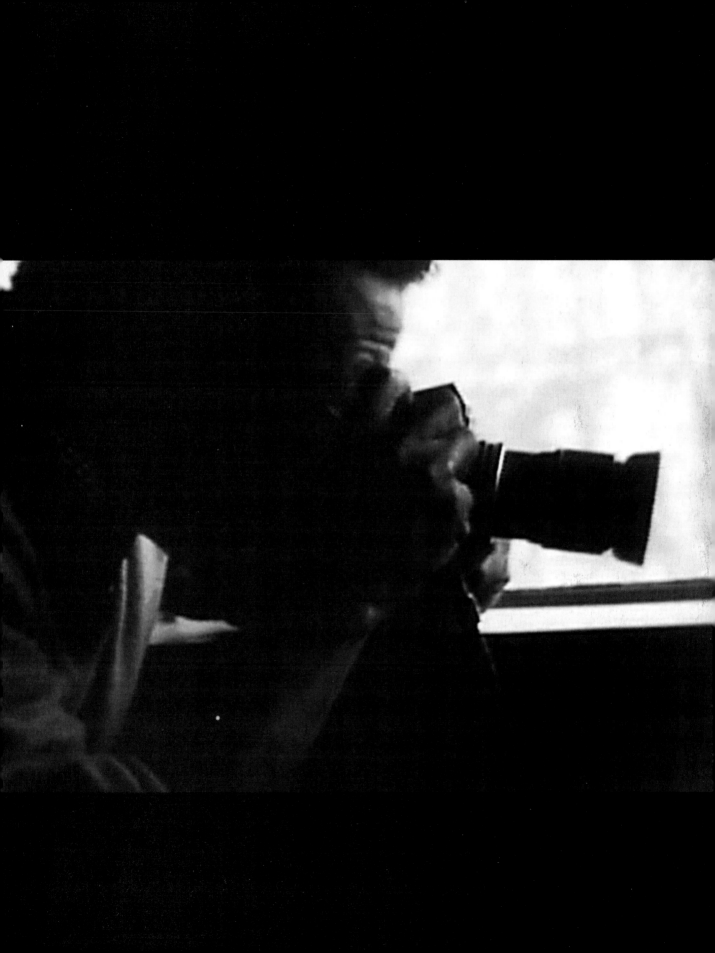

On April 23, 1968, CBS News aired a half-hour documentary, *The Weapons of Gordon Parks*, about the acclaimed photographer, filmmaker, composer, and author (*fig. 1*). The program was unusual for its time. It celebrated black accomplishment, still a rare subject on American television. It uncompromisingly addressed the topic of racism from the perspective of a black person. And it departed from the conventional television news format, opting instead for an artful and impressionistic structure in which photographs, music, and narration, all by Parks, were elegantly interwoven with CBS footage of the artist at work.

In its opening sequence, the documentary makes clear one of its central themes: that racism could easily have destroyed Parks had it not been for his artistic talent. In a voiceover, Parks ruefully describes a prison execution he once witnessed as a journalist. Reflected on the glass wall that separated him from the condemned man, he observes, he could see his "own image emerging from his.... I recall the elaborate conspiracy of evil that once beckoned me towards such a death." As the narrative unfolds, Parks is shown in his New York studio, engaging in what are for him empowering and life-affirming acts: loading his camera with film and looking through its viewfinder. "Years ago I found them, one by one," says Parks of the aesthetic "weapons" on which his survival would depend. "They were all half hidden, in obscure cubbyholes, stretching along the labyrinthine corridors of my early life."

The program's second vignette also alludes to the power of images to save its subject. Parks is seen sitting at a light table examining small color transparencies through a magnifying loupe. In voiceover, he remembers the difficulties of his childhood. He speaks of the abject poverty and discrimination his family faced in rural Kansas, of his mother's early death, and of her final wish to send him, the youngest of fifteen children, to live with his married older sister in St. Paul, Minnesota. He speaks of a stoically silent father, unable to express his feelings or desires, not even to the son he is about to lose. He tells of the breaking up of his family and the loneliness and isolation he felt as a teenager. As he talks, the camera pans across the slides on the light table, and then focuses on the image of a single black hand, palm open, raised in a gesture of defiance—an icon, perhaps, of Parks's own rebelliousness, the symbolic hand into which he would continually place the weaponry he would employ to fight prejudice.

The loving attention to Parks's photographs, as well as the idea that they possessed the ability to liberate and embolden him, provides what may well be the documentary's most unusual angle: that visual images could play a formidable role in the struggles of a people, both personal and public. Until this time, television coverage of African-Americans and the civil rights movement was predominantly story-based: producers and writers tended to see the battle for racial justice as a continuum of news—protests, civil disobedience, legislation,

fig. 1 (previous page)
The Weapons of Gordon Parks
1968
(Gordon Parks)
Courtesy of CBS News Archives

verdicts, and legal decisions. The camera was the tool that recorded these events, made them visible, more immediate, and even, in a sense, more real. But rarely did the media consider the power of visual representation itself—the authority of images to change the world, as *The Weapons of Gordon Parks* suggests—despite the hunger of TV news for compelling imagery that it could use to captivate, and potentially increase, its audience.

It would take a figure as commanding as Parks, and a news organization no less respected than CBS, to make the point that pictures mattered in the war against racism. This was an abiding concept not just in the TV documentary but also in the text on which it was based: *A Choice of Weapons*, the autobiography that Parks had published two years earlier, in 1966. In the book, he conjures a time when African-Americans were "always in battle," to quote Richard Wright, forever toiling against the insidious forces of bigotry.[1] This struggle meant that Parks, like millions of black people before him, would hold many weapons in his hands, most tragically a switchblade he contemplated (but refrained from) using to rob an elderly trolley conductor on a cold, desperate night in St. Paul. Parks faced an uphill battle, trapped in a world of racist loathing, a place where "achievement seemed almost impossible."[2] And eventually, he reached his breaking point: "It was becoming more and more difficult [for me] to live with the indifference, the hate. . . . I wouldn't allow my life to be conditioned by what others thought or did, or give in to anyone who would have me be subservient."[3]

For Parks, the crusade for dignity and freedom was principally a search for his voice—for a way of being heard, of transcending the muteness that imprisoned his father. Ironically, it was Parks's understanding of the authority of visual images, "the power of a good picture," as he would say, that allowed him to speak loudest.[4] He encountered this power in the book that had become his bible, *12 Million Black Voices* (1941), which told the story of African-American oppression and survival through the eloquent words of Richard Wright and uncompromising images shot by Farm Security Administration photographers. He saw this same power in the paintings and sculptures he looked at carefully on frequent visits to the Art Institute of Chicago in the late 1930s. He saw this power in the photographs that he, himself, had begun to take. These images were commanding enough to merit him the first Julius Rosenwald Fellowship in photography in 1941 and a job in the Farm Security Administration, for which he documented American poverty and racism *(fig. 2)*. He would soon be working for *Life* as a photojournalist, and as editorial director of *Essence*.

Parks was not alone in his understanding of the potency of visual images. The civil rights movement, in its campaign for racial equality and justice, would come to equate pictures with weapons, the tools that Parks had relied on for decades to fight "effectively against intolerance."[5] "The history of black liberation

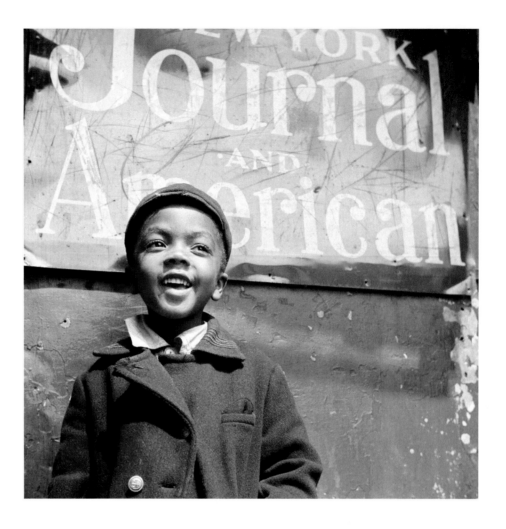

fig. 2
Gordon Parks
New York, New York. Harlem
Newsboy, 1943 May–June,
LOC, Prints & Photographs
Division, FSA-OWI Collection
[LC-DIG-fsa-8d28520]

movements in the United States," as the cultural critic bell hooks perceptively observes, "could be characterized as a struggle over images as much as it has also been a struggle for rights, equal access."[6] These images could work in innumerable ways, from bolstering black pride to helping convince white Americans of the severity of prejudice and the ways it endangered democracy. Yet despite books, exhibitions, and documentaries on Parks and other artists, photographers, filmmakers, designers, and television producers and directors of the civil rights era, the story of the remarkable role played by visual culture in shaping and fortifying the movement remains one of the least understood in recent American history.

The modern civil rights movement—which spanned roughly a quarter-century, from the early 1950s to the mid-1970s—was born in a period of great social and cultural change in the United States. The end of World War II marked the culmination of a forty-year cycle of economic and military expansion, war, poverty, and political unrest. Broad demographic shifts, including the exodus of African-Americans from the rural South to the urban North, were transforming America's ethnic and racial landscape. In the "Great Migration," black people, escaping the racism and poverty of the South, saw the North as a place to forge a better and more emancipated life. Northern cities, however, were not the solution that many were looking for: white racism was still a problem, and the challenges of living in urban environments proved daunting for many. But the North could be relatively fertile ground for African-American enfranchisement and antiracist activism.

The nation, having survived the Depression and vanquished its enemies in World War II, reluctantly turned its attention to its own history of injustice. As federal courts struck down segregationist statutes and some local legislatures advanced antidiscrimination laws, African-American leaders saw an opportunity to fight for true equality by appealing to white people's sense of fairness and justice. They pointed to the injustice to thousands of black soldiers who had served with honor in World War II, only to return home to the indignities of bigotry and neglect.

The environment for activism was aided by other factors, such as the educational and economic gains of black people in the urban North and the increasing prominence of Negro colleges, black churches, and other institutions devoted to African-American expression, learning, and empowerment. The consolidation of black political clout was also important, as African-Americans migrated from rural areas to densely populated cities, in both the North and the South. The proximity and concentration of urban black populations, in turn, afforded ease of dialogue and communication. And the increasing popularity and financial support, tendered by both black and white patrons, of the National Association for the Advancement of Colored People (NAACP), the nation's preeminent civil rights organization, lent organizational muscle to the movement.

One element in the arsenal of the modern civil rights movement, though, is rarely included in its history: the vast number of potent images, disseminated by new or enhanced technologies of visual communication, that made their way into the culture at large. The struggle for racial justice in the United States was fought as assuredly on television and in movies, in magazines and newspapers, and through artifacts and images of everyday life as it was on the streets of Montgomery, Little Rock, and Watts. The movement produced myriad images in multiple formats, which reflected shifting sensibilities and contexts, from the modest illustrations in early black magazines such as the *Crisis*, to the CBS News specials *Breakthrough in Birmingham* (1963) and *Ku Klux Klan: The Invisible Empire* (1965) and other televised reports on the state of American race relations.

While scholars and writers have considered how these images documented the movement, few have looked beyond the subject of documentation to the ways they helped alter prevailing ideas and stereotypes. *For All the World to See* constitutes one of the first attempts to examine the roles of visual images in shaping, influencing, and transforming the fight for civil rights in the United States.[7] It explores images in both high and popular culture, and tracks the ways in which they represented race in order to perpetuate the status quo, stimulate dialogue, or change beliefs and attitudes. The book argues that the modern civil rights movement, coextensive as it was with the birth of television and the rise of picture magazines and other forms of visual mass media, effectively capitalized on the power of visual images to edify, convince, and persuade.

There is no question that visual images have influenced how Americans see and think about race. This is true because much of what defines race in society was, and is, innately visual. Ideas and observations about race are, more often than not, communicated through visual cues, symbols, and stereotypes. To talk about race is to talk about skin color: black, yellow, white, and brown. To talk about race is to talk about the shape of the eyes or nose or the texture of the hair, about clothes or hairstyle or body types.

During the period of the modern civil rights movement, powerful visual images infiltrated the culture at large—locally and nationally—against a backdrop of extraordinary events. It was a time of segregationist bombings, brutal lynchings, race riots, sit-ins, marches, boycotts, and turbulent political campaigns. In the 1950s and 1960s, U.S. Supreme Court rulings on segregation, voting rights, and miscegenation were countered by an unending campaign of white resistance, exemplified by the activities of the Ku Klux Klan, the John Birch Society, and the states' rights movement. Antiracist activists and civil rights leaders were slain. And de facto segregation (even in the "liberal" Northeast) remained a stubborn, almost intractable problem. Ultimately, *For All the World to See* is intended neither as a history of the civil rights movement nor as a comprehensive accounting of its visual culture.

Many significant events, and many images and objects, will not be discussed. The book focuses on a select number of actions, objects, and episodes that most vividly or typically demonstrate the relationship between visual images and the struggle for racial justice.

In his landmark work as chief counsel to the NAACP Legal Defense Fund in the 1950s, Thurgood Marshall often reminded his colleagues that success was as much about "morale and legitimacy" as it was about prevailing in individual cases. Marshall's observation relates to a central theme of *For All the World to See*. It was not just through political or legal writing but also through compelling images that the civil rights movement altered perceptions about race, and thus advanced the case of black legitimacy within white America as it bolstered morale within black communities across the nation. This struggle for morale and legitimacy—for the hearts and minds of Americans of all colors—was fundamentally an epic battle against invisibility. The notion of the invisible was an abiding metaphor for a movement intent on confronting the numerous ways in which the realities of race in America were ignored and obscured in society—from the bigotry, both virulent and passive, that most white people refused to acknowledge to the mainstream culture's erasing of black humanity, talent, and intelligence.

This metaphor lies at the heart of one of the most influential and seminal books of the civil rights era: Ralph Ellison's *Invisible Man* (1952). The novel is an eloquent examination of the nature of bigotry and its effects on both victim and perpetrator, told from the perspective of a young, nameless black man in the midst of a nightmarish journey through the nation's racial divide. On his way, he confronts racism in many forms—from a humiliating "battle royal" in the Deep South, where he is ordered by his college to fight other black men under the leering eyes of a white audience, to his work as a leader in the Brotherhood, a communistlike organization in Harlem that eventually betrays him. *Invisible Man* is an unapologetically political work, one that Ellison himself described as an appeal to "personal moral responsibility."[8] It boldly challenges the laws, rules, and conventions that render mute and unseen a people whose only crime is the color of their skin. The narrator constantly faces the heartbreaking paradox of a life lived under the tyranny of racism, that of a strong, gifted, and intelligent man who has almost no visibility, no standing in the society at large:

> I am an invisible man. No, I am not a spook like those who haunted Edgar Allan Poe, nor am I one of your Hollywood-movie ectoplasms. I am a man of substance, of flesh and bone, fiber and liquids and I might even be said to possess a mind. I am invisible, understand, simply because people refuse to see me.

Like the bodiless heads you see sometimes in circus sideshows, it is as though I have been surrounded by mirrors of hard, distorting glass. When they approach me they see only my surroundings, themselves, or figments of their imagination—indeed, everything and anything except me.

Ellison's narrator struggles to free himself—and the story of his people—from this invisibility, only to find his efforts rebuffed and thwarted. He is expelled from the Negro college he attends, for example, after he takes an elderly white trustee to a poor black neighborhood in order to show him the brutality and destructiveness of segregation in the South. *Invisible Man* explores the irreconcilable differences that shape how black and white people see race. The cruel history of black oppression that the narrator attempts to bring into the light is the very history from which his white tormentors avert their eyes, lest they confront ugly questions and even uglier answers and truths. The protagonist's self-image differs radically, as well, from white people's warped perception of him: a normal person transformed through the poisoned lens of racism into a sideshow freak.

"The very term 'invisible,'" Frederick Karl writes of the novel's abiding theme, "suggests that not even what is seeable is indeed visible; that the invisible remains the stronger element; the more powerful and insistent presence."[9] In Ellison's worldview, the war against racism is, in great part, a fight to overcome society's pervasive need to obscure or obliterate the realities of race. One of the greatest lessons of *Invisible Man* lies in its awareness of this relationship: we are no more powerful, Ellison seems to say, than when we recover and reveal that which has remained unseen and unacknowledged.

This was a lesson that the leaders and supporters of the civil rights movement understood and learned to act on. In this regard, visual culture was an exemplary weapon, to paraphrase Gordon Parks, poised to do the job that words alone often could not. As the Reverend Wyatt Walker, executive director of the Southern Christian Leadership Conference (SCLC) in the 1960s, commented, new or advanced modes of communication in the mid–twentieth century were pivotal in supporting the cause of racial justice: "the media had a tremendous [effect] on our movement . . . because it gave a window to America to see what segregation was like. America had never seen it before."[10]

In their unique ability to offer seemingly irrefutable evidence and testimony as an "objective record . . . of an actual moment of reality and an interpretation of that reality," photography, film, television and other forms of visual representation have been innately powerful tools in the war against ignorance and bigotry.[11] Words, on the other hand, are hampered by their

physical and conceptual distance from reality: they are always and inevitably many steps removed from the corporeal world, the result of the translation of objects and events into a rigid linguistic system.

Verbal language, dependent on the point of view and biases of the speaker and subject to exaggeration, omission, and deceit, could be easily denied. To bigots in the South, words that described the brutality of segregation would be dismissed as lies or the protestations of fragile, ungrateful, or overly sensitive souls. To northern white liberals—complacent in the belief that racism was a southern problem, and fearful of any intimation to the contrary—certain words were best ignored, lest things get too uncomfortable. To African-Americans, long subject to the capricious behavior and whims of white people, words offered little more than false promises and shattered dreams.

Visual images—certainly subject to manipulation but also direct and vivid optical records of the things and events they represent—would come far closer to representing the "Truth" that the great writer and civil rights leader W. E. B. Du Bois believed was black people's most potent weapon against injustice. No image could act alone, of course. No image could, by itself, change the world, for every visual representation is dependent on context: the words, circumstances, distribution, and beliefs that endow pictures with greater levels of meaning and influence. In this sense, the leaders of the civil rights movement—and their vigilant enemies—were often exceptionally gifted image-makers. They understood, and took advantage of, the complex relationship between innovative technologies for representing the world and a society eager for new ways of seeing. The adage that a "picture is worth a thousand words" was never more valid than in the battle for and against civil rights—the innumerable efforts to prove, or disprove, the idea that racism was a scourge that imperiled both democracy and the future of America.

If what the white American reads in newspapers
or sees on television conditions his expectations of
what is ordinary and normal in the larger society,
he will neither understand nor accept the black American.

 Kerner Commission
 Report of the National Advisory Commission
 on Civil Disorders (1968)

IT KEEPS ON ROLLIN' ALONG: THE STATUS QUO

You were born into a society which spelled out
with brutal clarity, and in as many ways as possible,
that you were a worthless human being. . . .
The details and symbols of your life have been
deliberately constructed to make you believe
what white people say about you.

 James Baldwin
 The Fire Next Time (1962)

There is no more typical black character in early American film than the handyman Joe in *Show Boat* (directed by James Whale, 1936; *fig. 3*). The brief supporting role—portrayed by the venerated actor and baritone Paul Robeson—is at once incongruous and unsettling. The part of the obsequious, inarticulate servant seems inappropriate for Robeson, a classically trained performer with leading-man good looks and a formidable intellect. Joe straddles the line between slave and freeman. He is defeated by prejudice and arduous, thankless labor, yet is confident enough to sing openly about the racism that beats him down. Even the world around him is contradictory, a mythic, carefree South out of sync with the film's urbane, socially conscious story of betrayal and intolerance.

 Show Boat was the second film adaptation of the popular 1927 Broadway musical by Jerome Kern and Oscar Hammerstein II, a production that was itself based on the best-selling novel by Edna Ferber.[1] In the film, Julie LaVerne, played by the white actress Helen Morgan in her last screen appearance, is the star of the acclaimed theatrical revue performed on the *Cotton Blossom*, a Mississippi showboat. After Julie's black ancestry is revealed, she and her white husband and costar are forced to give up their act. Magnolia Hawks (Irene Dunne), the daughter of the ship's white captain, replaces Julie, along with a new leading man, Gaylord Ravenal (Allan Jones), an inveterate gambler. The two eventually marry, leave the ship, and move to Chicago to start a new life with their baby daughter. No longer able to control his addiction, the now destitute Gaylord abandons his wife and child. In the end, Magnolia triumphs in the face of catastrophe: she returns to the stage and becomes a star.

 The character of Joe, though tangential to the story, functions as the film's icon of southern black subservience and its beacon of hope and optimism. It is he, in a dramatic, soulful rendition of "Ol' Man River" at the outset of the film, who is given the task of setting up *Show Boat*'s message: that human beings can overcome almost any hardship. The song, which recounts the difficult life of a riverboat worker, is also a metaphor for the withering effects of racism on black people in the South. As Joe intones his tale—"You an' me, we sweat an' strain, body all achin' an' racked wid pain"—the close-up of his face alternates with a montage of him and other black men engaged in backbreaking toil. The implied perseverance and dignity of these people, not their oppression, is the point of the scene—and indeed the movie: the power of the human soul to deliver itself from adversity. Like the great Mississippi River, the song seems to suggest, life "keeps on rollin' along," no matter what obstacles stand in its way.

 The scene is undeniably compelling. But it is also disturbing, beset by a melancholic, even tragic, aura. There is more than a hint of weariness and sadness in Robeson's expression, that "uneasily tied knot of pain," as Richard Wright described it, so evident in the faces of black entertainers of the period.[2]

fig. 3 (previous page)
Show Boat
1936
(Paul Robeson)

The situation in which the actor found himself—stuck in a small role, unable to reap the monetary rewards or recognition afforded to white actors of his talent and stature—was typical for black performers in mainstream American film. The character of Joe, as written, was little more than a stereotype. He was a shadow of the complex human being that Robeson struggled to reveal through the nuances of physical gesture and facial expression, body language that laid bare the character's sorrow and doubt, and the actor's as well. "[I am] sick and tired of caricatures," Robeson stated unequivocally in 1937, the year after *Show Boat* was released, adding that he saw no future for himself in American films "because the South is Hollywood's box office."[3]

Even in its most progressive efforts, even in films that broached the subject of racial injustice, such as *Show Boat*, the motion picture industry reined in African-American performers. Sometimes, this suppression was literal, part of a strategy of racial appeasement that called for white actors to play black characters or that segregated black performers into a handful of scenes that could be excised from movies when they were screened in southern theaters. Other times it was subtle— substituting a cliché for a complex human being, for example—a means of dispelling the anxieties that the image of strong black people provoked even in the most liberal white audiences. In 1941, in an essay on African-Americans in film published in the *Amsterdam News*, W. E. B. Du Bois observed:

> Negroes have received some recognition and employment; the roles [that] they portray have improved somewhat in character during the last twenty years; that is, the Negro appears now not simply as clown and fool but now and then in more natural and human roles. On the other hand, all Negroes are quite aware that anti-Negro propaganda still goes on through the films: that in every scene that brings in a jail there will be Negro prisoners prominently displayed; that the Negro clown is still frequently met and that almost never can a Negro take a role that involves real manhood.[4]

These ambiguous, subtly hostile depictions reflected the values and anxieties of the white people who controlled the mainstream media and, by extension, the pervasive racism that was the rule rather than the exception in the United States at the birth of the modern civil rights movement. These images, however, were more than just a "diagnostic tool, a measuring device for the state of race relations."[5] They were weapons that shattered the egos of black people and enabled the prejudices of white people. More than any other force, the media established the prototypical black person for most Americans.[6] Thus, to understand the role and the place of media-driven pictures of race is to better comprehend the extent to which visual culture was both a target and a tool in the historical struggle against racism.

Like almost all black entertainers of the period, Paul Robeson was less of a human being in the eyes of Hollywood. This was true despite his brilliance. Valedictorian of his 1919 graduating class at Rutgers University, he was one of only three classmates accepted into Phi Beta Kappa. He was a noted collegiate athlete, "the greatest to ever trot the gridiron," according to the Rutgers football coach Walter Camp.[7] He earned a law degree at Columbia. He found fame as a stage and screen actor and as a singer. His concerts and recordings of African-American folk songs helped popularize them in the United States and abroad. Between 1925 and 1942 he appeared in eleven films, in such critically acclaimed roles as Joe in *Show Boat*, the Reverend Isaiah T. Jenkins and his brother Sylvester in *Body and Soul* (directed by Oscar Micheaux, 1925), Brutus Jones in *The Emperor Jones* (Dudley Murphy, 1933; *fig. 4)*, Umbopa in *King Solomon's Mines* (Robert Stevenson, 1937), and David Goliath in *The Proud Valley* (Pen Tennyson, 1940).

Robeson was perhaps the best-known and most widely respected black American in the 1930s and 1940s. Yet in the years following his well-regarded work in film, his standing in American culture simmered down to "a great whisper and a greater silence."[8] (His last film, *Tales of Manhattan*, directed by Julien Duvivier, was released in 1942.) Robeson's decline was the result of several interconnected factors. For one, he was politically outspoken: He founded an anti-lynching organization. He openly questioned why African-Americans should fight in the military of a government that tolerated racism. He refused to sing or act before segregated audiences. He urged Congress to outlaw racial bias in baseball. After traveling to the Soviet Union—a nation he believed was tolerant and friendly—he protested

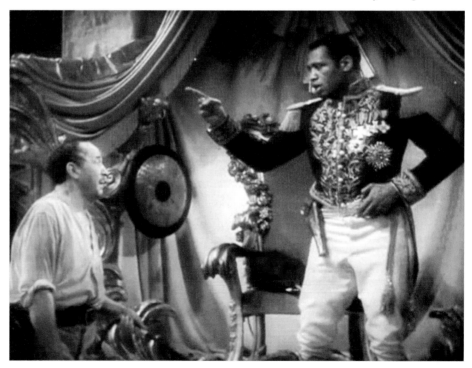

fig. 4
The Emperor Jones
1933
(Dudley Digges, Paul Robeson)

the growing Cold War hostilities between the United States and the USSR. His artistic and political crusade impelled him to sing in more than twenty languages in order to spread the gospel of peace and racial justice throughout the world. It also prompted the House Un-American Activities Committee (HUAC), in 1947, to accuse him of communist ties and the U.S. Department of State to revoke his passport in 1950.

Well before Robeson espoused his political beliefs, it was his race that undercut his standing in Hollywood. The color of his skin meant that he, like every other African-American performer, would be denied the complex leading roles readily available to white actors. "It was the absence of the *reality* of Negroes as men and the absence of the *reality* of Negroes as *dramatic* individuals, as I knew them to be in everyday life," observed the poet and essayist Calvin Hernton of the superficiality of these characters. "Only singular aspects of the Negro—his dancing, or musical, comic, religious, bellicose, or sly characteristics, to name a few—were portrayed, as if they represented the whole of his emotional wellspring."[9]

The liberal white men who ran the entertainment industry tolerated Robeson, and were able to cast him convincingly in menial parts, only as long as he remained a model of "modernist inwardness," physically attractive and strong but passive and unrevealing of his feelings or political beliefs. When he became an activist "race man" who used his potent masculinity—his good looks, imposing presence, and estimable talent and mind—to advocate radical race and class politics, he turned into the kind of powerful, outspoken black man who producers believed would offend white audiences.[10] The very gifts and attributes that made Robeson a great man placed him in opposition to the acceptable image of African-Americans in mainstream culture.

These tolerable depictions came most often in the form of reassuring stereotypes: doting mammy, wide-eyed darkie, stuttering fool, flirtatious harlot, and dutiful, long-suffering servant. As the literary critic Sterling Brown observed in 1933, these character types were in turn based on conceits—derived from disciplines as varied as literature, art, and science—that went back to the time of slavery: the contented slave, the wretched freeman, the comic Negro, the brute, the tragic mulatto, the local-color Negro, and the exotic primitive.[11] In the years following Brown's assessment, these types were constantly reconfigured and updated in popular culture to suit the changing social status of African-Americans and the comfort level of white consumers. As late as 1959, the actor Sidney Poitier complained of the relatively narrow scope of black roles: "As things are now, I rarely can play the part of a human being caught in conflict. There is great narrowness in our work."[12]

These roles were ubiquitous in Hollywood films throughout the early years of the civil rights movement and well into the 1960s: Stepin Fetchit

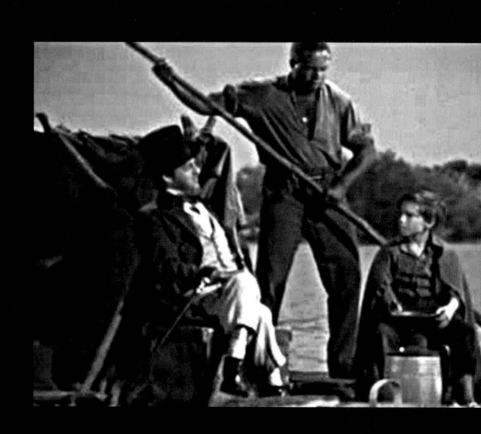

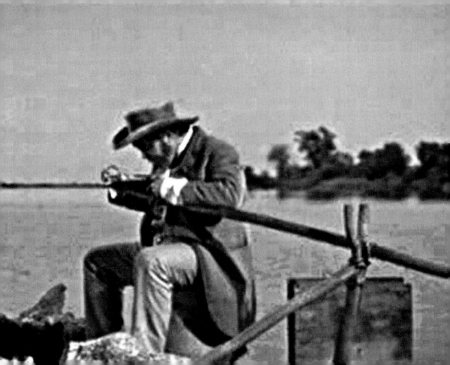

as the listless, puerile George Bernard Shaw in *Stand Up and Cheer!* (directed by Hamilton MacFadden, 1934); Bill "Bojangles" Robinson as Walker, the antebellum butler and tap-dance partner of child actress Shirley Temple in *The Little Colonel* (David Butler, 1935); Ethel Waters as the sassy Petunia Jackson, struggling to get her husband, Joe, to give up gambling and lead a righteous life in *Cabin in the Sky* (Vincente Minnelli, 1943); Hattie McDaniel as the devoted Mammy in *Gone With the Wind* (Victor Fleming, 1939); and Archie Moore as the obsequious, dithering Nigger Jim in *The Adventures of Huckleberry Finn* (Michael Curtiz, 1960; *fig. 5).*

The timid and fearful quality of these characters mirrored the timidity and fearfulness of many white Americans around the question of race. The increasing assertiveness and power of black people after World War II—as well as their vast migration to what had been relatively segregated communities—"spread white anxiety and resentment throughout the nation, even as it rendered open proclamations of racial inferiority passé."[13] Consequently, for many white people, any encounter with a black character, no matter how fleeting, was provocative, for it made visible the mostly unseen object of their racial fears: the black bodies they usually ignored, the black voices they usually disregarded, the black humanity they usually could not acknowledge.

The images born of these fears, whether in movies or in the culture at large, were at once cynical and nimble, affording blackness a token presence in mainstream popular culture while affirming the superiority or supremacy of whiteness. Typical black characters personify what the film historian Donald Bogle has called the "acceptable Good Negro." As they are "chased, harassed, hounded, flogged, enslaved, and insulted," these figures "keep the faith, n'er turn against their white massas, and remain hearty, submissive, stoic, generous, selfless, and oh-so-very kind. Thus, they endear themselves to white audiences and emerge as heroes of sorts."[14]

These characters transformed complex human beings into ciphers, blank screens onto which white people's safe and reassuring fantasies of blackness were projected. A 1926 *New Republic* profile on Paul Robeson typified this imperative, as it transformed the artist into a benign caricature meant to appeal to the racial egocentrism of its white readers:

> The singer's Negroid features are more marked on stage than off His nose becomes a triangle of whiteness, his eyes white moons, his skin takes the milky lights that turn black into bronze. He has never seen a Georgia road gang but when he sings Water Boy the very accent and spirit of the Negro laborers enter into him.... Yet I have never seen on the stage a more civilized, a more finished and accomplished artistic gesture than his nod to his accompanist, the signal to begin the song. This gesture is the final seal of Paul

fig. 5 (previous page)
The Adventures of Huckleberry Finn
1960

Robeson's personal ease in the world. Even a southerner would have difficulty in negating its quality and elbowing its creator from a sidewalk.[15]

This description was rife with subtly encoded phrases—"the milky lights that turn black into bronze," for example, or "a more civilized, a more finished and accomplished artistic gesture"—meant to bestow on Robeson a surrogate, provisional whiteness and thus render him irresistible to all but the most hardened bigot. As a result, the writer's responsibility to her African-American subject took a back seat to the needs and self-interests of her predominantly white audience.

American culture endlessly facilitated racial myopia. No matter how race or racism was handled, it was inevitably viewed from the perspective of whiteness. As late as 1957, a media organization no less ostensibly progressive than CBS News concluded that documentaries on race should be pitched to the majority population in order to reach the largest possible audience: "It is necessary to provide a broad basis for viewer involvement," stated an internal memo. "Therefore, social and political problems pertaining to a minority should always be presented in terms of their importance to the majority."[16]

The detrimental effects of racial pandering, evident in so many of the African-American characters and subjects of mainstream culture, were even more demoralizing to black audiences. To see oneself depicted as a second-class citizen was to be thrust into a state of cognitive dissonance, forced to reconcile one's humanity and complexity with society's stereotypical and unsympathetic view of blackness. In *The Souls of Black Folk* (1903), Du Bois viewed this incessant mental state as a "double-consciousness," the psychic distance between the way black people viewed themselves and how others perceived them. He argued that the black man was "a sort of seventh son, born with a veil, and gifted with second-sight in this American world—a world which yields him no true self-consciousness, but only lets him see himself through the revelation" of an ever pervasive whiteness. Du Bois described "two warring ideals within one black body" trying to reconcile one's race with a culture that persistently excluded and ridiculed black people.[17]

The predominant view of race in America was at war with black people's dignity and sense of self. Despite the decline of overt racism after World War II, African-Americans were not wholly accepted by most white Americans. They were seen neither as wholly debased or dangerous nor as equals. Images of blackness reflected the larger culture's ambivalent view of race. To have represented black people as strong and socially equal to whites would have crossed the threshold of white tolerability; to have portrayed them as slaves, fiends, or clowns would have been disconcerting to black viewers and some liberal white viewers as well. Most

conventional depictions of African-American men and women, when they existed at all, were relegated to a hazy yet obdurate middle ground—distant enough from the former representation to insinuate acceptability and social parity, close enough to the latter portrayals so as not to threaten or bewilder the white spectator.

The character of Joe exemplified this middle ground, an image of black masculinity that was at once unthreatening but not entirely erased. In mainstream films, well into the 1960s, African-American men were almost never portrayed as romantic leads or, indeed, even as sexual beings. "To see a Negro kiss or pet on the screen," wrote Calvin Hernton of the innate racism of this prohibition, "would send large numbers of white people, throughout the United States, cringing and recoiling in prurient disgust or excitement."[18] For the most part, the archetypal black male character was a pre-sexual or asexual being—a childlike man, jester, biblical figure, or servant—the "mannish boy" of Muddy Waters's 1955 blues classic. In the song, an African-American man recounts how, when he was a five-year-old, his mother told him that he would one day be "the greatest man alive." But now, as "a man, way past twenty-one," he laments, he will always be perceived as a boy.[19]

The imperative to diminish black manhood was motivated by many factors: the notion, rooted in long-standing stereotypes, that black people were "sexually vulgar and repulsive";[20] the sexual anxieties felt by many Americans, not only about people of color, but also about themselves; the envy that black beauty or physical prowess provoked in insecure white people; the prurient fear of black men as sexually virile and predatory, and threatening the purity of white women, and further the integrity of the white race; and perhaps most important, the perceived need to keep black men in their place by disallowing their sexuality and the full range of their humanity. As Hernton observed, to recognize the "*human validity* of Negro sexuality is one of the necessary ways of affirming the Negro's essential manhood. This would constitute a tumultuous psychological revolution with ramifications no less significant than the changes resulting from current civil rights activities."[21]

The resistance to this revolution was the tragic legacy of a nation that willfully enslaved its darker brothers and sisters. A century after the Civil War was fought in the name of freedom, the mere suggestion of black political rebellion continued to inspire ingenious forms of conceptual imprisonment. The laws that ended segregation to some extent put an end to the white man's physical domination of the black body. But they did not stop the arbiters of culture from holding hostage the imagery of blackness. Fifteen years after Paul Robeson appeared as Joe, just as the modern movement for racial justice was getting under way, the hostage-taking continued: *Show Boat* was remade for the third time, in a lavish Technicolor

production directed by George Sidney and featuring the respected black opera singer William Warfield in the role of the hapless ship worker.

The complexity and scope of American racial attitudes—from the virulent white supremacy of the Deep South to the sometimes ambivalent liberalism of the urban North—helped account for the popularity of images of blackness that were at war with black people and with themselves. To most viewers at the time, including many African-Americans, such depictions would not have been perceived as either grotesquely racist or overtly progressive. Yet they were sufficiently positive *and* demeaning to find their way into the full spectrum of media, including the films and television shows of progressive Hollywood producers, the magazines of African-American publishing companies, and the newspapers of the segregationist South.

Nowhere was this agility more apparent than in the mainstream media's obsession with domestics and servants, a mania that touched a variety of disciplines. The black domestic was a stock character in film, for instance, where kindly, vigilant souls cooked, scrubbed, ironed, raked, hauled, planted, and chauffeured their way into scores of productions. American television, too, fell for such clichés. The first nationally broadcast series to feature an African-American actor in a leading role, *The Beulah Show* (ABC, 1950–53; *fig. 6*), focused on the whimsical antics of a housekeeper. The half-hour situation comedy, a spin-off of a popular radio show, starred Ethel Waters in its first two seasons and Hattie McDaniel and Louise Beavers in its third.[22]

In the show, Beulah worked for a white family—Harry Henderson, a lawyer; his wife, Alice; and their young son, Donnie. She also interacted with black characters, including her boyfriend, Bill Jackson, who ran a fix-it shop, and her dim-witted best friend, Oriole, a maid who worked for the white

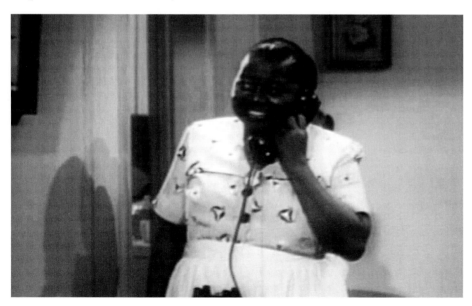

fig. 6
The Beulah Show
1950
(Hattie McDaniel)

family next door.[23] In a dehumanizing device then typical for mainstream film and television, the plotlines of *The Beulah Show* implicitly contrasted the "nuclear and extended family structure of the white Henderson household with the complete lack of family" in the life of its black characters.[24]

The unflappable Beulah, ever watchful of the problems and needs of her white employers, was the show's heroine. In one episode, she cooked a lavish southern meal to help Harry win over a client. In another, she taught the awkward Donnie how to dance and impress the girls. Although unsuccessful in her own frequently comic efforts to get Bill to marry her, she knew just how to help Alice save her marriage. Despite the innate intelligence and generosity of its central character, critics, civil rights leaders, and many black viewers attacked *The Beulah Show* for perpetuating stereotypes. This criticism focused on the pandering to white people's expectations of black servitude and the program's disregard for the inroads made by black professionals after World War II. Although black people continued to work as maids, butlers, bellmen, porters, and farmers, they were transcending the barriers of race, in such fields as education, medicine, law, business, and finance.

The National Association for the Advancement of Colored People (NAACP), at its annual convention in June 1951, condemned *The Beulah Show* for its tendency to reaffirm the opinion of "uninformed or prejudiced peoples that Negroes and other minorities are inferior, lazy, dumb and dishonest."[25] Despite this criticism, the image of the black domestic haunted American television well into the 1970s—from the supporting roles of Rochester (Eddie Anderson), the backtalking, gravel-voiced valet on *The Jack Benny Program* (CBS, 1950–64; NBC, 1964–65), to Florida Evans (Esther Rolle), the cantankerous maid on *Maude* (CBS, 1972–78). Not until 1968 did the first black female character in a nonmenial leading role appear on the small screen—a widowed nurse and mother, Julia, portrayed by the actress and singer Diahann Carroll.[26]

Advertising, too, was drawn to the imagery of black servitude. For most of the period of the modern movement, African-Americans were rarely depicted in ad campaigns. An important study of the "occupational status" of black characters in advertisements from the 1949–50 editions of the nation's most popular magazines—*Collier's*, *Ladies' Home Journal*, *Life*, the *Saturday Evening Post*, the *New Yorker*, and *Time*—found that black people were represented less than one percent of the time. And nearly eighty percent of these depictions were of cooks, maids, servants, and other domestic workers.[27]

In most cases, the ads were subtly crafted to avoid direct interracial contact, as four examples from the mid–twentieth century demonstrate: In a 1939 print campaign for Yardley's English Lavender perfume, an elegantly attired black porter—grinning broadly, the whites of his eyes and

fig. 7
Old Virginia Yessuh
1954
Collection Civil Rights Archive, Center for Art, Design and Visual Culture (CADVC)

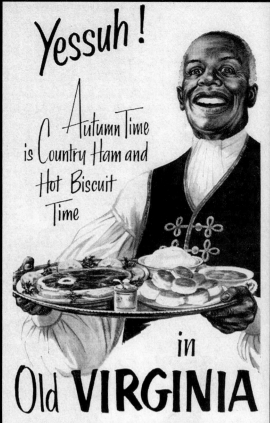

teeth exaggerated—attends to the luggage of a stylishly dressed white woman. While servant and employer are adjacent to each other, they are metaphorically worlds apart. The man is stooped over and situated behind the woman, and the two do not make eye contact. Similarly, a 1948 ad for General Tire and Rubber Company depicts a smiling black chauffeur, loaded down with luggage, beaming at his mink-swathed white employer, who walks several paces ahead of him (*pl. 1*). In contrast to the Yardley ad, the suggestion of interracial contact is even more oblique: the woman's back is to the man, her face is cropped out of the picture, and only her legs are visible as markers of her race.

A 1954 advertisement from the Virginia Department of Conservation and Development avoids interracial contact altogether (*fig. 7*). It features a lone black butler holding out a sumptuous tray of food, as if to invite the viewer into his world of southern hospitality. "Yessuh! Autumn time is country ham and hot biscuit time," he proclaims, his colloquial affirmation reminding the white tourists who are the targets of this ad that he is there to serve them. And in a 1939 advertisement for Hoover vacuum cleaners, two black maids, decked out in crisp uniforms, are shown chatting over a picket fence: "Mah lady gives me Sundays off," says one woman. "Yeah?—Well, I gets part of every day off—mah folk's got the Hoover," brags the other.

The purpose of these ads was not to inspire racial understanding, of course, but to sell products. Like all advertising campaigns, they were designed to elicit in the consumer an instantaneous sense of trust in the claims of the product, as well as comfort with and desire for it. Typically, they depicted characters contentedly "relating to each other in and through the consumption of products." One of the main purposes of this conceit was to establish "an emotional bond, a contact and then a connection between characters in the ad" and the consumers who viewed it.[28] Although a few mainstream advertisers reached out to African-Americans—the Pepsi-Cola company, for example, developed campaigns aimed at black consumers as early as the 1940s—it was not until late in the modern civil rights movement that African-Americans were considered a demographic worthy of this outreach.[29] Nor did most advertisers view interracial contact, whether between individuals in an ad or between black characters and white consumers, as a useful scenario for selling products to target audiences.[30]

Indeed, the near absence of black people in advertisements reflects the anxieties they engendered in sponsors, advertising agencies, and many consumers. The story of *The Nat King Cole Show* is typical in this regard. The fifteen-minute weekly musical variety show premiered in November 1956 on NBC. Cole, an acclaimed vocalist and pianist, was the first black performer to host a network variety series. He was also one of the earliest victims of corporate racism on television. Advertisers, fearful that white southerners would boycott their

products, shunned the program. Although the manufacturers of Arrid deodorant and Rise shaving cream occasionally bought time on the show, corporate sponsors generally avoided it. Compelled to air most episodes without commercials, NBC canceled the show after thirteen months. "Madison Avenue is afraid of the dark," quipped a disillusioned Cole, referring to the New York street then known as the center of the advertising industry.[31] As late as 1968, Whitney M. Young, Jr., director of the National Urban League, implored advertisers to confront this fear in order to "educate the masses of viewers that black people, like themselves, have an important role in American life."[32]

For the most part, however, sponsors avoided black people for concern of turning off white consumers. Advertising executives were equally reluctant about encouraging their presence, which would incur the wrath of lucrative clients by jeopardizing their public image and profits. Images of black subservience offered advertisers, and the agencies that supported them, an expedient and cynical way to craft an illusion of racial largesse while demeaning one group in order to make another feel more in charge, content, and worthy. "Blacks as workers contributing to the comfort of whites had become the standard social assumption," writes the artist and curator Michael D. Harris, "and the black dialect one found whenever black people were given a voice on stage, in literature, or in popular culture was a confirming signifier of inferiority that justified their lesser social status."[33] This assumption was deeply rooted in Anglo-American custom. As in the United States, it became fashionable for British aristocracy in the eighteenth century to import black servants from Africa, buy and trade them at inns and coffee houses, and train them as houseboys and maids. The portrayal of black servants in American culture of the late nineteenth and the twentieth centuries was built on this insidious tradition of "representing slaves as docile attendant figures who functioned primarily to elevate the importance of white subjects.[34]

The image of the black servant became popular with advertisers, unconsciously or otherwise, as a means of appealing to white consumers' sense of supremacy and entitlement to the rewards of quality products. This strategy differed little from the way the power brokers of American society, whether the mighty bosses of industry or leaders of government, historically manipulated white people by affirming their superiority to a class of people below them. Whites who were economically or socially disenfranchised were encouraged to see the color of their skin as valuable, an asset so desirable and protected that well into the twentieth century legal standards were established to search out blackness even in the "whitest" of people. Only those who could prove their racial purity, a status that as little as "one drop" of African blood could deny, had a legitimate claim to their whiteness.

Nineteenth-century European immigrants, who initially defined themselves as Irish, German, or Italian, eventually came to see themselves as "white" Americans. The white ruling class assuaged disaffected and underpaid white laborers and farmers by advocating racial solidarity. They disparaged and demeaned black people. They manipulated workers into believing the myth of an endangered and precious white race, and perpetuated the idea that African-Americans were the true enemies of the virtuous white worker. White laborers knowingly exchanged unreasonably low wages for a "psychological wage. They were given public deference and titles of courtesy because they were white. They were admitted freely with all classes of white people to public functions, public parks, and the best schools," privileges that did little to immediately improve their economic standing.[35] Poor white workers were encouraged to see themselves in alliance with the white bourgeoisie and not with the black victims of oppression and slavery.

One character in twentieth-century consumer culture pandered to this alliance more skillfully and relentlessly than any other: From when she entered public life as a product trademark in 1889, Aunt Jemima set herself apart from white people as "the ultimate symbol and personification of the black cook, servant, and mammy."[36] She was originally a character in a minstrel show, who cakewalked to the song "Old Aunt Jemima," written by the African-American entertainer Billy Kersands, one of the most prominent blackface minstrels of his day. Chris L. Rutt, a founder of the Pearl Milling company, attended a performance of the show in St. Joseph, Missouri, and adopted the character of Aunt Jemima who he believed would connect with white consumers inclined to identify black cooks with southern hospitality and comfort.[37]

Rutt was able to capitalize, as well, on the wide dissemination of images of minstrelsy in the culture at large. Minstrel acts, whether solo or part of larger vaudeville shows, toured the nation and were widely advertised and represented through newspaper accounts and broadsides. White and black Americans alike, even if they did not attend these shows, "would have been familiar with their depictions of 'darky' types."[38] In their endless representation, these performances created a new and durable class of racial stereotypes that obscured the complex and often mixed messages of minstrelsy. As Michael Harris observes, the original "Old Aunt Jemima" followed a tradition of black minstrelsy through which African-Americans "expressed their resistance and displeasure with the social order, often with allusions or coded references that white audiences usually missed."[39] The campaign by Rutt, and by subsequent owners of the Aunt Jemima franchise, obliterated any hint of criticism or resistance. Instead, they used the fantasy of the servile, devoted mammy to affirm white people's superior social status.

Well into the 1970s, the character of Aunt Jemima—and members of her extended family including her black husband, Uncle Mose, and white master, Colonel Higbee—appeared in print and television advertising campaigns and on numerous products and promotional items: packaging for self-rising pancake flour and syrup; and a broad array of premiums, including salt and pepper shakers, rag dolls, tableware, playing cards, cutout paper dolls, cookie jars, and syrup pitchers (*pl. 2*). In a testament to her popularity, regional and local businesses nationwide employed images of Jemima in their advertising and signage as an instantly recognizable symbol of southern charm. After R. T. Davis bought the Rutt's company in 1890, he searched for a spokeswoman, a real-life Aunt Jemima whom he could brand with the firm's theme of southern hospitality. He settled on Nancy Green, an African-American domestic from Chicago, and created for her a fictional personal history—a tale of life on a plantation and of "loyalty to the South and to her master"—that traveled with her across the United States as she promoted the company's products.[40]

Aunt Jemima was an ever-present symbol that resonated with multiple messages: She was a submissive black maid who played to the historical authority of white people. She was a corpulent and asexual matron, a woman unlikely to bring to mind the discomforting and ubiquitous stereotype of black women as sexually primitive and permissive or, by extension, the fantasies of miscegenation that this notion implied. She was set into a vivid spectacle of easygoing plantation life, a mythic, nostalgic world seemingly free of the cruelty of slavery and the troubling, present-day reality of racism in the South and the rest of the nation.[41]

The Aunt Jemima campaign embraced a strategy that was common in mid-twentieth-century popular culture: racial nostalgia. Films such as *Show Boat*, *Gone With the Wind*, and *Song of the South* (directed by Harve Foster and Wilfred Jackson, 1946), for example, resonated with longing for a historical era far removed from the harsh reality of contemporary race relations. Racial nostalgia was an outgrowth of the "plantation tradition" in literature, art, and popular culture.[42] Despite the geographical, economic, and cultural diversity of the South—relative to other businesses, cotton plantations hardly dominated southern life—the myth of carefree plantation life was the source of endless interest and fascination.[43] Such imagery ignored the reality of black rebellion and self-sufficiency—as well as the violence of white racism, both historical and contemporaneous—opting instead for "pleasantly picturesque" representations of African-Americans as inferior, dependent, content, and inevitably touched by the "shadow of the plantation."[44] The positive values of black humanity, perseverance, and dignity were replaced by the "slave's traditional attitude of respect and 'easygoing trustfulness.'"[45]

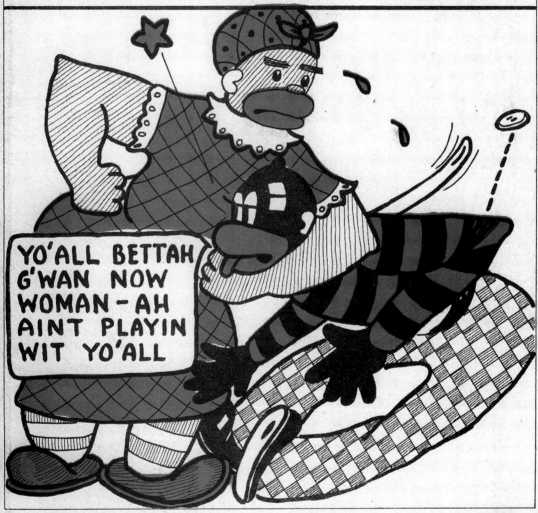

By way of footnotes the following pages contain many short, pithy, inspirational epigrams taken from the book "Stray Thoughts," by Crump J. Strickland, once listed by Southern Baptists as "one of the five best" books in print for young people.

The Civil War drama *Gone With the Wind*, billed by its producers as *the* definitive story of the Old South, subtly extolled the glory of the plantation and the fortitude of white southern landowners, who struggled to protect the values and mores of a society under siege. Based on the 1936 novel by Margaret Mitchell, the film told the epic story of star-crossed lovers—Scarlett O'Hara (Vivien Leigh) and Rhett Butler (Clark Gable)—against the backdrop of Yankee invasion and lawlessness, at a time when the city of Atlanta burned (its residents the blameless victims of, the film suggests, northern agitators) and Union soldiers pillaged O'Hara's ancestral home. Played out in a mythical world of lavish period costumes and opulent stage sets, the movie to a great extent rewrote the history of the Civil War from the perspective of the white master: Yankee liberators were now rapists and plunderers, white slaveholders the victims of northern aggression, and black slaves the beneficiaries of their munificent white owners.[46]

In a discussion of racial nostalgia, it is important to note that a rabidly racist visual culture, itself a remnant of the slaveholding days of the nineteenth century, continued in the Deep South well into the civil rights era. While these ugly and sadistic representations were varied and worked in multiple ways, their inevitable purpose in the South was to further the cause of Jim Crow segregation laws. From the end of Reconstruction until the rise of the modern civil rights movement, these edicts enforced white supremacy and racial separation in the American South. The name Jim Crow came from a minstrel routine—"Jump Jim Crow"—first performed in blackface in 1828 by its southern white author, Thomas Dartmouth ("Daddy") Rice, and subsequently by many imitators.[47] The term came to be a derogatory epithet for African-Americans and a designation for their segregated life.

From the late 1870s onward, southern state legislatures, no longer controlled by carpetbaggers and freedmen, instituted laws that required the separation of whites from "persons of color" in public accommodations. As a rule, any man or woman suspected of black ancestry was for the purpose of these laws a "person of color." Pre–Civil War statutes that had favored people of mixed racial ancestry—particularly the half-French "free persons of color" in Louisiana—were abandoned. In 1896, the United States Supreme Court, in *Plessy v. Ferguson*, upheld the constitutionality of racial segregation, declaring that "separate but equal" accommodations neither violated the rights of black people nor tainted them "with a badge of inferiority." After *Plessy*, the effort to thwart contact between blacks and whites and to see them as unequal was extended to a range of public and private institutions and situations, including marriage, education, entertainment, recreation, travel, and the service industries.

The alienation of the races, and the concomitant fear of inter-racial intimacy, that lay at the heart of segregation were deeply rooted in the

fig. 8
Clean Fun Starring Shoogafoots Jones
1946
Collection Civil Rights Archive,
CADVC

Western psyche. In the nineteenth and twentieth centuries, many scientists and cultural theorists, in the United States and Europe, viewed contact between the races as innately unhealthy. Their arguments were motivated not by concern for the well-being of black people but rather by anxieties about the corruption of the white race and the downfall of civilization that would result. Under such thinking, interracial contact was unwholesome, interracial sex or marriage abnormal, and the children of those unions inexorably feeble and impaired.

The imperative to prevent or forestall this contact shaped the racist imagery of the South. These depictions appealed for separation by distinguishing sharply between the humanity and supremacy of white people and the lowliness of black people. Such stereotypes were created as easily recognizable markers of black deviance or debility: the subhuman cannibal; the wretched Sambo with bee-stung lips (fig. 8); the bug-eyed buffoon; and the pickaninny, based on the atavistic, cotton-picking black child of southern myth. This imagery was modeled on earlier character types—created by scientists, pseudoscientists, writers, and artists—with the purpose of "proving" black inferiority. In some instances, these types likened black people to animals; in others, they were offered as evidence of weakness, backwardness, depravity, pathology, or inadequacy.

The most divisive, pervasive, and dramatic symbol of segregation in the Deep South, though dominated by words, was visual. Segregation signs (pl. 3) demarcated the world around them into racial camps through simple verbal cues, sometimes augmented with arrows or pointing fingers. The orders they barked were at once succinct and loathsome: "Whites Only," "Colored Entrance Only," "White Ladies Only," "Colored Seated in Rear," "We Serve Colored, Carry Out Only," "No Dogs, Negroes, Mexicans." Whether crudely written or mechanically printed, these wood, paper, and metal plaques were posted at the entrances, exits, and water fountains of the meeting areas, waiting rooms, halls, auditoriums, salesrooms, and restrooms of institutions and accommodations, both public and private. They served at the behest of a patchwork quilt of statutes enacted locally throughout the South—from a Georgia law requiring separate public parks to a South Carolina directive that forbade blacks and whites from working together in the same rooms of textile factories.[48]

Backed by draconian laws that were enforced by police, these signs were undeniably powerful. But their ability to impose segregation was not absolute. Large numbers of African-Americans lived in the South, often within or near white neighborhoods, and thus were afforded some economic power. Since black people required the same products as white people, such as food, household goods, and clothing, they were a rich source of revenue for southern businesses. Many stores, despite legal proscriptions and the presence of racist signage, were forced to sell to black customers. "The signs of segregation were as much admissions of weakness

as labels of power," writes Grace Elizabeth Hale. "African American southerners could not vote, but despite white efforts to keep them down, they could spend."[49] If white and black consumers shopped in the same stores, they were, however, not treated equally. Black customers were often ignored or otherwise mistreated. Still, white salespeople were sometimes forced to serve them, in effect contradicting the authority of signs that mandated the rigid separation of the races.

While segregation was particularly heinous in the Deep South, it was not limited to that part of the country. In other regions, de facto segregation enforced a visual culture underwritten by racial anxiety. The imagery of black belittlement—mainstream versions of the savage tribesman, illiterate handyman, enfeebled child, and other black character types of southern fantasy—continued to feed a national hunger for racial nostalgia and negative depictions of black people. These images, represented on products as varied as birthday cards and clothing (*pl. 4*), would disappear only after decades of appeals from civil rights leaders.

The oblivious, watermelon-eating black child, a common character type of the Jim Crow era, was exceptionally popular in the visual culture at large. In a print advertisement for the Lakeside Press, a division of R. R. Donnelley & Sons Company of Chicago, a young black boy is depicted devouring an enormous slice of the fruit. The vacant, distracted expression on his face, partly obscured by the mammoth piece of melon, suggests that he is consumed by both hunger and delight. On one level, the image employs a standard and time-tested strategy in advertising: the use of an adorable and contented child to sell a product. On another, it evokes an enduring southern stereotype (*pl. 5*). A line from the accompanying text points to the negative connotation of the image: "It takes a lot of different brains to do *any* good job of printing." Words and image together set up a subtle contrast between the vigilance and competence of the men of the Lakeside Press—a company whose business it was, "every-minute-of-the-day . . . to know all about your job"—and the carefree child who serves as its mascot.

A poster for the American Corn Millers' Federation, published in the 1930s and created by the illustrator Charles E. Chambers, updates another character type, the pickaninny, to serve the needs of a promotional campaign. The placard depicts a cute, rambunctious black girl riding a gigantic ear of white corn that is affixed to a go-cart (*pl. 6*). Until this time, white corn, as opposed to the common yellow variety, had been unpopular with American farmers. The poster was part of a drive to inform growers about the new interest of manufacturers in products made from the white grain, such as tortillas, taco shells, hominy, and grits. Its imagery was also nefarious: the contrast of the girl's dark skin with the corn's almost artificial whiteness emphasizes her race. The ear of corn dwarfs the wide-eyed child, her legs suggestively straddling its huge phallic form. The image, like many in its day, casually implies black defilement and belittlement in order to

drive home the idea that whiteness is valuable: "Grow white corn for extra profits," reads the evocative slogan.

The regressive, nostalgic sentiment of these images was as unconsciously appealing, in its own way, to white northerners as it was to southern bigots. The imperative to look back to the race relations of an earlier time was motivated by many things—from the malevolent yearning for an era when white power was sacrosanct to the need to divert attention from the complex and painful dynamic of contemporary race relations by harking back to a period when racism was even more explicit and severe. If southern bigots conjured the past in order to valorize it, white moderates often did so in order to allay the feelings of guilt, confusion, and anxiety that the campaign for racial equality, and its call for the sharing of power and resources, were dredging up in the present.

The Negro in American Life (1952; *fig. 9*), a booklet published by the United States Information Service in its Cold War propaganda campaign to sell to the world the idea of Western democracy, retold the story of slavery as a way of avoiding the present-day reality of racism in America. The pamphlet was unusually candid for a government publication, revealing, rather than concealing, "the nation's past failings . . . for the purpose of presenting American history as a story of redemption."[50] The text argued that the end of black enslavement affirmed the power of democracy, as opposed to totalitarian government, to restore justice and equality in the United States. It was democracy, in other words, that made possible the undoing of this disgraceful period in our history and the eventual reconciliation of a divided nation.

The pamphlet employed contemporary black-and-white photographs to demonstrate and reaffirm the racial health of the United States: sixteen white students and one black student are shown in one picture along with an African-American teacher. "In New York, a Negro teacher teaches pupils of both races," reads its caption. In another photo, a group of black children congregates in front of a rural school: "Education and progress for the Negro people move together," the caption declares. "Thousands of new rural schools, like the one above, provide free education in the South." Produced in the early years of the modern civil rights movement, *The Negro in American Life* nevertheless banished all images of the negative or threatening side of American race relations—the lynched bodies, grotesque stereotypes, and destitute black families of the South, the de facto segregation of the North, and the specter of political protest.

The Negro in American Life did not entirely ignore the subject of modern racial injustice, which was much on the mind of the nation at the time. The pamphlet minimized it in relation to a considerably more evil past, celebrating how far we had come as a nation. Implicit in its argument that slavery was the "cardinal cause" of racism in the United States was the idea that with its end, the worst was

fig. 9
The Negro in American Life
1952
Collection National Archives

over for American blacks.[51] In making this case, the United States Information Service sugarcoated the racial problems that the nation lived with, an inconvenient truth that would have hampered the implicit comparison between wholesome democracy and dissolute communism.

In the end, the status of African-Americans in mainstream visual culture at the birth of the civil rights movement was tenuous at best. In venues across the country—public and private, urban and rural, national and local— black people were repeatedly ignored, disparaged, or cast out to the margins of society. More than just pejorative or belittling, this imagery erased the humanity of its subjects. African-Americans were only very rarely included in mainstream mid-twentieth-century popular culture, and when they did appear, their depiction usually obscured more than it revealed. "Despite the bland assertions of sociologists, 'high visibility' actually rendered one *un*-visible," Ralph Ellison wrote of the regressive but ubiquitous images of race, "whether at high noon in Macy's window or illuminated by flaming torches and flashbulbs while undergoing the ritual sacrifice that was dedicated to the ideal of white supremacy."[52]

Ellison's observation, made in a revised introduction to *Invisible Man* written thirty years after its original publication, alludes to an enduring theme of the novel: that true power lay in the refusal to be rendered "*un*-visible." In Ellison's worldview, the act of overcoming invisibility—of bringing into the light the face, humanity, and story of a people as well as the reality of their oppression—was as great a force as any in the struggle for racial justice. It is not surprising, then, that the publication of *Invisible Man* coincided with the founding of the modern civil rights movement, for both emerged at a critical juncture in our nation's history, when new technologies for seeing and representing the world were revolutionizing the idea of what it meant to make something visible. The movement would soon learn the power of the camera to impel a nation to confront what it could not, would not, see. The war for racial equality had begun, not only with the shout of protest and the rustle of marching feet, but also with the click of the shutter.

We believed in 1945 that Black Americans
needed positive images to fulfill their potential.
We believed then—and we believe now—
that you have to change images before
you can change acts and institutions.

John H. Johnson
Succeeding Against the Odds (1989)

THE NEW "NEW NEGRO": THE CULTURE OF POSITIVE IMAGES

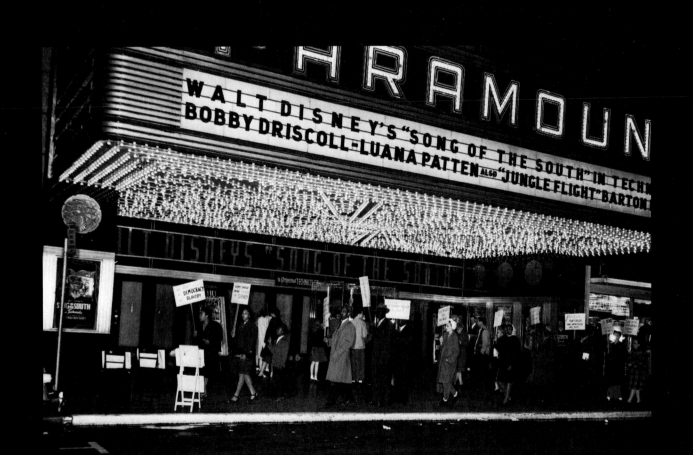

On a brisk afternoon in December 1946, members of the Theater Chapter of the National Negro Congress gathered under the marquee of the Palace Theater in New York. They were there to protest the negative portrayal of African-Americans in the movie *Song of the South*, released several weeks earlier by the Walt Disney Studio. The racially integrated group, determined to be seen and heard by as many people as possible, could not have selected a more conspicuous location: the Palace was situated in Times Square, the nation's busiest street.

The demonstration was small, but provocative, orchestrated to get the attention of both passersby and reporters. Picketers carried an effigy of "Jim Crow" in a wooden coffin, a prop later confiscated by police. They chanted a parody to the tune of "Jingle Bells": "Disney tells, Disney tells, lies about the South. We've heard all those lies before, right out of Bilbo's mouth," a reference to Theodore Gilmore Bilbo, an outspoken and virulently racist U.S. senator from Mississippi.[1] The demonstrators carried placards: "The *Song of the South* is slightly off-key because Disney says it's wrong to be free," read one. "We fought for Uncle Sam, not Uncle Tom," stated another, alluding to the black servicemen who fought bravely in a segregated military in World War II, then returned home to brutal discrimination. Protesters distributed handbills that condemned the film for its use of "offensive dialect" and its portrayal of black people as "low, inferior servants."

The picketers' strategy paid off. "*Song of the South* Picketed, Line at the Palace Protests Disney Portrayal of Negro," read a *New York Times* headline the following day, and the related article repeated the demonstrators' allegations and quoted liberally from their signs and leaflet.[2] The New York rally, news of which spread across the nation, was not an isolated event.[3] Local civil rights groups picketed movie theaters in a handful of American cities. On April 2, 1947, in downtown Oakland, California, protesters marched outside the Paramount Theater (*fig. 10*), bearing signs that read "We want films on Democracy, not slavery" and "Don't prejudice your child's mind with films like this."

The activity against *Song of the South* was not limited to protest rallies. Adam Clayton Powell, Jr., Harlem's representative in Congress, implored the New York City Bureau of Licenses to shut down theaters screening the film, condemning it as "not only an insult to American minorities, but an insult to everything that America as a whole stands for."[4] *Ebony*, then the most widely circulated African-American picture magazine, ran a two-page photo-editorial on the film, declaring it "lily-white propaganda" that "disrupted peaceful race relations." The piece was more than a critique—it was a call to arms. "It's about time that colored Americans wised up and went to work, counter-punching against the Hollywood that has given them perhaps their worst black eye," the editors concluded.[5]

The National Association for the Advancement of Colored People, the country's leading civil rights organization, joined the chorus of detractors. Its

fig. 10 (previous page)
M. L. Cohen
Untitled (Song of the South protest, Oakland)
April 2, 1947
Courtesy of the Oakland Museum of California, Gift of Mr. Martin J. Cooney

executive secretary, Walter White, rejecting the idea of a public demonstration against the film, addressed the media directly. On the day that *Song of the South* opened in New York, he dispatched a telegram to hundreds of newspapers nationwide criticizing the movie for its "dangerously glorified picture of slavery" and its depiction of "an idyllic master-slave relationship."[6] Several years earlier, well before the movie's completion, White had approached the Disney studio about the NAACP's concerns.[7] After repeated inquiries, the studio refused to send him a treatment of the picture, and later denied his request for an advanced screening.

The NAACP did not let up in its criticism. In January 1947, two months after the movie's premiere, White sent a telegram to *Parents* magazine protesting its decision to award *Song of the South* a medal of merit. "One of the chief causes of racial friction in this country is the half-truths and untruths which are planted in the unsuspecting minds of young people which in later years cause the perpetuation of dangerous and divisive prejudices," he wrote of the movie's misleading view of history and its reliance on black caricatures and stereotypes.[8]

The unaffiliated protests of the NAACP, the National Negro Congress, *Ebony*, and other institutions and individuals against *Song of the South* anticipated an important tactic in the modern struggle against racism: the skillful, calculated use of the media to take on the "half-truths and untruths" perpetuated by the media itself. These activists understood the enormity of the problem they faced; the film was but one transgression in a popular culture teeming with offensive black stereotypes. But it was also the perfect target for media-savvy crusaders: aggressively marketed and widely reviewed, *Song of the South* was Disney's first box-office hit since the end of World War II.[9]

The film was an apt target because it was successful, but also because of its insidious content. An archetypical example of racial nostalgia, *Song of the South* was based, in part, on a cycle of short stories first published in the *Atlanta Constitution* in the late 1870s by Joel Chandler Harris, a southern white newspaperman. These tales were in turn based on African and African-American folklore. Uncle Remus, an elderly ex-slave, was Harris's sagelike, dialect-speaking narrator, who spun life-affirming yarns about Br'er Rabbit—an animal that the author, for reasons that remain unclear, depicted as wily, anthropomorphic, and black. On the one hand, Harris equated African-Americans with animals, an unmistakably demeaning allusion. On the other, the rabbit's ability to outsmart the animals of prey that stalked and threatened him made him crafty and powerful—a reference, perhaps, to the ways in which black people had historically outwitted their racist tormentors.[10]

Disney's *Song of the South* is set in the Deep South of the 1870s. It centers on the trials of a little boy, Johnny (Bobby Driscoll), who, after his parents separate, moves with his mother from Atlanta to his grandmother's plantation.

The child, isolated and lonely, yearns for his father and life back in the big city. He tries to run away, only to encounter Uncle Remus (James Baskett), an elderly black plantation worker, who takes him under his wing. The old man draws on the magical tales of Br'er Rabbit, an animal so clever that he could survive almost anything, to help Johnny deal with his sense of hopelessness and despair. Even though he uses these stories to reassure the child—spinning them as cautionary tales about the perils of leaving home, for example—he is harshly reprimanded by the child's mother: "I'm trying my best to bring up Johnny to be obedient and truthful," she says, confusing storytelling with lying. "But you and your stories are making that very difficult."

Wounded and disgraced, Uncle Remus resolves to leave the plantation. A heartbroken Johnny runs after the wagon that takes his friend away, too late to catch him. As he darts across a pasture, the boy is chased and then mauled by a charging bull. He languishes, near death, in a coma. His despondent mother nurses him. His father returns from Atlanta to be with him. The plantation workers stand vigil outside his window, serenading him with their prayers. But nothing seems to rouse Johnny from his deadly sleep. In the film's mawkish climax, a chastened Remus returns to the plantation to tend to the injured child. Only then does the boy awaken, to find his family reunited and his beloved friend at his bedside.

The innocuous plot only hints at its "deeply revealing and disturbing American fantasies about slavery and blackness."[11] While Disney did not set out to make a racist film—the studio actually attempted to weed out offensive racial content from its script—it nevertheless endorsed a range of stereotypes.[12] Despite his wisdom and kindness, Uncle Remus is, like all of the film's black characters, a diligently constructed symbol of black compliance and servitude. He speaks in dialect. He moves in a slow, deliberate shuffle. He has a girlish giggle and a childlike grin. He is portrayed as a man so simple and innocent that his closest buddies are the cartoon animals that prance around him.

Song of the South was one of the first Disney productions to combine live action and animated sequences, relegating, for the most part, human characters to the former and animal figures to the latter. In the film's most celebrated scene, however, Uncle Remus is superimposed onto a vividly colorful, two-dimensional field of animated critters, so that he is squarely in the animal realm. As he struts across the screen singing "Zip-A-Dee-Doo-Dah," his cheeks kissed by butterflies, Mr. Bluebird alighting on his shoulder, he bonds with creatures that are, like him, blithe and uncomplicated. "I hope the animal kingdom will forgive me for telling these stories on them," Baskett proclaims in a 1946 radio advertisement for the film, underscoring his special connection to the world's nonhuman creatures. As if to further this association, Disney hired black actors to provide the

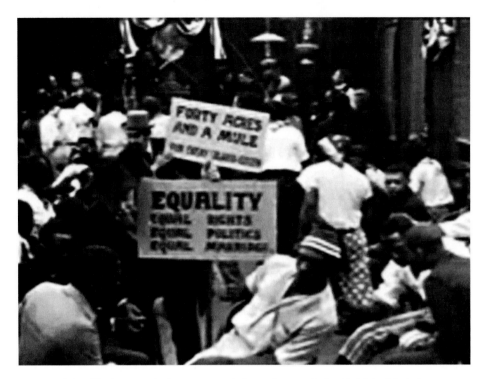

voices of the film's animal characters—Johnny Lee as Br'er Rabbit, Nick Stewart as Br'er Bear, and Baskett, in a dual role, as the sinister Br'er Fox.

Song of the South is most egregious, perhaps, in its racial nostalgia, its summoning a time when white people reigned and African-Americans were little more than carefree and acquiescent slaves. In one scene, the plantation's African-American inhabitants—who live in run-down shacks and wear tattered clothes, in stark contrast with their employers—sing joyously around a campfire. In another, a dim-witted maid, played by Hattie McDaniel, the first black actor to win an Academy Award (for her role as Mammy in Gone With the Wind), twitters merrily as she prepares a blueberry pie. "The master-and-slave relation is so lovingly regarded," wrote the New York Times film critic Bosley Crowther in a rebuke to the film, "with the Negroes bowing and scraping and singing spirituals in the night, that one might almost imagine that . . . Abe Lincoln made a mistake. Put down that mint julep, Mr. Disney!"[13] The studio, in defending the picture, emphasized that its story took place after the Civil War. But because the movie at no point establishes a specific time period, many critics and viewers were led to mistake its plantation workers for slaves.

The public criticism of Song of the South, rather than the reckless censorship some have alleged it to be, was part of an ongoing information campaign designed to place the topic of black representation on the national agenda.[14] The NAACP, the most prominent organization to take on Disney, advocated neither a boycott nor suppression of the movie. Instead, it waged a sophisticated war of

fig. 11
The Birth of a Nation
1915

words designed to publicize the idea that errant images could harm black people. The organization was relatively successful in this regard. Excerpts from Walter White's November 1946 press release were quoted in a number of periodicals, including *Variety*, the daily newspaper of the entertainment industry, and the *New York Times*, which followed its review of the movie with an item on White's statement.[15]

The NAACP's proactive campaign against racist imagery can be traced back to its beginning in 1909. Its founding members understood the innate power of visual culture, especially the influence of the nascent medium of film. In 1915, the association organized a national protest against *The Birth of a Nation* (*fig. 11*), an epic silent film about the aftermath of the Civil War, directed by D. W. Griffith. The picture—a faithful adaptation of *The Clansman* (1905), a much-reviled novel by Thomas Dixon, a white-supremacist Baptist minister—portrayed the end of slavery and Reconstruction as utter failures and the Ku Klux Klan as the savior of an imperiled white race.

The NAACP faced an uphill battle, because *The Birth of a Nation* had broad support. The film was hailed by critics as extremely innovative and was immensely popular with white audiences. President Woodrow Wilson was reported to have remarked that it was "like writing history with lightning," his only regret that "it is all so terribly true."[16] The NAACP unsuccessfully called for a nationwide ban, arguing that the film heightened racial tensions and threatened public safety—a charge substantiated by the unprovoked slaying of a black teenager in Indiana by a white man who had just seen the picture.[17] The NAACP also published a cycle of scathing reviews, written by W. E. B. Du Bois in the *Crisis*, the monthly magazine he edited for the organization. And through its Boston chapter it issued a forty-seven-page booklet, *Fighting a Vicious Film: Protest Against* The Birth of a Nation. Proclaiming the film "three miles of filth," the booklet challenged its veracity and motives, in words that would echo in the association's criticism of *Song of the South*: "The producers of the film do not hesitate to resort to the meanest vilification of the Negro race, to pervert history, and to use the most subtle form of untruth—a half truth."[18] The NAACP opposed *The Birth of a Nation* with each re-release. In 1921, it petitioned the mayor of Boston to outlaw the film, because of "its malicious misrepresentation of the colored people, depicting them as moral perverts."[19]

Twenty years later, building on the campaign against *The Birth of a Nation* but backing down from its censorious tone, the NAACP tried to enlist the motion picture industry in its fight for more positive images of African-Americans. Early in the 1940s, the organization helped build an informal alliance with white liberals in the film community. Working with studio executives, Walter White attempted to establish an ad hoc committee—a "Hollywood Bureau"—to monitor the portrayal of African-Americans on the screen and promote constructive and

more realistic roles for black entertainers. "What is more important," asked White, "jobs for a handful of Negroes playing so-called Uncle Tom roles or the welfare of Negroes as a whole? If the choice has to be made the NAACP will fight for the welfare of all Negroes instead of a few."[20]

A decade later, with plans for the Bureau still foundering, the NAACP turned its attention to the new medium of television, speaking out against two programs it deemed particularly offensive: *The Beulah Show* (1950–53), a comedy about a black maid and the suburban white family she served, and the first television series with an all-black cast, *The Amos 'n Andy Show* (CBS, 1951–53; *fig. 12*), a half-hour situation comedy, based on one of radio's most popular programs, about a dialect-talking, self-deprecating businessman and his zany, shiftless business partner.[21] But as the modern civil rights movement was coming into its own— and black entertainers were making modest inroads in film and television—the NAACP rethought its strategy for attempting to improve the image of African-Americans in the media and abandoned its plan for a Hollywood Bureau.

Although *Song of the South* remained popular with white audiences—the studio released the film five times over a forty-year period— the campaign against it had lasting effects.[22] If it did not stop the Disney Studio from producing films that were unflattering to other racial groups—there were, for instance, stereotypes of American Indians in *Peter Pan* (1953)—it helped dissuade the film industry, including Disney, from trafficking in negative depictions of black people. The determined, media-driven campaign against *Song of the South* made Hollywood uncomfortable. Producers, now fearful of alienating liberal white or African-American viewers—the latter a growing demographic for the film industry—began avoiding the racist clichés freely employed by Disney.[23] As

fig. 12
Amos 'n Andy
1952
(Napoleon Simpson,
Spencer Williams)

the film historian Donald Bogle observes, the protest against the picture "glaringly signaled the demise of the Negro as fanciful entertainer or comic servant."[24]

While such imagery did, in fact, continue to appear sporadically in films and television throughout the 1950s and early 1960s—*Beulah*, *Amos 'n Andy*, and the film *The Adventures of Huckleberry Finn* are obvious examples—the activism of the NAACP and other organizations and publications established an undeniable legacy that eventually brought about a major shift in the racial content of American popular culture. As early as 1944, the Hays Office—created by the major film companies to improve the industry's image and provide internal regulation through, among other things, a severe and censorious moral code—had acknowledged the increasing influence of African-American activists, "good people, [who] in recent months have become most critical" of their depictions in film.[25] In a December 1944 memo to the Disney Studio, concerning the questionable racial content of the yet to be completed *Song of the South*, a representative of the Hays Office warned, "I suggest again the advisability of your taking counsel with some responsible Negro authorities concerning the overall acceptability, from the standpoint of Negroes, of this story."[26] Within the entertainment industry, black performers were speaking out. The actress and singer Lena Horne, for one, refused to accept the tempered and restrictive roles that Hollywood traditionally reserved for black actors: we want "the Negro [to] be portrayed as a normal person," she stated.[27]

Not surprisingly, the early attempts of mainstream visual culture to support the positive imagery demanded by black activists were often begrudging or tentative. Indeed, many producers and publishers believed that depictions of black servitude were "positive" as long as they were uplifting and not grotesque. The Disney publicity department insisted that *Song of the South*, rather than degrading to black people, was a "monument to the race"; Uncle Remus, after all, was "a kindly, philosophical old man."[28] As hundreds of advertising campaigns and scores of movies and television programs affirm, the Disney Studio was not alone in its misconception.

The government of the United States, offering its own version of positive black imagery, turned to a compromised and divisive historical figure. In two early tributes to African-American achievement, the U.S. Congress selected Booker T. Washington—educator, acclaimed author of *Up from Slavery* (1901), and principal of the Tuskegee Normal and Industrial Institute (1881–1915)—as the first black person to be depicted on an American postage stamp (1940) and coin, a commemorative silver half-dollar (1946–51; *fig. 13*). The obverse of the coin, like the face of the stamp, shows a bust of Washington; its reverse, the slave cabin in which he was born. The stamp was intended for general use, the half-dollar for distribution to collectors, under the category of "noncirculating legal tender." Such coins were sold for a premium over their face value, and were issued to celebrate

fig. 13
Booker T. Washington Fan
ca. 1945
MNH Plate Block:
Booker T. Washington
1940
Commemorative Half Dollar:
Booker T. Washington
1946
All Collection Civil Rights
Archive, CADVC

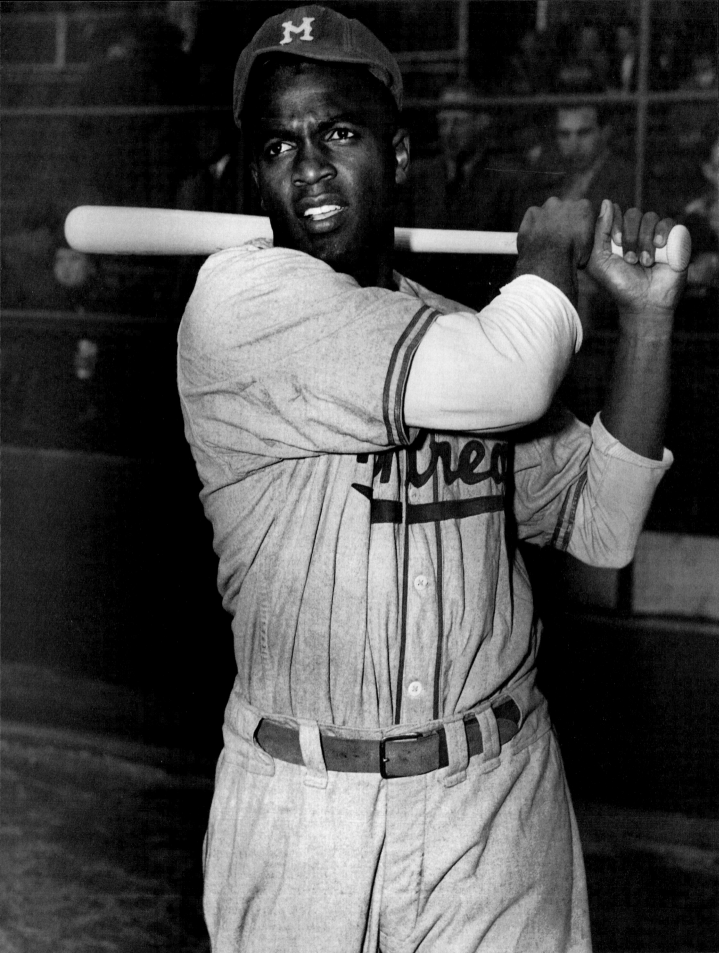

historical events or to raise money for memorials, in this case the Booker T. Washington National Monument in Hardy, Virginia.[29]

While acknowledging the need to cast African-American accomplishment in a favorable light, Congress chose a relatively conservative leader, known as much for appeasing white power as for challenging it: Washington called for "compromise" rather than protest, rejecting the forceful activism of such early civil rights leaders as the abolitionist orator and statesman Frederick Douglass. He advocated vocational training for African-Americans, defying education reformers such as Du Bois, who supported a rigorous academic curriculum.[30] He refused to publicly condemn Jim Crow laws or lynching. He implored black people to accept segregation—a view that incensed many of his contemporaries, including Du Bois, who labeled him "The Great Accommodator."

Washington's conciliatory politics made him a safe and tentative symbol of black authority and achievement, the perfect hero for a nation with little tolerance for African-American assertiveness. While Congress authorized a stamp in 1948 to honor the botanist George Washington Carver, Washington's loyal colleague at the Tuskegee Institute, it would take decades for the honor to be bestowed on less conciliatory black figures: Douglass (1967), Harriet Tubman (1978), the Reverend Martin Luther King, Jr. (1979), Whitney M. Young, Jr. (1981), Du Bois (1992), and Malcolm X (1999). To date, no African-American has appeared on U.S. circulating legal tender, either on printed currency or coins. And in the sixty years since the Booker T. Washington half-dollar was first issued, Congress has approved only three additional commemorative pieces with African-American themes. One of these is the George Washington Carver–Booker T. Washington silver half-dollar (1951–54), struck as part of a Cold War propaganda campaign to "oppose the spread of communism among Negroes in the interest of the national defense."[31]

Professional sports represented another significant and early realm for mainstream black representation. Through the 1950s and 1960s, images of black athletes began to penetrate the culture at large through newspapers, picture magazines, newsreels, movies, television, and sports memorabilia, such as baseball cards, clothing, and toys. The integration of major-league baseball in the late 1940s represented a turning point in this process. For more than seventy-five years, black players were banned from playing with whites in the major leagues. In response to this unwritten segregationist policy, the Negro leagues were formed in the late nineteenth century, a collection of professional baseball associations made up of predominantly African-American teams. While the Negro leagues issued posters and handbills in relatively small quantities, for distribution to black audiences (*pl. 7*), and were routinely covered in African-American periodicals, images of black ballplayers were effectively absent from the mainstream.

fig. 14
Jackie Robinson Swinging Bat
April 10, 1947
© Bettmann/CORBIS

The end of segregation in baseball meant that black players would be regularly covered by the media and depicted on baseball cards and other memorabilia. With the development of photography in the nineteenth century, baseball teams posed for group and individual portraits. The invention of offset lithography allowed these images to be printed onto small cards made of heavy paper stock and distributed as mementos, most notably as premiums in cigarette packages. After World War II, the baseball card industry accelerated. Cards were distributed as premiums in packages of bubble gum, hot dogs, bread, and cereals. With Jackie Robinson's hiring in 1946 as the first black major-league baseball player of the modern era, African-Americans could, for the first time, be represented as part of this franchise (*fig. 14*).[32]

Robinson's success opened the way for a steady stream of black players into organized baseball. Former Negro League stars Roy Campanella, Joe Black, and Don Newcombe soon joined the Brooklyn Dodgers, and Larry Doby became the American League's first black star, with the Cleveland Indians. By 1952 there were 150 African-American players in professional baseball, the best of the Negro Leagues having migrated to the integrated minors and majors. Black baseball heroes were now able to assume their rightful place alongside their white contemporaries in mid-twentieth-century mainstream visual culture (*pl. 8*).

If baseball cards were relatively race-neutral—their content was generally straightforward and factual—periodicals were usually more ideological in their handling of black athletes. Although popular mainstream magazines of the 1950s, such as *Life*, *Look*, *Sports Illustrated*, and the *Saturday Evening Post*, featured photo-essays on them, these were as concerned with the racial anxieties of white readers as they were with the accomplishments and struggles of their subjects. Black athletes were typically portrayed as apolitical and unthreatening, "their decency and gentleness away from the field" the focus.[33] Magazines inevitably sidestepped the problem of racism or referred to it euphemistically, and avoided the suggestion that their black subjects might protest against it. In a September 1957 profile of the tennis great Althea Gibson, in *Sports Illustrated* (*pl. 9*), a somber photograph of a once "shy and awkward" champion—not at play, but hunched over, her eyes cast down as she dries off between sets—accompanies Gibson's sobering admission that "you have to be a nice person to be a tennis player, or you don't amount to much."[34]

Such benign acknowledgment of black achievement served a useful, if qualified, purpose in the struggle for civil rights, inspiring race pride in a people long subjected to negative images of themselves in the mainstream press and appealing to white Americans to "abide by the doctrines of fair play and sportsmanship."[35] But it was no panacea for the scourge of racism, despite the widespread belief that the enfranchisement of blacks in sports would inevitably lead to the end of segregation in society as a whole. In 1948, the *Cleveland Plain Dealer*, for example, declared that white

acceptance of black athletes—an overstatement to begin with, based principally on Robinson's promotion to the major leagues a year earlier—was also a noteworthy victory for American race relations, a historical event "more spectacular and noble than all the . . . laws ever devised . . . Talents and skills are above city ordinances and they don't need their specious support."[36]

But as John Hoberman observes in *Darwin's Athletes*, such thinking was itself specious and premature, "a white auto-intoxication that [was] fed by the impossible dream of being rid of racial conflict as a factor in everyday life."[37] Two decades after the *Plain Dealer* editorial, a study on the social and cultural status of the black athlete, published in *Sports Illustrated*, concluded that the integration of professional and collegiate sports had done surprisingly little to resolve the problem of white racism, in athletics or in society. "The concept of sports as an integrating force is a myth in the first place, a legend nurtured by people who should know better," a retired University of Kansas basketball coach commented in the piece. "[Most colleges] go about in a dream world of race, imagining that they are assisting in the slow evolutionary process of integration" while remaining unaware of their racist behavior.[38]

Images of unthreatening black sports figures—wrested from the reality of prejudice, its continued effect on their lives, and their own reactions to it—amounted to little more than a new form of stereotype. The media tended to dwell on the physicality and strength of black athletes, and ignore their minds and souls. "What white America demands in her black champions is a brilliant, powerful body and a dull, bestial mind—a tiger in the ring and a pussycat outside," observed Eldridge Cleaver.[39] As the Kerner Report, a study by a federal government commission that investigated urban riots in the United States, concluded in 1968, the mainstream media had for decades relegated African-American representation to a stark dichotomy of stereotypes: criminals, on the one hand, and apolitical and passive entertainers and sports figures, on the other.

The increasing dominance of black athletes over their white counterparts in the late 1950s and the 1960s—which was aided by the integration of high school sports after *Brown v. Board of Education* and the accelerated recruitment of African-American athletes in collegiate and professional sports—only exacerbated the media's anxieties about alienating white readers. Perhaps nowhere was this more obvious than with the boxer Cassius Clay's first appearance on the cover of a national mainstream magazine. The vivid portrait of the Olympic champion on the cover of the March 22, 1963, *Time* represents him as simultaneously boisterous and beatific. He is shown naked from the waist up. His head is cocked to one side. Although his stare is intense, even defiant, his eyes are cast upward, thus avoiding direct contact with the reader. His mouth is open, an allusion, perhaps, to his gregariousness. ("Some people think Cassius Clay talks too much," reads a line

The CRISIS

November 1938 ● Fifteen Cents

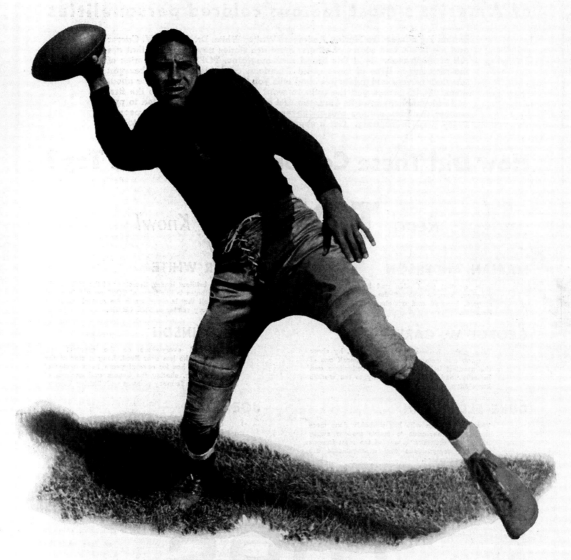

SYRACUSE'S SIDAT-SINGH
(He got revenge on Maryland, 53-0, beat Cornell—See page 350)

OUT-OF-DATE COLLEGES

RANDOLPH EDMONDS

from the interior article.) His empty boxing gloves hover above his head, holding open a book of psalms—a constellation of objects that frames his head like a halo.

The cover story is no less confusing and ambivalent: it paints Clay as apolitical and patriotic, making no reference to the bigotry he continued to experience in his hometown of Louisville. "Man, the U.S.A. is the best country in the world, counting yours," he is quoted as telling a Russian reporter. "I ain't fighting off alligators and living in a mud hut."[40] Yet, in the course of the next few years, Clay—who became a devout Muslim and adopted the name Muhammad Ali, given to him by the Nation of Islam leader Elijah Muhammad—would speak out against racism in America, vehemently oppose the Vietnam War, refuse to be drafted into the U.S. military, and write eloquently of a lifelong political fervor shaped by a childhood beset by racism.[41] While the *Time* story mentions the fighter's victories, it spends more time on his extroverted personality, immodesty, and lavish spending habits than it does on his professional accomplishments or ideas about boxing. "Cassius' permanent record at Louisville's Central High School lists his IQ as 'average,' but when he graduated in 1960, he ranked 376th in a class of 391," the article reports, instantly robbing him of seriousness or intellectual or emotional gravity.[42] It reserves its most unambiguous praise not for Clay but for a syndicate of wealthy businessmen who will now own and manage him. "That's class, man," reads the caption under a photograph of the ten immaculately dressed white men now presumably responsible for cleaning up the boxer's less than "classy" image.[43]

Overall, the black press was usually more strategic, supportive, and progressive in its attitude toward African-American sportsmanship. Black periodicals across the nation aggressively documented the careers of African-American athletes, often earlier and with far greater frequency than mainstream publications (*fig. 15*). Athletes' stories were routinely tied to the broader matters of racial prejudice and segregation in American life, and their successes were interpreted as a "measure of racial progress."[44] Black newspapers such as the *Pittsburgh Courier* and *Chicago Defender* and magazines including the *Crisis* and *Ebony* invited readers to "dote on the victories won and records established"—which included Jesse Owens's symbolic triumph over fascism in the Berlin Olympics of 1936, Joe Louis's record-breaking ascendance to the world heavyweight boxing championship, and Althea Gibson's U.S. Open championships in the late 1950s—and to see these achievements within the context of the broader struggle for racial equality and justice.[45]

These publications, in their campaign against segregation in major-league baseball, for instance, consistently linked the story of prejudice in professional sports to the even more intractable problem of racism in everyday

fig. 15
The Crisis
November 1938
CADVC and NMAAHC wish to thank the Crisis Publishing Co., Inc., the publisher of the magazine of the National Association for the Advancement of Colored People, for the use of this image from the *Crisis*.

life.[46] As Jackie Robinson endured his difficult first season in the spring and summer of 1947, a period marked by racist taunts and by the honor of being named Rookie of the Year, the black press repeatedly made this connection, reporting on the prejudice that would haunt the ballplayer in the majors and editorializing on his role as a beacon of "the hopes, aspirations and ambitions of thirteen million black Americans," people who continued to suffer the indignity of racial oppression.[47] Through stories, photographs, and photo-essays, Robinson was positioned as an intelligent, progressive, and exceedingly talented man who, in newly integrated professional baseball, might achieve for his race a rare, if only symbolic victory over white power.

The black press remained vigilant throughout the modern struggle for civil rights. As late as July 1973, *Jet* magazine ran a cover photo of Hank Aaron, with the provocative banner: "Hank Aaron Discusses Racism and His Race for Ruth's Record." By contrast, a *Newsweek* cover a month later paired a similar shot with the more dispassionate "Chasing the Babe," alluding only to the ballplayer's (eventually successful) attempt to surpass Babe Ruth's long-standing home-run record.

While much writing on the era has contended that the struggle for civil rights depended on outside forces—northern liberals, the federal government, courts, mass media, philanthropic foundations, white college students—the differences in sports reporting remind us of the extent to which the modern movement was organized and sustained principally by African-Americans, especially "indigenous black institutions, organizations, leaders, and resources."[48] In his groundbreaking book, *The Origins of the Civil Rights Movement*, the historian Aldon Morris argues that black leaders, organizers, and institutions consistently fought racism years before the mainstream, employing sophisticated tactics of nonviolent protest, legislative lobbying, and positive image making.

African-Americans were never "equal partners" in the mainstream, not even in the most progressive cultural and social institutions, and were "systematically excluded from their decision-making process"—a disenfranchisement that was as absolute in southern legislatures as it was in the executive offices of the nation's magazine publishers, film studios, and television networks.[49] "This institutional subordination naturally prevented blacks from identifying with the institutions of the larger society," Morris writes. "In short, the larger society denied blacks the institutional access and outlets necessary to normal social existence."[50]

Thus, African-Americans dedicated to the cause of civil rights needed to be both aggressive and creative, compelled, as they were, to build new institutions, strategies, and images for challenging the status quo. As Morris's reading of the movement suggests, the idea of the black sports figure as symbol of the unfairness and durability of racism and the potential for its demise arose not in the pages of *Life*, *Look*, or *Time*, but with African-American civil rights groups and media. The NAACP, for one, in its ongoing campaign to promote positive images—and to

protest against negative ones—engaged in "massive educational efforts aimed at depicting blacks in a realistic and not stereotypical manner."[51] The organization launched a "Double V" campaign during World War II to promote victory over racist enemies abroad and over prejudice at home. Aside from its success in creating words and images that publicly tied the battle against fascism to the struggle against racism in the United States, the initiative resulted in a major legislative victory: the establishment of the Fair Employment Practices Commission and the subsequent passage of Fair Employment Practices laws in a number of states. With the passage of an FEP law in New York State in 1945, civil rights organizations moved to force professional baseball to comply with the law, and this was significant in Robinson's being hired by the Brooklyn Dodgers. The effects of this ideological and cultural shift trickled down to black representation as African-American periodicals showered readers with triumphant depictions of Robinson, both to instill pride and to pressure mainstream publications to follow their lead and promote the cause of African-American legitimacy within the larger culture.[52]

The imperative of African-Americans to take charge of the struggle for racial justice was reflected throughout visual culture. In the early years of the modern civil rights movement, black photographers, artists, filmmakers, producers, publishers, and editors worked arduously to recast the negative image of the race that was then common in popular culture. The rise of African-American pictorial magazines was arguably the most public and far-reaching of this activity. The origins of these publications can be traced to the nineteenth century, when black periodicals were often local and makeshift and had few if any illustrations.

Convinced that African-Americans needed a publication to better serve their needs and aspirations, W. E. B. Du Bois envisioned a widely circulated pictorial magazine (*fig. 16*). Armed with "a knowledge of modern publishing methods" and "a knowledge of the Negro people," he turned to state-of-the-art technology, including the economical printing of black-and-white photographs and graphic images.[53] His first magazine, *Moon Illustrated Weekly*, survived for a year; his second, *Horizon: A Journal of the Color Line*, lasted for nearly three. In 1909, along with other intellectuals, black and white, Du Bois founded the NAACP, and in 1910, he launched its influential monthly, the *Crisis* (*fig. 17*). He would remain its editor for nearly twenty-five years.[54]

The objective of the *Crisis* was to "set forth those facts and arguments" that revealed "the danger of race prejudice" in order to galvanize and motivate black resistance to racism and segregation.[55] More than any other factor, it was the deft balance between word and image that accounted for the magazine's success. Du Bois's visual approach was popular with readers: within a few months of its launch, the *Crisis* announced that it would "increase the number and quality of the illustrations" so as to render it "a pictorial history of the Color Line."[56] In its

first decade, subscriptions to the magazine increased tenfold.

In the publication's early issues, Du Bois alternated strident articles and editorials about the reality and effects of racism with stories about black accomplishment. In the former, pictures served as persuasive evidence, as in the gruesome photographs that illustrated pieces about violence against black people (*fig. 18*). In the latter, pictures celebrated or commemorated: photographic portraits accompanied obituaries, profiles, or the "Men of the Month" column (*fig. 19*). For Du Bois, the stark depiction of bigotry could not by itself lessen its destructive effects; more affirmative images were necessary. The subtle interaction between negative and positive imagery was "crucial to the impact of the magazine," allowing it to document racial prejudice and at the same time demonstrate, by example, the ability of black people to triumph over it.[57]

As his conceptual understanding of the magazine evolved, Du Bois replaced "blazing editorials," with more dispassionate reporting on the complex and often paradoxical realities of black life.[58] He also began to favor the literary and visual arts. The emphasis on aesthetics mirrored the black philosopher Alain Locke's notion of the "New Negro," an idea that was inspired in part by Du Bois's early writing. The New Negro was a cornerstone of the Harlem Renaissance of the 1920s, an intellectual movement of artists, writers, and musicians determined to transform the "stereotypical image of Negro Americans as ex-slaves, members of an inherently inferior race—biologically and environmentally unfit for mechanized modernity and its cosmopolitan forms of fluid identity—into an image of a race of culture-bearers."[59] While the *Crisis* continued to report on and denounce racism, it devoted "more and more attention to the role of the arts," especially literature, graphic art, and photography, in providing new and positive images of black people.[60]

Well into the civil rights era, the *Crisis* published hundreds of features aimed at correcting "misunderstandings of or distorted ideas about African Americans" and validating their "contributions to national and global culture."[61] Employing prose, poetry, fiction, photographs, and drawings, these features challenged the status quo by ennobling, rather than concealing, black talent, intelligence, tenacity, and achievement. In this regard, Du Bois viewed portraiture as an indispensable device:

> I sought to encourage the graphic arts not only by magazine covers with Negro themes and faces, but as often as I could afford, I portrayed the faces and features of colored folk. One cannot realize today how rare that was in 1910. The colored papers carried few or no illustrations; the white papers none. In many great periodicals, it was the standing rule that no Negro portrait was to appear and that rule still holds in some American

fig. 16
Lotte Jacobi
W.E.B. Du Bois
ca. 1950
© Lotte Jacobi Collection, University of New Hampshire. Courtesy of Photography Collections, University of Maryland Baltimore County

THE CRISIS

A RECORD OF THE DARKER RACES



Volume One NOVEMBER, 1910 Number One

Edited by W. E. BURGHARDT DU BOIS, with the co-operation of Oswald Garrison Villard, J. Max Barber, Charles Edward Russell, Kelly Miller, W. S. Braithwaite and M. D. Maclean.

CONTENTS

PUBLISHED MONTHLY BY THE

National Association for the Advancement of Colored People

AT TWENTY VESEY STREET NEW YORK CITY

ONE DOLLAR A YEAR TEN CENTS A COPY

fig. 17
The Crisis
November 1910
The CADVC and NMAAHC wish
to thank the Crisis Publishing Co.,
Inc., the publisher of the magazine
of the National Association for the
Advancement of Colored People,
for the use of this image from
the *Crisis*

fig. 18
The Crisis
September 1917
The CADVC and NMAAHC wish
to thank the Crisis Publishing Co.,
Inc., the publisher of the magazine
of the National Association for the
Advancement of Colored People,
for the use of this image from
the *Crisis*

periodicals. Through our "Men of the Month," our children's edition and our education edition, we published large numbers of most interesting and intriguing portraits.[62]

Du Bois believed in the power of affirmative visual images to inspire and motivate. "Pictures of colored people were an innovation," he said in 1951, citing what he believed was one of his most important accomplishments as editor of the *Crisis*. "At the time it was the rule of most white papers never to publish a picture of a colored person except as a criminal."[63] If the magazine's

MEN OF THE MONTH

of Chicago. In 1889 he began to practice in St. Paul, and he became, as the years went by, one of the great criminal lawyers of the Northwest.

But McGhee was not simply a lawyer. He was a staunch advocate of democracy, and because he knew by bitter experience how his own dark face had served as excuse for discouraging him and discriminating unfairly against him, he became especially an advocate of the rights of colored men. He stood like a wall against the encroachment of color caste in the Northwest and his influence and his purse were ever ready to help. As a prominent member of the Catholic church and a friend of Archbishop Ireland and others, he was in position to render unusual service.

He died at 51, leaving a widow and one daughter. His pallbearers were among the most prominent men, white and colored,

THE LATE FREDERICK LAMAR McGHEE

A GREAT ADVOCATE.

WHEN the twenty-nine colored men met at Niagara Falls in 1905 and stemmed the tide of abject surrender to oppression among Negroes, Frederick L. McGhee of St. Paul was a central figure; and he is the first of that faithful group to die. He was born in Mississippi on the eve of the Civil War, educated in Tennessee and studied law with the well-known E. H. Morris

THE LATE JOSEPHINE SILONE-YATES

relentless depiction of racial oppression addressed the status quo—grounding the reader in the truth of a daunting present—its images of black success offered a glimpse of a hopeful future. The *Crisis* would offer no less than a collective portrait of African-American life, a repository of role models and ideals to which black people could aspire.

Du Bois led the way for other editors and publishers. In 1942, John H. Johnson, a twenty-four-year-old African-American businessman and son of a poor Arkansas family, started a publishing enterprise that would become an empire and would forever alter popular culture's approach to race. Johnson's first job, as an assistant to the president of Supreme Life Insurance, a Chicago company founded to serve black people, required him to monitor stories about African-American life in local and national periodicals. It was then that he learned of the "almost total white-out on positive black news in white-oriented media."[64] Disheartened, yet motivated by what he found, Johnson left the insurance business to begin his own magazine, *Negro Digest*.

Negro Digest offered a "creative mix of opinion, debate, exposition and literary expression."[65] Adopting the format of the then popular monthly *Reader's Digest*, it was composed mostly of material reprinted from other sources. Neither a literary journal nor a glossy consumer rag, the magazine was pitched to a general black readership. Its editors strove for ideological "neutrality," avoiding a militant tone and giving voice to diverse positions. In its early issues, the *Negro Digest* attempted to remain nonpartisan and objective, going so far as to reprint a "letter to the editor" from another publication that justified lynching as a means of upholding the "social order." Bowing to pressure from its readers, the magazine became more assertive and opinionated in its coverage of racism and civil rights, topics that its editors acknowledged as central to the survival and future of its black readership.[66]

Negro Digest was an instant success: within two years, its monthly circulation increased to nearly 100,000. But its emphasis on text over pictures, much as with *Reader's Digest*, limited how it addressed and influenced its readers. The magazine's roster of writers—Du Bois, Langston Hughes, Fannie Hurst, Paul Robeson, Carl Sandburg, Norman Thomas, and Walter White, to name a few— was undeniably impressive. Johnson, however, came to believe that words were not always as effective as visual images, and that he was "making the same mistake in neglecting pictures that I was making in holding on to the successful *Negro Digest* idea."[67] In his autobiography, he wrote of the central role played by visual media immediately after World War II:

> People wanted to see themselves in photographs. White people wanted to see themselves in photographs, and Black people wanted to see themselves in photographs. We were dressing up

fig. 19
The Crisis
November 1912
The CADVC and NMAAHC wish to thank the Crisis Publishing Co., Inc., the publisher of the magazine of the National Association for the Advancement of Colored People, for the use of this image from the *Crisis*

THE NEW "NEW NEGRO": THE CULTURE OF POSITIVE IMAGES

for society balls, and we wanted to see that. We were going places we had never been before and doing things we'd never done before, and wanted to see that. We wanted to *see* Dr. Charles Drew and Ralph Bunche and Jackie Robinson and the other men and women who were building the campfires of tomorrow. We wanted to know where they lived, what their families looked like, and what they did when they weren't onstage.

The picture magazines of the 1940s did for the public what television did for the audiences of the 1950s: they opened new windows in the mind and brought us face to face with the multi-colored possibilities of man and woman.[68]

Johnson understood that pictures were persuasive, immediate, and evidentiary. They offered the kind of unequivocal depiction of black achievement, attractiveness, perseverance, and affluence that would inspire African-Americans to "fulfill their potential."[69] "You have to change images before you can change acts and institutions," he later observed.[70] Three years after the premiere of *Negro Digest*, Johnson launched *Ebony*, the first lavishly illustrated consumer monthly for African-Americans. He chose the name—a "fine black African wood"—as a metaphor for the quality and visual beauty of the new publication.[71] Consciously modeled on *Life*, then the nation's most widely read picture magazine, *Ebony* featured photo-essays as well as other photographic formats.

Johnson attempted to strike a balance in *Ebony* between hard-hitting reporting and more lighthearted fare devoted to subjects as varied as celebrity gossip, cooking, entertainment, and black achievement in business and the arts. The magazine intended to "mirror the happier side of Negro life—the positive, everyday achievements from Harlem to Hollywood," *Ebony* announced in its inaugural issue. "But when we talk about race as the No. 1 problem of America, we'll talk turkey."[72] Although the magazine avoided the muckraking and louder editorializing of the era's dominant black periodicals—mostly local newspapers, such as the *Detroit Tribune*, the *Michigan Chronicle*, the *Chicago Defender*, the *Pittsburgh Courier*, and the *Amsterdam News*—it actively covered the story of civil rights.

If Du Bois adroitly balanced downbeat and positive depictions in the *Crisis* in order to motivate black readers into social activism, Johnson did so for the purpose of nurturing their social aspirations. In stark contrast to the somber tone of Du Bois's publication, *Ebony* emphasized upbeat imagery, even as it covered the difficult and ongoing struggle for racial justice. Johnson's magazines were committed not just to black equality, as was the *Crisis*, but also to building an empowered and informed African-American middle class. As the historian James Hall observes, the publisher wanted to "mobilize and maximize class desire, to satisfy aspiration toward, and admiration of" clearly presented images of successful

people of color, a fantasy of affluence and freedom "open to both those who have made it and those still struggling."[73] Through a number of visual strategies—portraiture, photo-editorials, and candid shots—*Ebony* juxtaposed the negative and the problematic with cheerful imagery that centered on the upward mobility of an emergent African-American bourgeoisie.[74]

Johnson's publications were crucial in enfranchising the image of black people in popular culture. To this end, they radically altered the way big business viewed the black consumer. While *Ebony*'s earliest issues contained few advertisements, its survival depended on income from sponsors, who needed to be convinced of the spending power of black people. A year after he started the magazine, Johnson was aggressively, and successfully, wooing America's wealthiest corporations. The founder and publisher of *Black Enterprise* magazine, Earl Graves, Sr., recently noted that Johnson was the "first publisher to open the eyes of Madison Avenue to the multibillion-dollar influence of the African-American consumer market. By showing the profitability of using Black models and Black-themed campaigns, he . . . changed the way American companies market their products to Black consumers."[75]

Johnson, the consummate salesman, adhered to a simple business philosophy: persuade the advertisers that it was in their economic "self-interest," and not just the publisher's, to reach out to the long-ignored African-American consumer.[76] The robust sales of Johnson's publications—by the mid-1950s, *Ebony*'s monthly circulation had soared to 500,000—was a convincing selling point. He was also able to identify demographic shifts taking place in the United States. After World War II, the African-American middle class, though still a small portion of the black population as a whole, was slowly but steadily expanding. This increase was the result of, among other factors, the unprecedented economic growth and prosperity of the nation as a whole and the early inroads made by the civil rights movement, especially in the large cities of the North and Midwest. During this time, predominantly white colleges started to admit black students, companies began recruiting African-American employees, and unions approached formerly excluded workers.[77]

Johnson's argument was persuasive. While many potential sponsors balked or offered him race-neutral or white-identified ads, others retrofitted existing campaigns or designed new ones, at great expense, to appeal to the black middle-class consumer. Transcending the predictable imagery of black servitude, these race-specific campaigns featured African-American celebrities, primarily from the realms of sports and entertainment, or black models, posing as ordinary people engaged in work, domestic, or leisure-time activities. They endorsed goods aimed specifically at people of color, products to straighten hair or lighten skin, for example, as well as those in general use—food, alcohol,

cigarettes, electrical appliances, and grooming products. And they represented a wide range of sponsors, from Bufferin analgesic tablets and Carnation milk to Remington Rand office equipment and Old Gold cigarettes.

Johnson's motives were political as well as economic. If *Ebony*'s business interests sometimes compromised its political reporting, the magazine was nonetheless an effective antidote to the injurious effects of a neglectful popular culture. As Henry Louis Gates, Jr., has commented, black Americans at mid-century were "starved for images" of themselves, and scoured black picture magazines and eventually television to find them.[78] Between 1940 and 1960, *Life* magazine rarely published affirmative images of African-Americans. It almost never included them in its definition of prosperity, progress, or "the American way of life," relegating them to the roles of servant, victim, and clown.[79] In its weekly reporting and in its special issues—"America's Assets," "This Pleasant Land," "Great American Churches," "U.S. Growth"—*Life* unfailingly depicted a white nation nearly devoid of black faces or subject matter.[80]

This "white-out"— endemic to *Life* and American popular culture as a whole—undeniably harmed black people. By the 1950s, the civil rights movement had begun to target the problem, making it a focus of its legal and legislative activities. It did so in a case no less important than *Brown v. Board of Education* (1954), arguing that de jure segregation enforced a habitually neglectful and negative public image of black people that threatened their legal status as well as their state of mind. At trial in *Briggs v. Elliott* (1951)—a lawsuit involving the school system of Clarendon County, South Carolina, that was later consolidated into the *Brown* case—the NAACP offered testimony by the African-American psychologist, Dr. Kenneth Clark, on the deleterious effects of stereotypes on black children.

In a pioneering study conducted by Clark in the late 1940s, sixteen African-American grade-schoolers between the ages of six and nine were shown separate drawings of black and white dolls, identical in every way except skin color. Individually, the children were asked to point out the doll they liked "best" and would "like to play with" as well as the doll that was "nice" and the one that was "bad." They were also asked to determine the race of the dolls and select the one that they believed looked most like them. Children easily identified the dolls' race, as well as their own. Ten out of the sixteen preferred the white doll and considered it "nice," while eleven of them saw the black doll as "bad." The results of the study were unequivocal: black children readily internalized the disapproving image of blackness then prevalent in all aspects of public life. "Subjected to an obviously inferior status in the society in which they live," Clark testified, black youth were "definitely harmed in the development of their personalities."[81]

Johnson provided a credible alternative to the relentless representation of black inferiority. He did so pragmatically, because the needs of his readers

and sponsors were not always the same. *Ebony*'s black subscribers had come to rely on sober reporting and editorializing on racism, features that repeatedly underscored their tenuous, if improving, status in society. Advertisers depended on cheerful, apolitical, and seductive imagery to sell products. They knew that consumers tended to spend more, and more adventurously, when they saw their lives as stable and the future as hopeful. Thus, the magazine's publisher and editors tipped the balance of its content toward affirmative stories and imagery. These were meant to serve the interests of readers and sponsors alike, providing readers with images that countermanded stereotypes and sponsors with stories that sold the idea of black success, stability, and affluence.

The culture of positive images encouraged by Johnson and others acknowledged the extent to which black liberation was equally a "struggle over images" and a "struggle for rights, for equal access."[82] The notion of visual representation as a potent ideological force motivated Du Bois before him in the *Crisis*. It inspired the Harlem Renaissance and its ideal of The New Negro. It impelled the protesters who railed against *The Birth of a Nation* and *Song of the South*. And it ultimately prevailed in the modern civil rights movement. As one of its venerated leaders, Roger Wilkins, recently noted, the legal "power to segregate," once thought to be racism's most effective instrument of control, was no match for "the power to define reality where blacks [were] concerned and to manage perceptions and therefore arrange politics and culture to reinforce" those perceptions.[83]

Johnson's agile reconciliation of the economic needs of big business and the political and psychological needs of his readers succeeded in wresting away from the power brokers of visual culture some of the authority to define this reality. In an age when new technologies for the mass production and distribution of pictures were expanding, the visual medium was more potent than reality in conditioning the attitudes of the public at large. From the birth of photography in the nineteenth century to the spread of color photography and television in the twentieth, mechanical reproduction was driven by the ideal of verisimilitude: the ability to create a seamless and hyperrealistic illusion of the world. In other words, the more "real" a picture appeared, the more successful it was understood to be.

Verisimilitude makes photographic images especially authoritative—in their capacity to serve as evidence, to represent the world in a concise, scientific, and easily digestible way, and to bestow truth, even as they manipulate reality. Photographs transcend the inexactness of language or speech. They offer an efficient way of "apprehending something and a compact form of memorizing it," in the words of Susan Sontag, "like a quotation, or a maxim or proverb. Each of us mentally stocks hundreds of photographs, subject to instant recall."[84] The popularity of illustrated tabloid newspapers and the rise of picture magazines

in the 1920s and 1930s intensified the public's trust of and faith in photography: readers increasingly came to "expect information to arrive in visual form."[85] As the French publisher Jean Prouvost observed at the time, "the image has become the queen of our age. We are no longer content to know—we must see."[86] Similarly, the American journalist Walter Lippmann, writing in 1922, lauded the power of photographs to influence people: "[They] have the kind of authority over imagination today, which the printed word had yesterday, and the spoken word before that. They seem utterly real."[87]

John Johnson's understanding of this authority was as profound as his insights into the psychology of capitalism. By his own admission, his main goal in publishing was not to "make history" but to "make money."[88] Yet, more successfully than any other businessman of his era, he also set out to remake the image of blackness within the culture at large—to create a kind of new "New Negro"—and in so doing he created a new and more positive "reality" for black people. By encouraging fresh paradigms for seeing and representing blackness within corporate America—that it was an asset rather than a liability, or that black consumers would respond best to positive images of themselves—Johnson started a visual revolution. And *Ebony* was just the beginning. Following on its success, Johnson Publishing Company launched other pictorial magazines, including *Tan* and *Ebony Jr.*, the first magazines for black women and children, respectively, and the pocket-sized *Jet* (1951–present).

In the quarter-century after the premiere of *Ebony*, constructive and self-assured images of black people were increasingly commonplace in the media. They appeared in a host of other, often short-lived black pictorial magazines inspired by Johnson's publications—*Brown*, *Hue*, *Negro Review*, *Our World*, *Say*, and *Sepia* (*pl. 10*). They found their way into books, posters, and advertisements. And they engendered an industry unto themselves, aimed at black consumers and dedicated to instilling pride through the representation of black achievers—from souvenir cards celebrating the life and career of Paul Robeson (1973; *pl. 11*) to limited-edition plaster busts commemorating black inventors and innovators, issued in 1967 as part of a promotional campaign by the Old Taylor Distillery company and created by the African-American sculptor and photographer Inge Hardison (*pl. 12*).[89]

The culture of positive imagery, however, could not by itself resolve the problem of racism. For that, the nation's white majority would have to confront the underlying causes and belief systems that engendered bigotry. It would have to admit its misdeeds, acknowledge and improve its attitudes, and be willing to share the power it jealously guarded. But in the early 1950s, most white Americans were in denial, unwilling even to recognize the pervasiveness of bigotry. They remained oblivious to the psychological and political weight of their own

race. The social and cultural status of whiteness, as "normal" and innate, insulated them to a great extent from honest self-inquiry and self-assessment. If black people, as a matter of survival, had to evaluate the status of their race in relation to the prejudice they experienced every day, white people were usually free to go about their lives never having to question the dividends afforded them by the color of their skin. There was little incentive for most white Americans to deal with a problem that was then subverting democracy, ruining lives, and sowing the seeds of social unrest.

As the civil rights movement evolved, its leaders faced a daunting question: how best to jolt white America out of its racial stupor? Although there was no single answer, it was clear to many that visual culture could once again play a critical role. Some implored the mainstream media to follow Johnson's lead—as it eventually began to do in the 1960s—and support the positive imagery that could bolster the morale of black people and promote their legitimacy in white America. Others believed that the movement needed a more effective means of convincing the nation of the gravity of the dilemma it faced. In its struggle to accomplish these goals, the movement soon came to rely on a new and extremely powerful visual medium, one that would forever change the nature of political communication: television.

PLATES

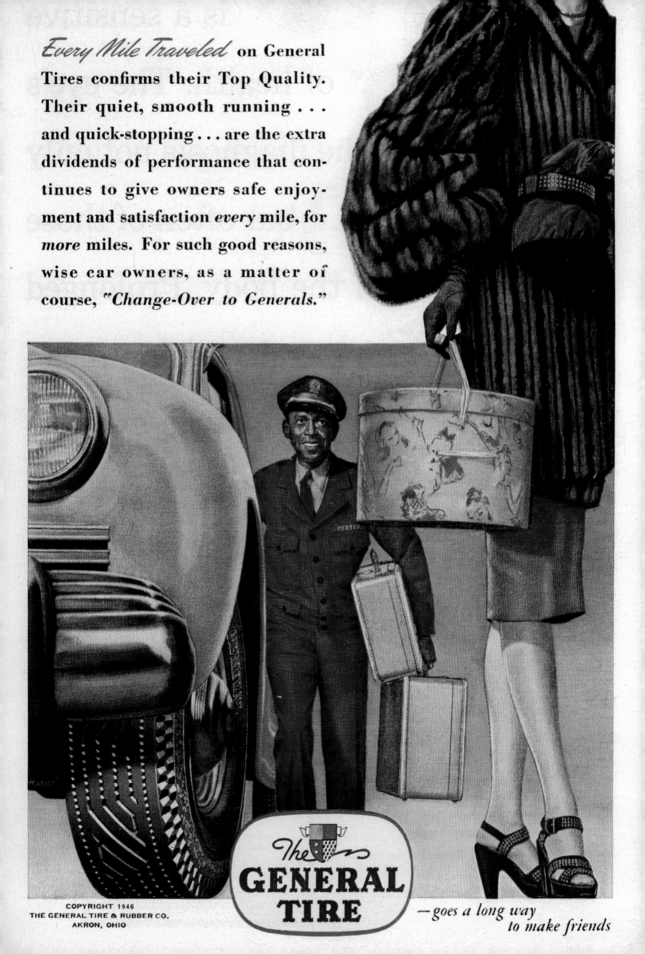

Every Mile Traveled on General Tires confirms their Top Quality. Their quiet, smooth running . . . and quick-stopping . . . are the extra dividends of performance that continues to give owners safe enjoyment and satisfaction *every* mile, for *more* miles. For such good reasons, wise car owners, as a matter of course, *"Change-Over to Generals."*

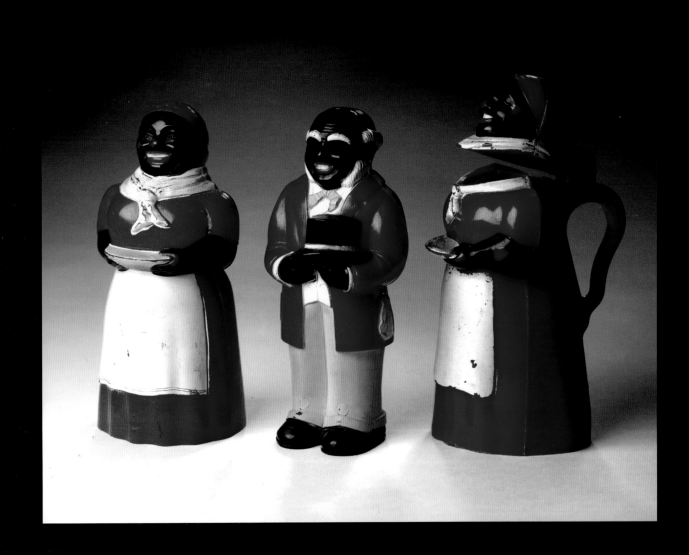

COLORED ENTRANCE
ONLY

ATLANTA, GEORGIA

SEPT. 1932

DRINKING FOUNTAIN

WHITE

COLORED

MONTGOMERY, ALA

14 JULY 31

GROW WHITE CORN
for Extra Profits

Negro BASEBALL

Pictorial ★ Year Book 25¢

1944 Records ★ World's Series Review
East-West Classic ★ All-America Team

pl. 8
Baseball Cards
Roy Campanella 1956
Jackie Robinson 1955
Jackie Robinson Bank 1950
Hank Aaron 1958
Willie Mays 1959

Collection Civil Rights Archive,
CADVC. Cards published courtesy
of Topps Company, Inc.

pl. 9
Sports Illustrated
September 1957
Collection Civil Rights Archive,
CADVC. Courtesy of John G.
Zimmerman, *Sports Illustrated*

PHOTOGRAPHS BY JOHN G. ZIMMERMAN

ALTHEA

Gibson, a shy and awkward

girl who had to fight herself as often as a hostile world,

this week will try for her first National Singles title at Forest Hills.

Here is a warm glimpse of her by an old friend

by SARAH PALFREY

WIMBLEDON was behind her, and the great victory which finally marked her as a champion. Now Althea Gibson (opposite) was at Sewickley, Pa. for the Wightman Cup matches played there a fortnight ago. I had come with her to see her perform. Of all the girls I have seen on past Wightman Cup teams, none was ever more proud to be elected than Althea was this year. When she tried on her white blazer for the first time before the matches at Sewickley, her expression and her manner verged on exaltation. She stood quietly looking in the mirror of Margaret Du-Pont's room, turning slowly around to see herself from all sides. Finally she said, "I don't want to seem fussy, but don't you all think the sleeves are too short?" And then, apologetically, "You see, this is the first one of these I've ever had and I want it to be just right. I am so thrilled to be a representative of America in these matches."

Two days later, in the late afternoon following her final match with Christine Truman, we headed out onto the Pennsylvania Turnpike for an all-night drive home. In that long ride, with Althea in the back seat of my station wagon occasionally sleeping, occasionally waking, I learned more about this quiet, withdrawn girl than I had ever known before.

We had an adventure, to begin with. We hadn't been rolling along the turnpike for an hour when suddenly traffic began to slow down, with cars in both lanes pulling off to one side. The next thing I knew, Althea said, "Look, someone's in trouble." I looked, but couldn't see anything. Then I noticed she was looking up—and there was a small plane, lights blinking, wobbling from side to side as its pilot tried to find a landing space on the crowded highway. "Come on, Sarah," Althea said. "Let's get out of the car. Then at least we can duck if we have to." We got out on the double.

It was none too soon. Down the plane came, missing us by only a few yards. "Phew!" I said. "That was close!" "Well," replied Althea, "I'm glad he made it. The Lord was with him."

A little later we stopped for dinner. I couldn't eat, but Althea downed a sturdy steak sandwich and apple pie a la mode. Afterward we talked for a while, about anything and everything. About marriage: "I'd like to get married, if I could have a career too. I think this is possible if the man is understanding and if the girl doesn't get swell-headed like some movie stars who start believing their own press reports." About careers: "I think I should get an apartment for myself in New York next year, study singing, maybe write a book. Let's face it: I've gotta make good while the iron's hot." About pro tennis: "It seems to me I can do the things I want to, like singing and writing, without turning pro. Anyway, I haven't been asked. Honestly not. And I think it's gonna take Jack Kramer quite a while to pay off that $125,000 to Lew Hoad. And from what I understand, women professionals never have done well on tours compared to the men."

She slept for a while, then awoke when I stopped to refuel. "Don't you want me to drive?" she asked. "No, really not," I replied. "I'm all pepped up by that airplane landing and can't sleep anyway." She settled herself and went back to sleep again. Once she awoke, smiling, and said: "You know, I had a dream just now about Dr. Eaton, the guy who took such good care of me down in South Carolina when I was a kid." "Was it a happy dream?" I asked. "It was a wonderful dream," she replied. "I was at his home again and swimming in a pool. Funny, isn't it?" she was asleep again in five minutes.

Early in the morning she awoke again, and we talked some more. We discussed tennis players ("You have to be a nice person to be a tennis player," Althea said, "or you don't amount to much. It brings out your good qualities"). We discussed junior tennis hopefuls, we discussed juvenile delinquency ("I'm worried about that," she said. "It seems to be getting worse instead of better"). We discussed books, Althea asking me about mine. Toward the end, she said:

"You know, I've often wondered what would have become of me if I wasn't a tennis player. I guess a lot of life is luck." She paused and thought a while. "But not just luck, either," she went on. "You've gotta be ready for something, too. When you're ready for something, it happens. You just know it in your own mind."

"Are you ready for the Nationals?" I asked her.

"Sure," said Althea. "I'm not afraid of any of the players there."

"I was hoping you would say that," I put in.

"What I mean is," Althea Gibson finished her thought, "if I play my right game the way I should, then I feel I can beat anybody. But I certainly don't want to be over-confident, because if I play badly, I can easily be beaten by some black sheep. But I don't think I will be."

TURN PAGE FOR MORE STARS IN COLOR, A TENNIS ANALYSIS, AND THE FOOTLOOSE SPORTSMAN

SEPIA

NOVEMBER, 1959

35¢

CLEVELAND:
CITY OF CULTURE
AND CHALLENGE

PRIVATE LIFE OF
DOROTHEA TOWLES

MR. MUHAMMAD
AND HIS
FANATIC MOSLEMS?

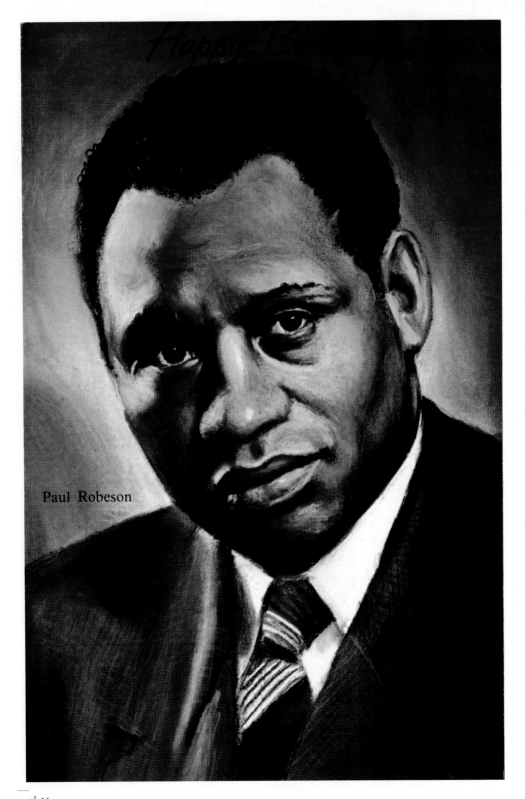

Paul Robeson

NORBERT RILLIEUX

(1806-1894)

He made all our lives a little sweeter.

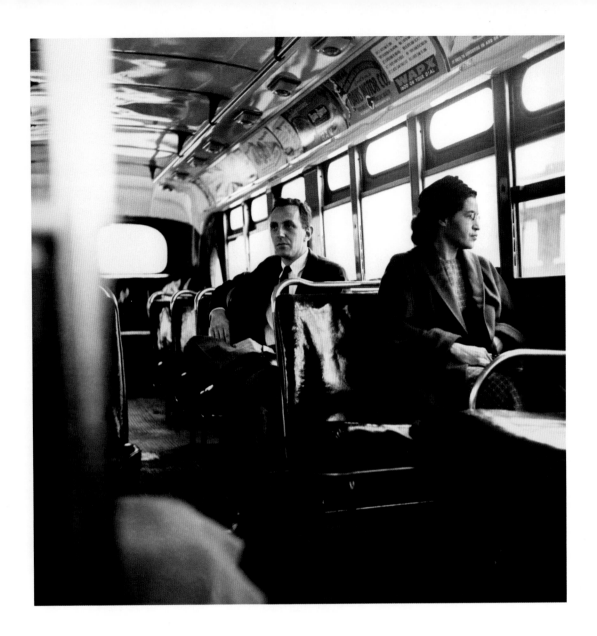

pl. 12
Inge Hardison
Norbert Rillieux
1967
Collection Civil Rights Archive,
CADVC

pl. 13
Rosa Parks Riding the Bus,
Montgomery, Alabama
December 21, 1956
© Bettmann/CORBIS

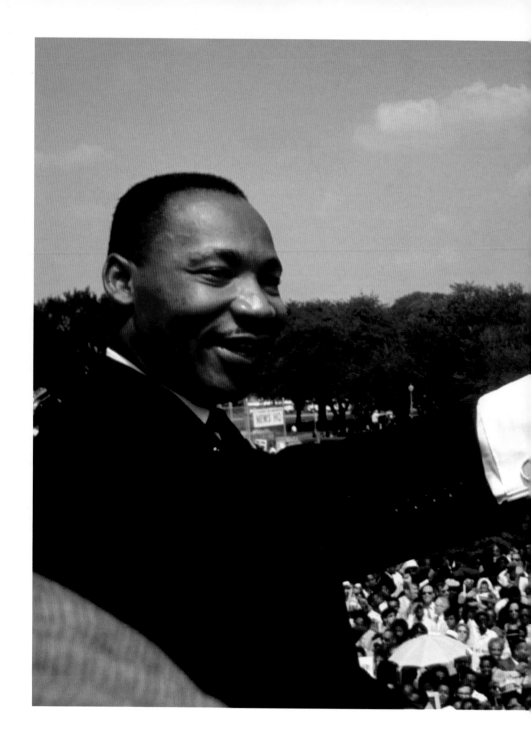

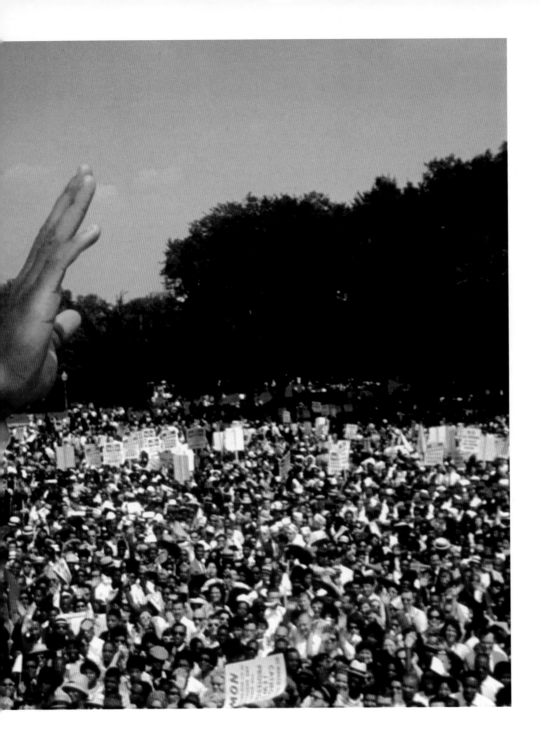

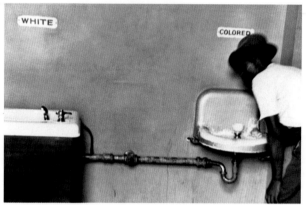

pl. 14
Lunch Counter Protest in
Raleigh, North Carolina
February 10, 1960
© Bettmann/CORBIS

pl. 15 (previous page)
Francis Miller
Fiery Speaker: The Rev. Dr. Martin
Luther King
August 28, 1963
Collection International Center
of Photography, The Life Magazine
Collection, 2005, 1013.2005.
Collection: Time & Life Pictures/
Getty Images

pl. 16 (opposite)
Robert Sengstacke
Savior's Day Gathering, Chicago
1966
© 1989 Robert A. Sengstacke.
Collection Civil Rights Archive,
CADVC

pl. 17 (above)
Elliott Erwitt
Segregated Water Fountains with
Black Man Drinking, North Carolina
1950
Courtesy of Elliott Erwitt,
Magnum Photos

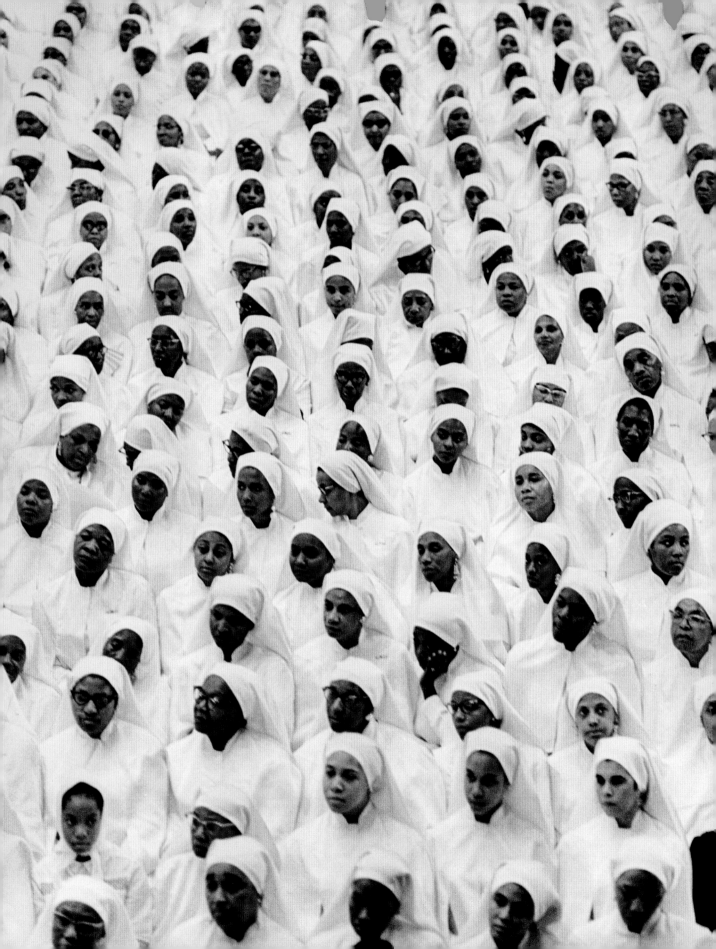

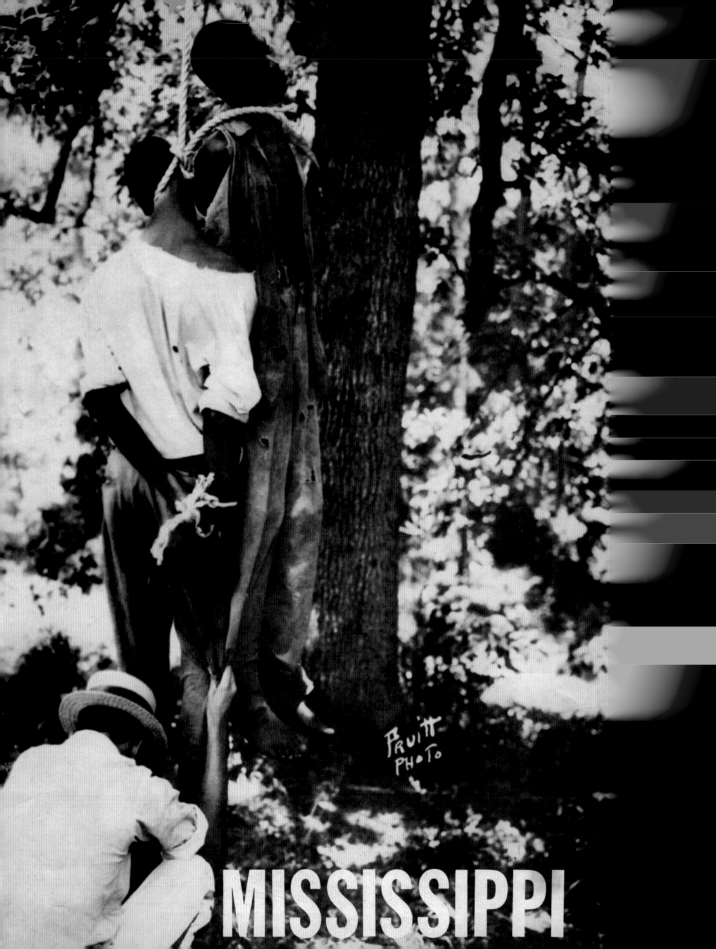

MISSISSIPPI

THE
MOVEMENT
Documentary
of a Struggle
for Equality

text by Lorraine Hansberry

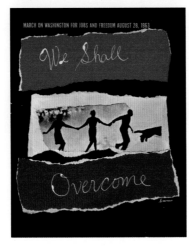

pl. 18
Student Nonviolent
Coordinating Committee
(photograph by Otis Noel Pruitt),
*Mississippi: The Lynching of
Bert Moore and Dooley Morton*
ca. 1965

Collection International
Center of Photography,
Museum Purchase,
991.2000

pl. 19
Danny Lyon (photographer)
*The Movement: Documentary
of a Struggle for Equality*
1964
Collection Civil Rights Archive,
CADVC

pl. 20
Louis LoMonaco
We Shall Overcome (cover and leaf)
August 28, 1963
Collection Civil Rights Archive,
CADVC. Courtesy of Louis
LoMonaco

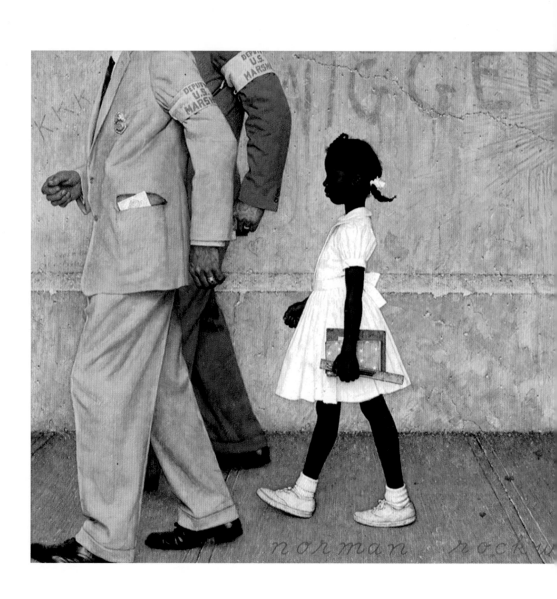

I AM A MAN

MEMPHIS

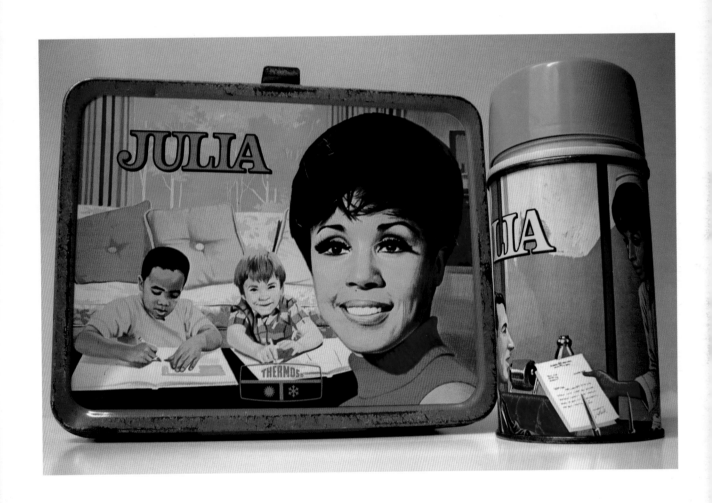

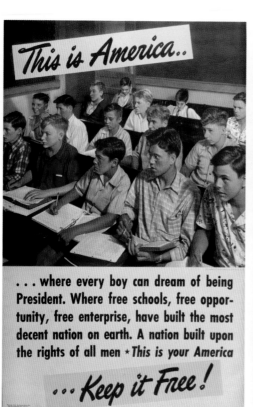

The Musical Doll

June & Julie

REAL ROCKING
MOTION
DELIGHTFUL
LULLABY MELODY

19" DOLL with 6½" BABY DOLL

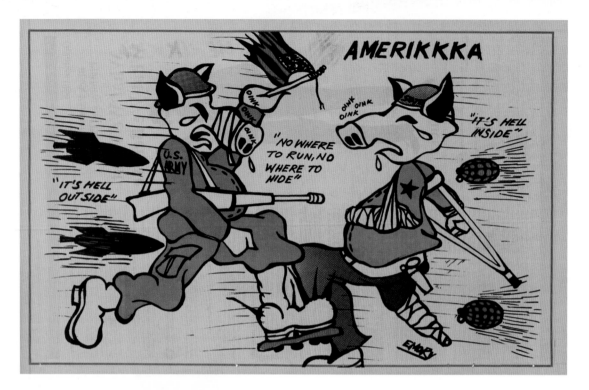

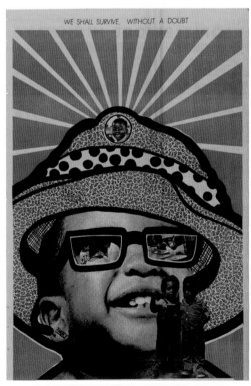

pl. 26
Emory Douglas,
AMERIKKKA
1970
Emory Douglas,
We Shall Survive Without a Doubt
1971
Both © 2009 Emory Douglas/
Artists Rights Society (ARS),
New York

pl. 27
Frank Cieciorka
*All Power to the People:
The Story of the Black Panther Party*
1970
Collection Civil Rights Archive,
CADVC
Reproduced with permission

ALL
POWER
TO THE
PEOPLE

THE
STORY
OF THE
BLACK
PANTHER
PARTY

75¢

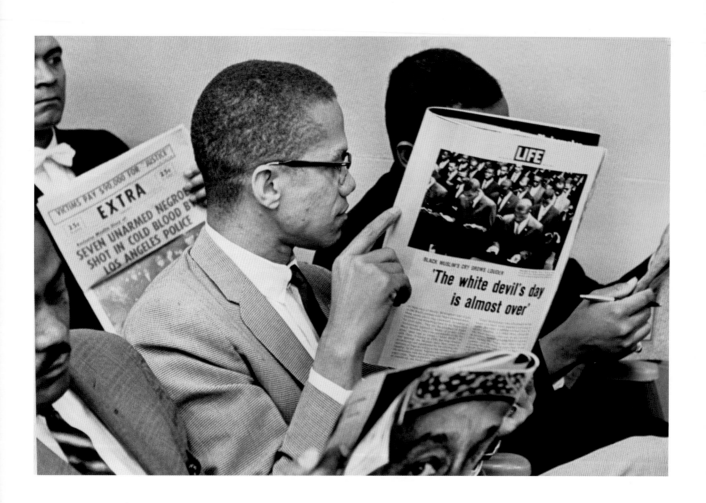

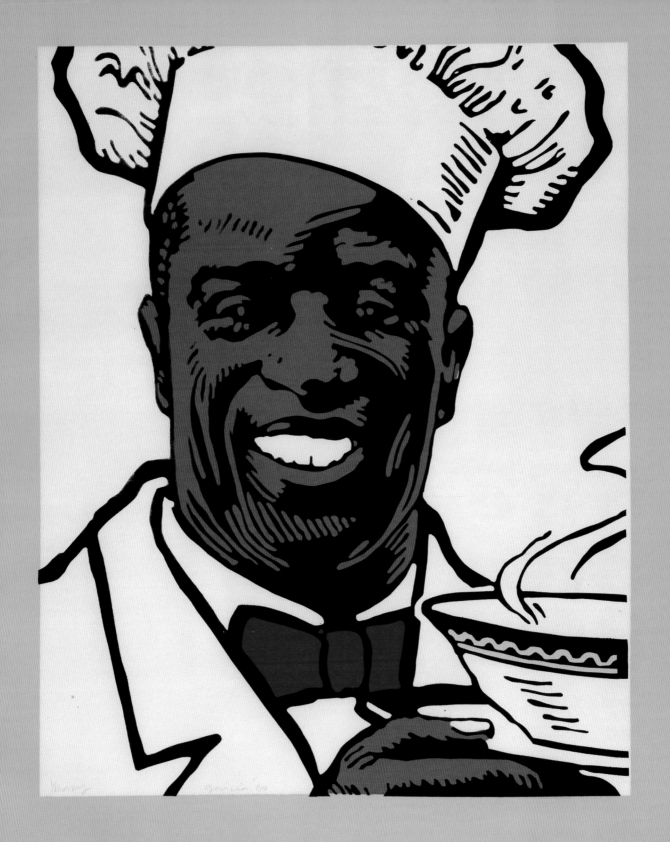

NO MORE O' THIS SHIT.

pl. 30
Elizabeth Catlett
Negro Es Bello II
1969
Hampton University Museum,
Hampton, Virginia,
Art © Elizabeth Catlett/
Licensed by VAGA, New York, NY

pl. 31
Family of Michele Wallace,
Fashion Show, New York City
1957
From left to right:
Grandmother Mme. Willi Posey,
cousin Cheryl, Michele,
cousin Linda, sister Barbara.
Courtesy of Michele Wallace

pl. 32
Childs Family
Washington, D.C.
1958
Collection of Faith Childs,
New York

The world seldom believes the horror stories of history
until they are documented via the mass media.
The Reverend Martin Luther King, Jr.
letter to Harold Courlander (1961)

"LET THE WORLD SEE WHAT I'VE SEEN": EVIDENCE AND PERSUASION

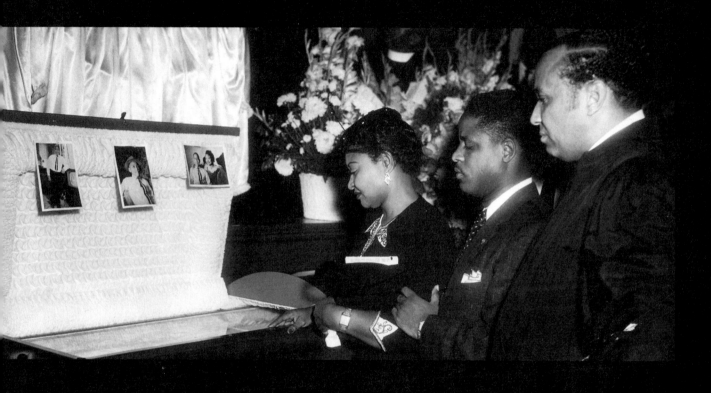

In late August 1955, Mamie Till Bradley put her fourteen-year-old son on a train to visit his southern relatives. She wanted her only child to spend the last weeks of summer with friends and family in the quiet rural setting of the Mississippi Delta, away from the bustling streets of Chicago. Emmett "Bobo" Till was an industrious, considerate, and trustworthy young man, well adjusted for a teenager shaken by his parents' divorce and his father's death during World War II. Little fazed him, not even the speech defect—a stutter—that was the consequence of a childhood bout with polio. Till was an extroverted young man who loved to be the center of attention. He was a good student, excelling in science and art.

But when it came to the perils of Jim Crow segregation, the teenager was, to a great extent, naive. Although Chicago was rife with prejudice, like any other urban center of the 1950s, it was not a place where a black man could be lynched for transgressing, even for an instant, the arbitrary rules of racial interaction. Mississippi was another story. Mrs. Bradley warned her son of the potential dangers that lay ahead. "[Do not] hesitate to humble yourself," she counseled in preparation for his trip, "[even if you have] to get down on your knees."[1]

A few days after he arrived, Till and eight other teenagers piled into his great-uncle's car and drove to the small town of Money, Mississippi. The details of the incident that followed remain unclear. What is known is that Till had a brief exchange with a white female shopkeeper, Carolyn Bryant, in her family store. The twenty-one-year-old Bryant, a comely woman who won two beauty pageants while in high school, was the daughter of a plantation manager and a nurse. Till allegedly whistled at Bryant and, jokingly, asked her for a date. Several of the young men who accompanied him later reported that they had dared him to flirt with the shopkeeper after he told them he had a white girlfriend back in Chicago, and that the incident was no more than a childish prank. Whatever Till's motivation, his fleeting interaction with Bryant set off a catastrophic series of events.

Three days later, in the middle of the night, Carolyn's husband, Roy Bryant, and her brother-in-law, J. W. Milam, along with at least one other accomplice, forcibly entered the house where Till was staying and abducted him at gunpoint. They drove the teenager to a toolshed, where they ruthlessly beat him. In the ensuing hours, they brought his nearly lifeless body to the banks of the Tallahatchie River, shot him in the head, tied a heavy industrial fan to his neck with barbed wire, and deposited his corpse into the raging water.

A fisherman discovered the body several days later. It was so badly mangled and decomposed that Till could be identified only by the signet ring on his right hand, inscribed with the initials of his father, Louis Till. The Tallahatchie County sheriff, Harold Clarence Strider, ordered the immediate burial of the body in Mississippi, ostensibly because of its decomposed state. Mamie Till Bradley resisted, and with the help of officials in Illinois, demanded that her son's remains

fig. 20 (previous page)
Photographer unknown
Emmett Till's Mother Next to His Casket
1955
Courtesy *Chicago Defender*

be returned to Chicago. "The main thing [they wanted] to do was to get that body in the ground so nobody could see it," she said of the Tallahatchie police.[2] Bradley suspected that Strider wanted to conceal her son's remains because he did not want the nation to see the evil that had been perpetrated by the citizens of Mississippi. Her suspicions were not unfounded. Although the sheriff released the body to Bradley, he did so on the condition that the casket remain sealed. Furthermore, he ordered that the corpse be packed in lye, a substance that would hasten its decomposition, and affixed onto the box a written warning that legally forbade anyone from opening it.

Bradley disobeyed the warning and insisted that the casket be opened. "What I saw in that box was not like anything I've ever seen before in my life," she recounted about her first viewing of the body at the A. A. Rayner funeral home in Chicago.[3] Her son's face was disfigured beyond recognition. His swollen tongue hung out of his mouth. His right eyeball was knocked out of its socket, resting in a mass on his cheek. His left eye was missing. The bridge of his nose was crushed. His right ear was severed in half. The top of his head was split open from ear to ear. A large, gaping bullet hole pierced his temple.

Rather than conceal the horror she had seen—if only for reasons of propriety or respect for the dead—Bradley embarked on a campaign to make visible what Strider and the state of Mississippi strove to hide. "I couldn't bear the thought of people being horrified by the sight of my son," she said later. "But, on the other hand, I felt that the alternative was even worse. After all, we had averted our eyes far too long, turning away from the ugly reality facing us as a nation."[4] Remarkably, she chose to present her son's body to the world, "and in so doing made the task of recognition a public project."[5] She arranged for an open-casket funeral and an extended public viewing (fig. 20), and she rejected the funeral director's offer to retouch Emmett's face: "Let the world see what I've seen," was her reply.[6] (Despite her insistence, the mortician modestly cleaned up the body.) During the four-day viewing, thousands of mourners filed past the glass-enclosed casket.

Bradley tacked to the open coffin lid a photograph of her son in happier times—accentuating the horror of his death by juxtaposing with his mangled and unrecognizable corpse the image of a handsome, smiling teenager in his Sunday best (fig. 21). The snapshot was taken in Chicago on Christmas Day, nine months earlier. Emmett wears a crisp shirt and tie. He leans against a Philco television, the ultimate symbol of comfortable, state-of-the-art middle-class life in the 1950s. Bradley's use of the photograph was strategic, stressing the heartbreaking reality that "a human body could be so horribly transformed" and a young man's humanity so willfully destroyed.[7] In the context of the viewing and funeral, the photograph, which was published in periodicals across the country,

fig. 21
Photographer unknown
Bo at Thirteen
Christmas 1954

underscored the enormity of the crime: the haunting specter of a cheerful, if naive, teenager blissfully unaware of the imminence of his death.

Bradley intuitively adopted a visual strategy not unlike that of W. E. B. Du Bois in his editorship of the *Crisis* half a century earlier: the juxtaposition of positive and negative images in order to reinforce the persuasive effects of both. In the magazine's early issues, Du Bois alternated gruesome images of racial violence with upbeat photographs of African-Americans in the context of "ordinary," everyday life. The pictures of violence, such as the grisly shots that illustrated pieces about lynching, served as evidence of racist malevolence. The other pictures, such as the photographic portraits that accompanied obituaries, profiles, or the "Men of the Month" column, were used to celebrate, commemorate, or simply establish the normalcy and humanity of their black subjects. By skillfully alternating these types of depictions, the *Crisis* simultaneously documented racial prejudice, underscored its arbitrariness, and suggested, by example, the possibility of triumphing over it.

Bradley's use of competing imagery helped emphasize, by contrast, the depravity of segregation in the South, by accentuating the difference between life under the rule of Jim Crow and life in a freer and more tolerant society. The widely reported trial and acquittal of Emmett Till's murderers by an all-white jury (Bradley, who attended every day, was forced to sit at the far side of the courtroom at the "Negro table," along with black journalists, witnesses, and legal advisors) would drive home this point (*fig. 22*). The funeral's visual dichotomy

fig. 22
Ernest C. Withers
Black Press at Emmett Till Trial
(Simeon Booker, Jimmy Hicks,
L. Alex Wilson, Clotille
Murdock, Ernest Withers,
Mamie Bradley, Congressman
Diggs, David Jackson, S. Johnson,
Hazel Brown, Dell Rio, Raphael
Moody, Marshall of Mt. Bayer,
and daughter)
Sumner, Mississippi
1955
© Ernest C. Withers. Courtesy
Panopticon Gallery, Boston, MA

fig. 23
Emmett Till in Casket
1955
Courtesy *Chicago Defender*

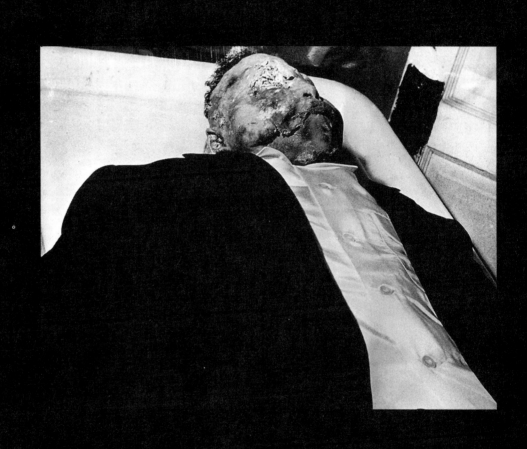

of a young man in life and death was meant to disrupt northern blacks' sense of security momentarily, as well as liberal white people's denial or ignorance, by reminding them that the boundary between freedom and oppression in the United States was both fragile and conditional. Bradley courageously warned of the danger of passivity at an NAACP rally in Cleveland a few weeks after her son's murder: "When something happened to Negroes in the South, I [used to say]: 'That's their business, not mine.' . . . Now I know how wrong I was. The murder of my son has shown me that what happens to any of us, anywhere in the world, had better be the business of us all."[8]

Bradley's effort to wake a sleeping nation was not simply visual but also media-driven, contingent as it was on distributing the image of her son, in death and in life, to as many people as possible. She permitted several photographers to take pictures of Emmett's corpse. She believed that only these photographs could fully convey to the public the political urgency of her son's death—images shocking enough to snap Americans, black and white, out of their meekness and denial:

> I knew that I could talk for the rest of my life about what had happened to my baby, I could explain it in great detail, I could describe what I saw laid out there on that slab . . . one piece, one inch, one body part, at a time. I could do all of that and people still would not get the full impact. They would not be able to visualize what had happened, unless they were allowed to see the results of what had happened. They had to see what I had seen. The whole nation had to bear witness to this.

> So I wanted to make it as real and as visible to people as I could possibly make it. I knew that if they walked by that casket, if people opened the pages of *Jet* magazine and the *Chicago Defender*, if other people could see it with their *own* eyes, then together we might find a way to express what we had seen.[9]

Mainstream periodicals at the time most often rejected graphic depictions of death as inappropriate for publication, but Bradley was able to turn to African-American publications for support. "There were people on the staff who were squeamish about the photographs," *Jet* magazine publisher John H. Johnson later recalled. "I had reservations, too, but I decided finally that if it happened it was our responsibility to print it and let the world experience man's inhumanity to man."[10] Gus Savage, editor and publisher of the *American Negro: A Magazine of Protest,* was one of the first to print these photographs. *Jet* published them on September 15, 1955, the historic issue selling out within days. Other black periodicals—the *Chicago Defender*, the *Pittsburgh Courier*, the *Amsterdam News*, and the *Crisis*—also published the images (*fig. 23*).

When she made these photographs public, Bradley understood their ability to astound and disarm viewers. The capacity to shock, of course, is one of photography's most striking and seductive assets. Sensational photographs dare us to look. They test the limits of our fears, squeamishness, visual endurance, and taste. They also sell magazines and newspapers. "The weight of words, the shock of photos," read a 1950s advertising slogan for *Paris Match*, one of Europe's most trendy and respected picture magazines. In the United States, tabloid magazines and newspapers like *Confidential* and *True Confessions* elevated sensationalism to a new level, capitalizing on the visual allure of the scandalous, the lurid, and the criminal.

But photographs of the disfigured remains of a martyr—the stark visual evidence of an unspeakable atrocity—challenged readers of the *American Negro*, *Jet,* and the *Chicago Defender* in ways both discomforting and political, forcing them to confront not only the corporeal, visceral evidence of a horrific crime but the chilling reality of human intolerance as well. African-Americans in the South saw reflected in Emmett Till's battered face their own physical vulnerability under the rule of Jim Crow segregation. Blacks in the North and elsewhere, and a few whites, might have seen something else: the haunting specter of their complacency or inaction. The social implications of these photographs were extraordinary. After the initial shock subsided, one could not have avoided thinking about their meaning and its consequences.

It is no wonder that no mainstream magazine or newspaper—ever fearful of making readers and, by extension, advertisers uncomfortable—would publish the postmortem photos that Till's mother so selflessly fought to make visible. (These images were also banished from television and newsreels.) Bradley wanted the world to see the shattered child she so dearly loved and now mourned precisely because she "understood the power of spectacle to do what words could not": to render viewers speechless and thus to leave them deeply shaken.[11] "We just did not have the vocabulary to describe the horror we saw, or the dread we felt in seeing it," she wrote years later. "Emmett's murderers had devised a form of brutality that not only was beyond measure, it was beyond words."[12]

It was Bradley's hope that African-Americans might fill the void of anguished silence with a passion to fight the tormentors of their southern brothers and sisters. It was her hope, too, that white people—confronted with the stunning, irrefutable visual confirmation of one of racism's most evil deeds— would acknowledge the deadly power of their self-righteousness, contentment, or intolerance. People would have to "face themselves," she later wrote of the photographs' political effects. "They would have to see their own responsibility in pushing for an end to this evil."[13]

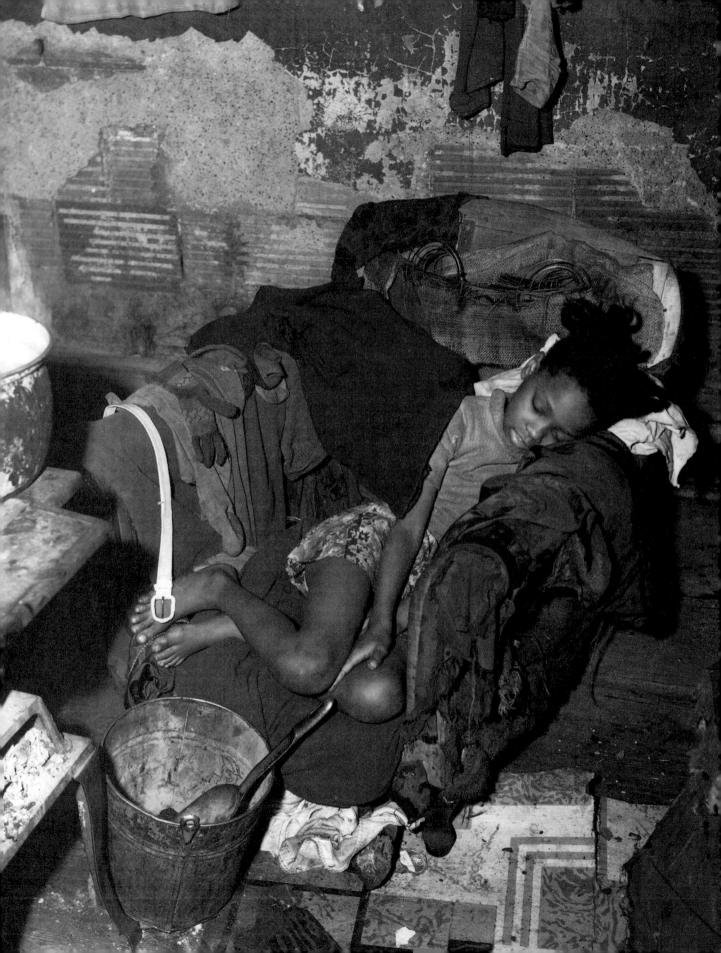

In her quest, Bradley was able to avail herself of photography's authority as evidence. Since its invention in the nineteenth century, the medium has been a valuable and effective tool for marking, affirming, analyzing, and verifying reality. Its widespread use transformed medicine, government, science, law, education, and politics, institutions that came to rely on its singular ability to represent the world through direct observation and mechanical reproduction. The verisimilitude of photography would lay the foundation for "an information era, in which knowledge is power and photography a crucial form of knowledge."[14] By the 1930s, with the rise of pictorial magazines in the United States, "popular trust in photographs increased as faith in the printed word declined."[15]

In 1935, President Franklin Roosevelt acknowledged as much when his administration supported the use of documentary photography in a number of agencies, including the Farm Security Administration, Civilian Conservation Corps, National Youth Administration, and the Office of War Information. The Farm Security Administration was assigned the task of sending a team of photographers across the nation to record the plight of the rural poor and migrant farmers displaced by dust storms: these images were distributed to magazines, newspapers, and other media outlets in an effort to convince a skeptical and unconcerned public of the need for federal intervention (*fig. 24*). Had it not been for the camera, more than a million rural families would have languished in poverty, out of sight of most other Americans.

Troubling subjects and events that could easily have remained hidden from view for reasons of politics, taste, or propriety—the squalor of the Depression, for example, or the horrifying remains of the Nazi death camps—became part of the public record through photography. In accurately documenting reality, and subjecting it to endless repetition in the media, these anguished images were also inherently persuasive. "Bearing witness is what photographs do best; the fact that what is represented on paper undeniably existed, if only for a moment, is the ultimate source of the medium's extraordinary powers of persuasion," writes the photo historian Vicki Goldberg. "The photograph, produced by a brief transaction between chemicals and light, is at once the most faithful and the most seductive of witnesses."[16] Distant, catastrophic events were transformed by photography into shared experiences that were, by nature of its evidentiary weight, difficult to deny or refute. And in so doing, it helped shape public opinion and build political consensus by providing stark visual confirmation of injustice free of the limitations of language or geography.

It is within this historical and cultural context that Bradley pursued her largely visual campaign to alter public opinion. By a number of measures, her strategy worked. The photographs of her shattered child were the most potent—and unimpeachable—witness to his tragic and senseless death; the

fig. 24
John Vachon
Sick Child
Aliquippa, Pennsylvania
January 1941
FSA/OWI, Photography Collection and *Look* magazine Collection, Prints & Photographs Division, Library of Congress [Reproduction number LC-USF34-062164-D], reprinted by permission of the Vachon family

images reached and moved millions of Americans. The historian David Halberstam called the tragedy the first great media event of the civil rights movement.[17] Charles Diggs, the first black congressman from Michigan, declared the photographs in *Jet* "the greatest media product in the last 40 or 50 years, because [they] stimulated a lot of interest and anger on the part of blacks all over the country." On another occasion he wrote that they were "the leading stimulant of interest in the black community and elsewhere."[18]

In 1955, contributions to the NAACP's "fighting fund," its recently foundering charity for victims of racial attack, reached record levels after the brutal photographs of Till's body were published. The Montgomery bus boycott—most frequently cited as the starting point for the civil rights movement—began three months after Till's death; some historians have argued that these events were related.[19] And a leader no less revered than Martin Luther King, Jr., invoked the memory of Till's killing, still fresh in the minds of African-Americans, in a 1958 speech that launched a major voter registration campaign by the Southern Christian Leadership Conference. Till was a "sacred martyr," King proclaimed, "used as a victim to terrorize Negro citizens and keep them from the polls."[20]

In 1966, the Harris polling organization conducted a survey for *Newsweek* that assessed the relationship between the Till murder, and other formative racial incidents, and the rise of African-American political activism during a time of "intense mobilization in black communities across the nation."[21] Respondents were first asked whether they could recall any of a series of events, including the Scottsboro trials (1931–37) and the slaying of Till to the Montgomery bus boycott (1955) and the March on Washington (1963).[22] The knowledge of these events was then correlated with the subject's inclination toward political activism. With the exception of the Scottsboro trials, which occurred some thirty years earlier, the survey suggested a positive link between the awareness of events and the inclination toward "collective action" and political activism as measured by such factors as the boycotting of racist establishments, participation in demonstrations, work for political causes or candidates, and contributions to and membership in antiracist political organizations.

The survey also found that three of the four "historical" incidents, those that had occurred more than a decade earlier—*Brown v. Board of Education*, the murder of Till, and the Montgomery bus boycott—had left a lasting "generational imprint" on the collective memory of African-Americans. It revealed that Till's story, the event most dependent on photography to convey its gravity, was an abiding and preeminent "symbol of racial injustice" as well as a catalyst in motivating black participation in civil rights.[23] The survey found that the brutality of the crime—something that might predictably have suppressed black activism,

especially in the Jim Crow South, where African-Americans remained particularly vulnerable—actually incited a political fervor potent enough to override fear.[24]

In the end, a stark and terrifying photograph incited a revolution, rousing thousands of brave men and women into action. The sociologist and activist Joyce Ladner speaks of the effect of the image on the young protesters she met in the early 1960s as a member of the Student Nonviolent Coordinating Committee (SNCC), the soldiers of the "Emmett Till Generation," as she calls them: "All of us remembered the photograph of Emmett Till's face, lying in the coffin. . . . Everyone of my SNCC friends . . . recall[ed] that photograph. [It] galvanized a generation as a symbol—that was our symbol—that if they did it to him, they could do it to us."[25]

Shelby Steele, too, recalls the almost overwhelming symbolic power of the murder. Till's slaying "sat atop the pinnacle" of black victimization, he writes. "We probed his story, finding in his youth and Northern upbringing the quintessential embodiment of black innocence, brought down by a white evil so portentous and apocalyptic, so gnarled and hideous, that it left us with a feeling not far from awe."[26] Muhammad Ali, another member of the Till Generation, recounts the hold that the photograph of the slain youth had on him as a teenager:

> [We] were about the same age. A week after he was murdered
> . . . I stood on the corner with a gang of boys, looking at pictures
> of him in the black newspapers and magazines. In one, he was
> laughing and happy. In the other, his head was swollen and bashed
> in, his eyes bulging out of their sockets and his mouth twisted
> and broken. His mother had done a bold thing. She refused to
> let him be buried until hundreds of thousands marched past his
> open casket in Chicago and look down at his mutilated body. . . .
> I couldn't get Emmett out of my mind.[27]

Mamie Till Bradley's heroic gesture was one of many efforts in the modern movement to exploit the persuasive authority of pictures. One significant source for imagery was the work of photojournalists and photographers. Many were African-American. Some were white. They published their pictures in periodicals that ranged from antiracist black newspapers to mainstream magazines such as *Life*, *Look*, *Newsweek*, and *Time*. Whether in direct support of the movement or not, these photographers were committed to documenting the people and events of the struggle and its aftermath.[28] The roster of these men and women, many of whom worked for major organizations, photo agencies, and periodicals, is long and distinguished.[29]

Their work, as well as that of countless amateurs and local photo studios, did not just record the ephemeral incidents and actions of the

movement; it allowed the story of the struggle for racial equality and justice to resonate throughout society. Making their way into magazines and newspapers, as well as books, television programs, and newsreels, photographic depictions were powerful, and often iconic, testaments to the destructive force of racism and to the bravery and righteousness of those who fought against it.

While civil rights organizers were keenly aware of the potential of images to effect change, they were not always impressed with the work of non-movement photographers—images that were "too sparse and too super-ficial" to represent their interests.[30] Some organizers took snapshots themselves, to document and support their arguments and observations about the state of American race relations; among these were James Forman and Robert Zellner of SNCC, the Reverend Wyatt T. Walker and Andrew Young of the Southern Christian Leadership Conference (SCLC), and Malcolm X. Organizations such as SCLC, SNCC, the National Council of Churches, and the Congress of Racial Equality (CORE) culti-vated teams of professional "movement photographers," both to support their work as a form of artistic expression and to use it as an instrument of motivation or persuasion. "It is no accident . . . that if our story is to be told, we will have to write it and photograph it and disseminate it ourselves," affirmed the activist Mary King in 1964 about SNCC, the organization most responsible for nurturing this type of imagery.[31] As the writer and curator Steven Kasher observes, these photographs were "like the justly famous freedom songs of the movement, they were aids to understanding feelings and strategies, cementing solidarity, and to spreading the passion. [They] were circulated within the ranks, hung on walls of 'freedom houses' and offices, disseminated as posters and in movement publications."[32]

Under James Forman's initiative and leadership, SNCC vigorously championed this type of photography. Forman recognized the power of the medium "to bear witness as events unfolded," and he believed that its evidentiary function made it a necessary and important part of the historical record.[33] He hired Julian Bond, then a Morehouse College student, poet, and activist, to direct an aggressive publicity campaign. Forman enlisted and helped train a team of photographers to augment this project, starting with Danny Lyon in 1962. He set up darkrooms in Atlanta and in Tougaloo, Mississippi, as well as a network for distributing work to organizations, publishers, and periodicals. SNCC established the Southern Documentary Project, which relied on snapshots to "record the cultural and geographic contexts of the movement as well as its dramatic events."[34] As part of its publicity outreach, the organization mounted photo exhibitions and published scores of photographic books, pamphlets, and posters.[35]

The subject matter of civil rights photography—both within and outside the movement—was diverse, reflecting varied concerns. In many instances, pictures documented the work of activists, organizations, and leaders. Images such

as *Rosa Parks Riding the Bus, Montgomery, Alabama* (Bettmann/Corbis, December 21, 1956; *pl. 13*), *Lunch Counter Protest in Raleigh, North Carolina* (Bettmann/Corbis, February 10, 1960; *pl. 14*), *Fiery Speaker: The Rev. Dr. Martin Luther King* (Francis Miller, August 28, 1963; *pl. 15*), *Selma March, Alabama* (Moneta Sleet, Jr., 1965), and *Savior's Day Gathering, Chicago* (Robert Sengstacke, 1966; *pl. 16*) contributed to a vast archive of pictures that tracked hundreds of demonstrations and events. In other cases, photographs recorded the details of black life in America or the harsh, everyday reality of racism, from the repressive social order of the Jim Crow South to the race-related violence and murder that plagued the movement from its inception (Elliott Erwitt, *Segregated Water Fountains, North Carolina*, 1950; *pl. 17*).

Civil rights activists had come to rely on more than just the medium's capacity to document events. They understood that it was also an adept messenger of ideas, able to illuminate the causes and effects of a problem, give a human face to abstract thoughts, and illustrate complex realities. More than anything, the movement seized on the ability of photographs to convey political meaning. As the photographer and theorist Allan Sekula observes, "every photographic image is a sign, above all, of someone's investment in the sending of a message."[36] Photographs, far from representing an irrefutable truth, are shaped by the point of view, motives, and biases of the person who takes them. They carry ulterior meaning, determined by and articulated through a range of conceits: the posing of subjects, the distance and position from which they are shot, attention to and choice of details, and the cropping of the field to include or exclude information. Their messages can also be altered or enhanced by their context—the social or cultural milieu in which they are made or distributed and their juxtaposition with other images or explanatory texts and captions.

As the critic and philosopher Roland Barthes observed in *Mythologies*, his analysis of contemporary myth, photographs can serve as forceful conduits for political ideas. Barthes offers as an example a shot that appeared on the cover of *Paris Match* in 1955 (*fig. 25*). It depicts an Afro-French child dressed in the uniform of the French military. His hand is raised in salute. His head is tilted upward. His raised eyes are fixed in the distance, presumably on the *tricouleur*, that great symbol of French militarism and civility.

Barthes discerns hidden messages just below the photograph's slick surface. He speculates on the magazine editor's motives. He analyzes the ways in which the complex image conveys multiple, even contradictory meanings. Beyond the literal representation of a black soldier boy giving the French salute, the cover suggests to Barthes a more manipulative political message: "that France is a great Empire, that all her sons, without any color discrimination, faithfully serve under her flag, and that there is no better answer to the detractors of an alleged colonialism

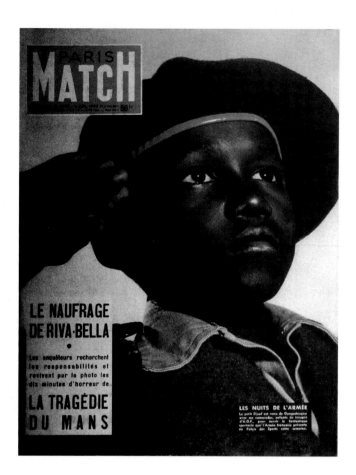

than the zeal shown by this Negro in serving his so-called oppressors."[37] A single photograph, in the context of a nation then involved in the violent war of independence being fought by its colonial subjects in Algeria, communicated incisive and complex opinions about race and power in modern France.

The photographers of the civil rights movement—rather than simply objective presenters—were often skilled commentators and agitators. A work by Ernest Withers, one of a handful of African-American photojournalists who covered the trial of Emmett Till's killers, exemplifies photography's conceptual gravity within the movement: *Complete Photo Story of Till Murder Case* (1955), a twenty-page photo booklet, contains black-and-white photographs together with texts and captions written by Withers. It initially appears to be a straightforward, if troubling, record of the murder and its aftermath. But with each uncanny, disquieting photograph it reveals itself to be something else: a penetrating, ironic commentary on racism. Withers's compelling yet subtle images challenge the eye to focus on details, to stare hard and long, in order to reap the visual rewards. Upon closer observation, the apparent ordinariness that the pictures document becomes extraordinary, as happens with a seemingly mundane shot of a large Coca-Cola sign (*fig. 26*). The photo is transformed into an astonishingly sardonic and unsettling commentary by a single, penetrating detail: a plaque affixed to the sign with the

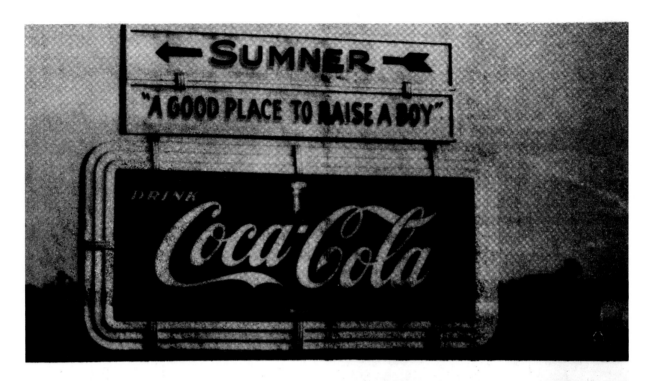

SUMNER, MISSISSIPPI, a farming town of about 780 population, whose motto, ironic enough, is "A Good Place To Raise A Boy," was chosen as the site for the murder trial since the body was found in Tallahatchie County of which Sumner is the county seat.

motto of the town where Till's murderers were tried and acquitted—"Sumner, A Good Place to Raise a Boy."

Such images remake the process of seeing into a transcendent conceptual act, a passage out of received ideas and myths about race. Civil rights photography resonates with arresting, mind-altering details, instances of visual intensity that "rise from the scene, shoot out of it like an arrow, and pierce" the defensive walls we erect to avoid painful or problematic realities.[38] Take, for example, the dangling corpses in Otis Noel Pruitt's photograph of the 1935 lynching of Bert Moore and Dooley Morton, for instance, the central image of a 1965 poster meant to underline the deadly grip of racism on the Jim Crow South (pl. 18). Or the screaming black protester, Atlanta high school student Taylor Washington, restrained by the stranglehold of a helmeted policeman in Danny Lyon's jacket photograph for *The Movement: Documentary of a Struggle for Equality* (1964; pl. 19), the first book of civil rights photography, a collaboration between Lyon and the playwright Lorraine Hansberry, commissioned by SNCC.

Civil rights photography inspired the work of painters and graphic designers. The artist Louis Lo Monaco used fragments of disturbing photographs from *Life* magazine—notably, the image of a rabid police dog poised to attack a demonstrator—in a souvenir portfolio of collages issued by the National

fig. 26
Ernest C. Withers
Complete Photo Story of Till Murder Case
1955
© Ernest C. Withers. Courtesy Panopticon Gallery, Boston, MA

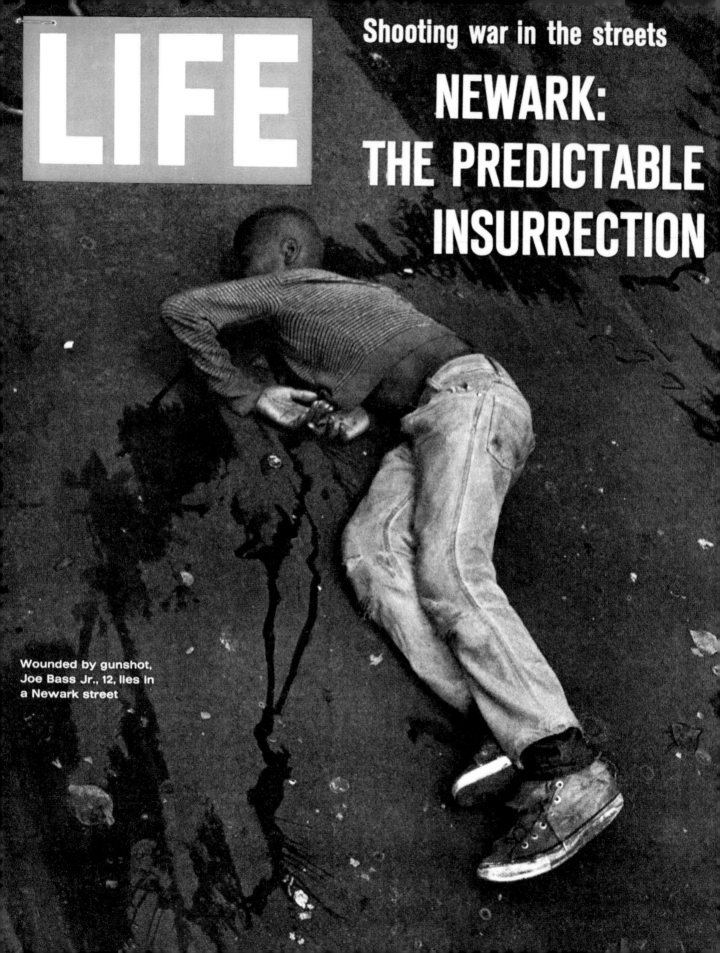

LIFE

Shooting war in the streets

NEWARK: THE PREDICTABLE INSURRECTION

Wounded by gunshot, Joe Bass Jr., 12, lies in a Newark street

Urban League for the 1963 March on Washington (*pl. 20*).[39] Based on a famous press photograph, Norman Rockwell's painting *The Problem We All Live With* (*pl. 21*)—published as a two-page illustration in *Look* magazine in 1964—depicts a six-year-old black girl, Ruby Bridges, surrounded by National Guardsmen as she walks to her heretofore segregated New Orleans elementary school, the words "Nigger" and "KKK" scrawled on the wall behind her. Inspired by a celebrated photo by Ernest Withers (*frontispiece*), a stark poster by Emerson Graphics in San Francisco, published shortly after the murder of Martin Luther King, Jr., is a poignant reminder of the urgency of the struggle he died for: "I Am a Man," it reads in large red letters, recalling the placards carried by black sanitation workers in the strike that brought the civil rights leader to Memphis on that fateful day in April 1968 (*pl. 22*).

　　　　As SNCC and other organizations recognized, civil rights photographs, no matter how persuasive their messages, were only as influential as their reach. Perhaps nowhere were these images distributed more efficiently than in magazines and newspapers, which reached millions of Americans on a regular basis. And nowhere were they used more aggressively than in black periodicals. Newspapers such as the *Amsterdam News*, the *Arkansas State Press*, the *Baltimore Afro-American*, the *Chicago Defender*, the *Norfolk Journal and Guide*, the *Philadelphia Tribune* and the *Pittsburgh Courier* and magazines such as *Ebony* and *Jet* routinely published images of racial brutality, pairing them with texts and captions that passionately stressed the severity and danger of racism and segregation. Most editors and reporters working in the Negro press "were vigorous supporters of civil rights and did not leave confusion about where they stood."[40] Many black publishers displayed the so-called Negro Press Creed in their newsrooms: "The Negro press believes that America can best lead the world away from racial and national antagonisms when it accords every man, regardless of race, color, or creed, his human and equal rights. Hating no man, fearing no man, the Negro press strives to help every man in the firm belief that all are hurt as long as anyone is held back."[41]

　　　　In the late 1950s, the white press, after decades of ignoring the problem, turned its attention to the subject of segregation. But unlike black periodicals, it was rarely activist in its reporting on race, the reticence due to a number of factors including the need to appear journalistically objective, the fear of alienating southern readers, and uncertainty about the movement and its motives. Still, the topic of racial brutality was increasingly appealing to a medium hungry for "that most valuable of photographic commodities—the image of extreme violence," the kind of pictures that were relatively scarce in the period between the Korean and Vietnam conflagrations.[42] In his pioneering study *The Civil Rights Movement: A Photographic History, 1954–68*, Steven Kasher has argued that the relationship

fig. 27
Life
July 18, 1967
Collection Civil Rights Archive, CADVC. Courtesy of Bud Lee/ The Serge Group and Time & Life Pictures/Getty Images

between mainstream journalism and the civil rights movement was symbiotic. The movement depended on the publication and distribution of visual evidence to make its case to the public. The media, meanwhile, turned to photographs of racial violence as a way of meeting their quota for the kinds of sensationalist pictures and stories that sell magazines and newspapers.

Throughout the 1960s, explicit images of racial brutality featured prominently in *Life*, arguably the nation's most important media outlet, read by more than half the adult population of the United States. Depictions of atrocities long available to black people through the African-American press were now more accessible to white readers—from the agonizing *Life* cover shot of the nearly lifeless body of twelve-year-old Joe Bass, Jr., wounded by stray police gunfire during a riot in Newark, New Jersey, in 1967 (*fig. 27*), to Joseph Louw's chilling photograph of Martin Luther King, Jr., as he lay dying on a terrace at the Lorraine Motel in Memphis (*fig. 28*).

Appearing with greater frequency in newspapers and magazines of the period, these arresting photographs highlighted the growing intensity, brutality, and exigency of the struggle for racial equality. The perils of black life in the Jim Crow South, a remote and obscure phenomenon for many Americans, vividly materialized on the pages of *Life*, *Time*, *Look*, and *Newsweek*. If white middle-class Americans previously saw the subject of race as something to avoid, the sheer repetition of images of racial dissension and hostility made it something that could not be ignored. By placing the question of civil rights front and center—and communicating the ugliness of the conflict through pictures that were not easy to deny or refute—the mainstream press, intentionally or otherwise, forged a path through which this imagery could enter the minds and hearts of many Americans, black and white.

While it is difficult to pinpoint the exact political effect of these pictures, they were undoubtedly forceful as sources of information and motivation for activists and as evidence of the seriousness of a problem that millions of people chose to ignore or deny. If the postmortem shots of Emmett Till inspired a generation of black activism, another group of pictures, of an incident eight years later, would play a similar, if less extreme, role in altering the racial attitudes of all Americans, black and white: the photographs and television footage that documented the May 1963 civil rights demonstrations in Birmingham, Alabama. These striking depictions of protest and retaliation represent a significant test case for understanding both the efficacy and the limitations of visual culture in influencing public opinion.

Alabama's largest city was a compelling target for a national media offensive against racism. In the early 1960s, Birmingham was seen widely as the most segregated city in the South, the nation's "chief symbol of racial intolerance,"

according to Martin Luther King, Jr.[43] City leaders refused to comply with federal desegregation orders, despite the considerable African-American population.[44] They would not integrate lunch counters, bus terminals, and other public accommodations. They shut down parks, golf courses, playgrounds, and swimming pools rather than conform to federal statutes. And they ignored the city's pervasive racial violence: African-American businesses, homes, and churches were regularly hit by gunshots and dynamite blasts. Birmingham's commissioner of public safety, T. Eugene "Bull" Connor, was notorious for disregarding, and even encouraging, attacks against black people, such as a Ku Klux Klan assault on peaceful Freedom Riders on Mother's Day in 1961.

Local civil rights leaders reached out to the national movement in an effort to strengthen their campaign. In the winter of 1962, the Reverend Fred L. Shuttlesworth, at the behest of the Alabama Christian Movement for Human Rights, a prominent Birmingham civil rights group, invited the Reverend King and his colleagues in the Southern Christian Leadership Conference to help organize the project. King, Ralph Abernathy, T. J. Jemison, and others co-founded the SCLC in 1957 to coordinate the action of local protest groups throughout the South. In turning to the SCLC, local leaders were connecting with an influential and relatively prosperous organization, one that would commit more than a million dollars and a hundred full-time employees to the Birmingham project.

In Alabama, the SCLC embarked on an extended, methodically organized campaign of nonviolent protests and boycotts, intended not only to end segregation in Birmingham but also to embarrass the city into concessions by provoking its white supremacist leadership into a fierce public reaction that would demonstrate to the nation and the world the unjustness of Jim Crow segregation. The SCLC leaders understood that this goal would be difficult to achieve; they were aware of the unsuccessful yearlong campaign organized by SNCC in Albany, Georgia, in 1961—an operation that produced few newsworthy skirmishes and little concrete improvement in race relations.

Albany, a small farming town with a forty-percent-black population, had one significant public relations advantage over Birmingham: a shrewd police chief, Laurie Pritchett. Drawing from his reading of King's *Stride Toward Freedom* (1958)—a text that applied Mahatma Gandhi's techniques of nonviolent protest to the civil rights struggle—Pritchett decided to blunt the political effect of the demonstrations by responding to them in kind, with passive resistance. He ordered his troops to minimize confrontations and avoid displays of force. When King was arrested after he joined the demonstrations, Pritchett paid his bail anonymously rather than allow him to publicize his incarceration as a symbol of the intemperance of the South. Downplaying charges of police brutality

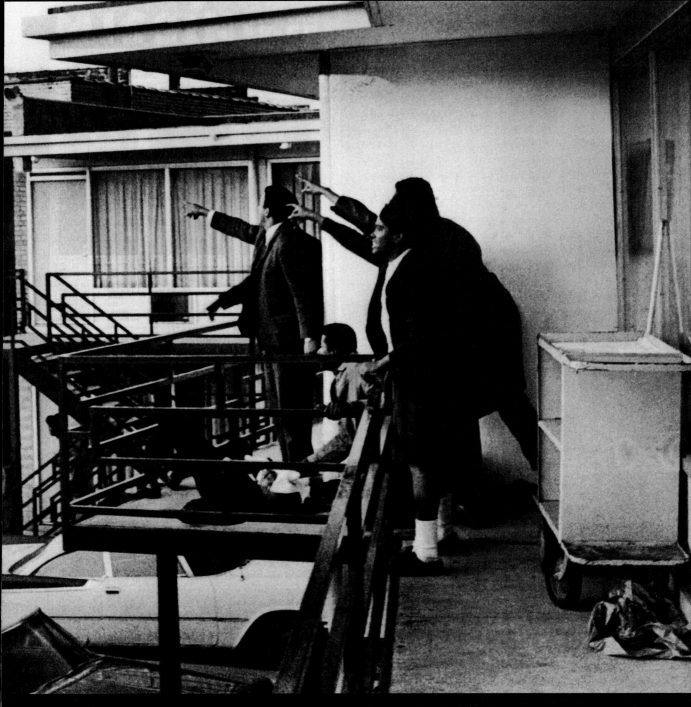

in the beating of Marion King, wife of the Albany community leader Slater King—an incident that impelled black protesters to hurl stones at her assailants—the chief slyly joked to reporters, "Did you see the nonviolent rocks?"[45]

As the historian Diane McWhorter observes, the "real lesson of Albany was that nonviolence could not succeed without violence—segregationist violence."[46] The leaders of the Birmingham operation were determined not to be outmaneuvered. They met in January 1963 to plan their project; the secret retreat included Shuttlesworth, SCLC directors Dorothy Cotton and Andrew Young, SCLC executive director Wyatt Walker, and King and Abernathy, the co-organizers of the 1955 Montgomery bus boycott. They considered and debated a number of matters, including the length and route of marches, the economic impact of a planned boycott of white-owned businesses, and most important, the nonviolent activities that could best goad the segregationists into public displays of intolerance.

The demonstrations began in earnest on April 3, with sporadic sit-ins and marches. Over the next few weeks, they garnered little attention or support. Many in Birmingham's black middle class, accepting the status quo or unwilling to put themselves in danger by taking a stand against it, remained unenthusiastic about the movement. The city's African-American pastors were reluctant to lend their backing. Police were making fewer arrests than anticipated. While African-American periodicals covered the demonstrations—and some, like the *Birmingham World*, helped mobilize the city's black population—the mainstream media, locally and nationally, ignored them. The movement had reached a critical juncture: without a bold move, it would probably not achieve its expressed goal of ending segregation in Birmingham.

The turning point came in the form of an improbable idea: a "children's crusade," proposed by King, that would put young people on the front line of protest. Diane Nash and her husband, the Reverend James Luther Bevel, founder of the SCLC Mississippi Project for voting rights, were hired to train students, many still in elementary school, in the techniques of nonviolent protest. While organizers were reluctant to place children in harm's way, they came to believe that the compelling spectacle of black youth pleading for their rights—and being mistreated by vicious segregationists—could most effectively sway public opinion. As Bevel observed: "Every nonviolent movement is a dialogue between two forces, and you have to develop a drama to . . . reveal the contradictions in the guys you're dialoguing with [in] the social context. That's called a socio-drama."[47]

For some critics, white and black, the drama was being sought at too high a cost. "School children participating in street demonstrations is a dangerous business," warned U.S. attorney general Robert F. Kennedy. "An injured, maimed or dead child is a price none of us can afford to pay."[48] Malcolm X dismissed the idea as cowardly and reckless: "Real men don't put their children on the firing line."[49] King

fig. 28 (previous page)
Joseph Louw
Police, Civil Rights Leaders Ralph Abernathy, Andrew Young, Jesse Jackson, and Others Standing on the Balcony of the Lorraine Motel over the body of the Slain Civil Rights Leader Dr. Martin Luther King, Jr., after His Assassination
April 4, 1968
Collection International Center of Photography,
The *Life* Magazine Collection, 2005. Courtesy of Time & Life Pictures/Getty Images

believed these sympathies to be misguided and he wondered: Where had the white critics of the children's crusade been "during the centuries when our segregated social system had been misusing and abusing Negro children? Where had they been with their protective words when, down through the years, Negro infants were born into ghettos, taking their first breath of life in a social atmosphere where the fresh air of freedom was crowded out by the stench of discrimination?"[50]

After much soul-searching, organizers scheduled a massive student march for Thursday, May 2. They were keenly aware of the potential for a public relations disaster. If even one child was injured, or worse yet, killed, they would be accused of exploitation. If students reacted violently to police brutality, they might be perceived as agitators rather than freedom fighters. Participants were required to attend rigorous training sessions, to learn about nonviolent protest and ways of protecting themselves from physical harm. "You are expected to be as disciplined as soldiers," they were warned at a meeting on the morning of the march.[51]

Later that day, thousands of truant black youths, filing out of the Sixteenth Street Baptist Church in rows of two, descended on the city. Within hours, more than nine hundred were arrested. The next morning, more students turned out, spurring additional arrests and filling Birmingham's jails to capacity. Bull Connor led the offensive against the demonstrators. After he ordered marchers to retreat, to no avail, he commanded firemen to push them back with specially retrofitted water cannons. Channeling water from two hoses through a single nozzle, the devices could tear off the bark of trees at a hundred feet and shatter bones at close range. The rapierlike jets battered the demonstrators, pinning them against buildings or sending them tumbling onto the street. One girl's face was cut as she fell to the pavement; another, struck in the head with a fierce blast, suffered a bloody nose. The situation grew more and more chaotic. Ankles were sprained. Ribs were broken. Blood spattered the wet ground. Amid the onslaught, some of the youths "cowered, others sat down, and still others sprawled out awash in the spray."[52]

A crowd of more than a thousand African-American onlookers, until now unwilling to join the demonstration but shocked at what they were seeing, turned into an angry mob. They shouted epithets and hurled bricks and bottles at the firemen and police. A new wave of stoic young marchers appeared, only to be hit by the water cannons. By now, officers were beating back protesters and bystanders with clubs. In an effort to restore order, Connor directed his troops to rein in the crowd with police dogs. The ferocious German shepherds, snapping at the ends of their leashes, pounced on their victims, tearing into flesh and gnawing several people so severely that they had to be hospitalized.

As if to prove that he was in control—or more important, that the white man was still in charge—Connor waved forward a group of white

spectators: "Let those people come to the corner, Sergeant. I want 'em to see the dogs work. Look at those niggers run."[53] Despite the commissioner's protestations to the contrary, civil order had collapsed in Birmingham. "For white people, it appeared that Armageddon had arrived," writes the historian Glenn Eskew. "The black masses knew it as Jubilee Day: the fear had gone."[54] The children's crusade had worked. Over the next few days, thousands of African-Americans who earlier had stayed on the sidelines joined the demonstrations.

The monthlong campaign of protests and boycotts pushed the city to its breaking point. An emergency meeting was called between the SCLC and the city's Senior Citizens Committee—an ad hoc group of seventy white civic leaders and businessmen—to negotiate an end to the conflict. On May 10, at a news conference attended by more than 150 reporters from around the world, Shuttlesworth announced a resolution: "The city of Birmingham has reached an accord with its conscience." In exchange for an end to the protests, the city agreed to four initiatives: the incremental desegregation of certain public accommodations; the hiring of black clerks and salesmen in the city's largest retail stores and the appointment of a "fair employment" committee; the release of jailed demonstrators; and the establishment of a "biracial committee" to work out employment and desegregation problems.

African-American reaction was mixed. Many local leaders were critical. Shuttlesworth, who insisted on reading a positive statement at the news conference out of respect for those who had risked so much, privately complained that little had been accomplished. As he delivered his prepared text, his expression seemed sad and defeated, not triumphant. The clause on nondiscriminatory employment, rather than being sweeping and immediate, called for an initial "token" hiring, followed by a modest and gradual increase during the next year, but culminating in no more than ten percent of the total number of workers at each store. Other provisions, such as the desegregation of public accommodations and the release of demonstrators and the dropping of charges against them, were equally ambiguous—the former applying only to large institutions, the latter depending on the approval of the new city council.

King's response to the accords, in contrast, was unequivocally positive. Like many of his collaborators in the national movement, he viewed Birmingham as a turning point in the war against segregation. "We must not see the present development as a victory for the Negro," he said. "It is rather a victory for democracy and the whole citizenry of Birmingham."[55] King's unbridled optimism infuriated local activists, especially Shuttlesworth, who accused him of betraying the needs of the city's black population in favor of a nationwide, media-oriented agenda.[56] Throughout the planning and implementation of the Birmingham project, King assured his colleagues that the "national repercussions derived from the

campaign were purely secondary to the local movement."[57] But as recent schol-arship suggests, the campaign's immediate political outcome may have been less important to him than its ability to generate a coherent story about good and evil in the struggle for civil rights.[58]

King believed that no medium would convey this story more powerfully than visual images. The tactics used to craft and focus this imagery were masterly: "There never was any more skillful manipulation of the news media than there was in Birmingham," Wyatt Walker later claimed.[59] What the movement wanted and got in Birmingham were "pantomimes of graphic violence, which yielded no serious injury."[60] As Walker put it: "Sure, people got bit by the dogs! I'd say at least two or three. But a picture is worth a thousand words."[61] With Walker and other close associates in the SCLC, King helped transform the fledgling Birmingham campaign into an awesome spectacle, a continuum of gripping visual images, "scene after scene, act following act, building in intensity."[62]

These nightmarish pictures appeared in thousands of newspapers and weekly magazines. There were numerous photographs of protesters being overwhelmed by water jets, but one of the most widely published images, and most iconic for the civil rights movement, was of a German shepherd lunging at the stomach of Walter Gadsden, a well-dressed young black man. As Senator Jacob Javits, Republican of New York, later observed, these photos had a profound effect: "I know of nothing which has more keened the American people to the moral impli-cations of . . . the struggle for civil rights, than the photographs which the American press and magazines have shown of actual events on the southern front. . . . It is only because pictures backed up the words, no matter how authoritative, that [this injustice] has been credited."[63]

There was perhaps no greater testament to the potential of photo-graphs to stir antiracist passion than the vehemence of segregationists in attacking them. By the early 1960s, many white southerners were convinced that the mainstream media was biased. Some charged that photographs of racial conflicts were faked or that written explanations of them were riddled with inaccuracies or lies. In 1965, Albert Persons, the white managing editor of a small Alabama newspaper and a "stringer" for *Life*, typified the segregationist view of the media's alleged favoritism in a pamphlet, *The True Selma Story* (*fig. 29*). In his analysis of the coverage of Birmingham in mainstream periodicals, "How 'Images' Are Created," Persons asserted that northern newspapers and magazines, chiefly *Time* and *Life*, engaged in unscrupulous picture editing and disregarded all but those photographs that appeared to support allegations of police brutality. "These magazines make no pretense of being objective—so they are not deceiving their readers on that count," Persons wrote. "It is unfortunate, however, that their readers have so little way of determining what is straight fact and what is, shall we say, only 'editorial license.'"[64]

How 'IMAGES' Are Created

BY ALBERT C. PERSONS

Almost anywhere in the world today the name "Birmingham" calls to mind vicious police dogs, thug cops, bombs that explode in the night and fire hoses mowing down innocent Negro children in the streets. If this were a true "image" of Birmingham then it would almost have to go without saying that the general populace (some 600,000), who are responsible for the city's government and actions of city officials is some kind of breed apart from the rest of the human race. Since this is not true, it follows that the world-wide image of Birmingham must be the artificial creation of some outside agency.

More than any other one single thing, the Birmingham image is a product of two publications with world-wide readership numbering in ten's of millions. They are LIFE and TIME. I worked for LIFE during the period of the Birmingham civil rights demonstrations in the Spring of 1963.

In the May 10, 1963 edition of TIME their story covering the Birmingham demonstrations carries this descriptive passage: ". . . furious, the Commissioner (Bull Connor) roared for his police dogs. The crowd in the park edged back; some hurried away. "Look at 'em run," yelled Bull. He saw a police officer holding back a crowd of white people nearby. "Let those people come to the corner, Sergeant," shouted Connor. "I want 'em to see the dogs work. Look at those niggers run."

No matter what else anyone might want to say about how Connor handled the Birmingham demonstrations, the one thing every reporter who covered this story knows is that Connor at no time allowed white spectators within one city block of the park where Birmingham City Police attempted to confine (and disperse) the several thousand Negroes who congregated there every day. Knowing this, and having rubbed elbows with Connor almost every day throughout a several weeks period, I questioned the TIME correspondent who had filed the report. He was Dudley E. Morris, at that time based in TIME'S Atlanta office. Morris got quite hot under the collar, but he finally admitted that he had not heard Connor make the statement, but that someone else told him Connor made it. Our argument took place in a motel room in downtown Birmingham. Present were several LIFE photographers and LIFE associate editor David Nevin.

Here is a picture that will look familiar to many readers. It is almost identical with one take by the Associated Press and widely distributed. TIME's caption with this picture in their edition of May 17, 1963 read: Birmingham Cops Manhandling Negro Woman. The building in the background is on the corner directly across the street from the 16th Street Baptist Church—Martin Luther King's command post for the Birmingham demonstrations. A short time before this picture was taken the last of several hundred little children had marched quietly up the sidewalk where the woman lies, to waiting school buses at the end of the block. The buses took the children to "jail" at the city fairgrounds. Most reporters, photographers and police were at that end of the block when the woman above came out of the doorway in the background. A lone policeman stood on the sidewalk by the door. The woman spat in his face and struck out at him. She is a very large woman. She fought and fell to the ground. She also took a large bite out of the leg of the squatting policeman. Several other officers came to his assistance. It took four to subdue her—without hurting her. The Associated Press photographer and I each took a picture. The captions used on his picture were not written by him, of course.

—16—

The woman in the picture above was drunk on Easter Sunday afternoon in Birmingham in 1963. She and hundreds of others had joined with a group which left a church deep in a Negro residential area. They were bent on streaming into town. Birmingham police had orders to prevent this. A stand-off developed and the crowd of chanting Negroes soon numbered more than a thousand. Police were almost helpless in efforts to disperse the crowd. The situation became explosive. The only whites were the police and a handful of reporters. The woman in the picture above struck out of the crowd at a police officer. He went in after her. She fought. It took the five policemen pictured here to get her into a wagon and off to jail—without hurting her. She could, of course, have been subdued quite easily if any of the police had wanted to use his club.

—17—

fig. 29
The True Selma Story
1965
Collection Civil Rights Archive,
CADVC
Reprinted with permission
from Albert C. Persons

In order to distinguish fact from fiction, Persons supplied the backstories to a series of black-and-white snapshots similar to those published in national periodicals but taken by the author—texts and extended captions meant to "document" the irresponsibility and criminality of black demonstrators. In the author's version of events, Bull Connor was a public servant doing his best to keep the peace in the face of a lawless and unruly mob: a female protester who was beaten by police was "drunk on Easter Sunday afternoon in Birmingham"; another deserved her thrashing because she "spat in [a policeman's] face and struck out at him."[65] Police dogs were "not used to 'attack' anyone. They [were] used to control and disperse crowds of people who [could not] otherwise be persuaded to move."[66] Even the fearsome water hoses were benign: "Negro boys play[ed] in the streams of water. . . . There [didn't] seem to be any 'children bleeding on the ground.'"[67]

Persons's abiding point—that photographs were highly vulnerable to manipulation—was not unreasonable. In effect, he argued that a single snapshot, representing only a fraction of a second of a complicated incident, might reveal only what the photographer or publisher wanted viewers and readers to see. Furthermore, such imagery, wrested out of context, was inevitably dependent on words for meaning and explanation. Nevertheless, Persons's testimony about the events leading up to these pictures was contradicted by hundreds of other

journalists. Indeed, the antisegregationist conspiracy he alleged would have necessitated the involvement of scores of editors, reporters, and photojournalists from the hundreds of unrelated periodicals that similarly documented police brutality.

While still pictures were an undeniably powerful force, they may well have been surpassed in ability to represent the drama and intensity of the struggle for civil rights by another medium, one that Persons chose to ignore: television. With its compelling and immediate reporting on the social conflicts of the period—chiefly the civil rights movement and the Vietnam War—television news could develop "an unprecedented broad appeal."[68] By the early 1960s, it delivered breaking stories faster and to "a larger *simultaneous* audience than any other medium."[69] After regular network broadcasting began in the United States in 1946, television steadily emerged as a dominant source of news. As improvements in technology and manufacturing made receivers more affordable, TV ownership grew dramatically—from nine percent of households in 1950 to a staggering ninety-one percent in 1963. In comparison to newspapers and magazines, television reporting was more immediate, intimate, and efficient. Nightly news programs were usually able to broadcast stories hours before the morning papers—an achievement made possible by Telstar I, a communications satellite launched in July 1962 that relayed television images swiftly around the globe. And as crews replaced cumbersome 35mm equipment with lightweight 16mm cameras in the early 1960s, they were able to move more fluidly through fast-paced events and to photograph them in real time and at close range.

The future of broadcast news and civil rights would quickly become intertwined. If the latter provided the movement with an almost unending stream of gripping stories and images, the former, intentionally or otherwise, would serve the cause of civil rights in multiple ways: as "a window through which millions could watch the black struggle," a means for bringing African-Americans into private homes where they would never before have been invited, a way of educating and inspiring black activists around the country (the Reverend Bevel and Diane Nash trained students in Birmingham by showing them NBC News footage of earlier demonstrations), and as a catalyst for impelling a skeptical nation to face the problems that it had previously ignored.[70]

Within months after Birmingham, the power of television became even more obvious to the movement—and the nation—in its extensive coverage, broadcast worldwide, of the March on Washington for Jobs and Freedom, in August 1963. At least five hundred cameramen, technicians, and correspondents wanted to report on what was then the largest political demonstration in American history. NBC News and ABC News interrupted regular morning and afternoon programming with special reports, ranging in length from five minutes to a half-hour. CBS News devoted three hours of continuous

live afternoon coverage (*fig. 30*). And national evening news programs offered recaps of the day's events, with NBC devoting an unprecedented evening-long examination of the march and the civil rights movement in general.[71]

These broadcasts gave viewers extraordinary access to a historic event, allowing them to witness it remotely and in detail—from the imposing bird's-eye view of a camera perched atop the Washington Monument, to up-close interviews conducted by teams of roving reporters. Civil rights leaders delivered eloquent and dramatic orations, among them King's "I Have a Dream" speech. A roster of noted entertainers sang or gave readings.[72] Some 250,000 people marched, chanted, and listened peacefully to the speeches and performances. As the *New York Times* TV critic Jack Gould commented, the "frozen word or stilled picture" of magazines and newspapers could not capture the visual and aural excitement. Only television could fully convey its sensory impact and instantaneously transmit its messages to millions of people around the world.[73] To Gould, the relatively new medium had become "an indispensable force," a means of awakening "the indifferent white millions for whom integration or segregation was of scant personal concern. The sociologists of tomorrow may find that it was television more than anything else that finally penetrated this huge camp of the uncommitted."[74]

Others agreed. As early as 1954, the *Pittsburgh Courier* noted that "perhaps no greater vehicle of communication is contributing to a better understanding of the American Negro than television."[75] Still, broadcast news had its detractors, especially media critics who ridiculed its dependence on emotionally charged, high-impact imagery; their view was built on a long-standing qualitative

fig. 30
March on Washington
1968
Courtesy of CBS News Archives

distinction between words and pictures in journalism. Print media required its audience to read and thus was commensurate with the literacy "of the privileged classes it most served."[76] Television news, critics argued, lacked rigor and depth, offering brief glimpses of sensationalistic stories that demanded little more than halfhearted attention. Despite photography's apparent verisimilitude and "television's claims to immediacy," it was the "written-ness of print journalism" that these commentators persistently "touted as a hallmark of its superiority."[77]

A man of profound eloquence and literary sophistication, King also instinctively realized that television news—and its careful balance of spoken word and moving image—was uniquely powerful to influence public opinion. Far more than magazines and newspapers, television efficiently communicated political information to a more or less socially apathetic nation. Then as now, most Americans absorb political knowledge through what the political scientist Doris Graber calls "passive learning."[78] In contrast to "active learning"—through, for example, reading, in which politically motivated individuals intentionally "extract information" from texts—the passive reception of ideas is more or less instinctive and involuntary.[79] Thus, even people with little or no interest in politics are often reasonably familiar with current events, because such events have permeated the culture, especially through television (and, more recently, the Internet).

Despite the absence of conscious intentions, the human brain can be stimulated by transient stories and images, and this activity can eventually affect one's thoughts and attitudes. The passive learning that results from this process—the progression from sensory stimulation to awareness, knowledge, and opinion—is intensified if stimuli occur repeatedly and fit into "existing schemas."[80] In the case of civil rights, the effect was enhanced by television's repetitive and fundamentally pictorial reporting, and its tendency to correlate civil rights imagery with shopworn clichés about war; TV coverage was punctuated with references to "uniformed forces, commanders and foot soldiers, armed attacks, the wounded, [and] state funerals."[81] In addition, television news, much more effectively than print media, could convey the immediacy and sensory impact of the stirring incidents of the civil rights era, their audiovisual continuum of cause and effect. The journalist and cultural historian Rodger Streitmatter notes that television's facility to "transmit the experience of actually *being part* of [an] event" enhanced its potential to influence a skeptical public, especially for a movement that struggled for years "to convince the majority of the justness of their cause."[82]

National civil rights leaders embraced television—sooner and with greater intensity than any other political group—because they understood its ability to get through to the "huge camp of the uncommitted" (in Jack Gould's words), and thus to shift national sentiment toward their cause. As Andrew Young saw it at the time, the movement was reaping millions of dollars in free publicity

as the focus of hundreds of stories on news programs that charged advertisers as much as $30,000 a minute.[83] Organizers scheduled demonstrations for optimum media coverage: early enough in the day to make the national evening news, or late enough to accommodate workers and thereby to assure a large turnout for news cameras. "If we missed *Huntley-Brinkley*, we could still get on the news at eleven," the media-savvy Wyatt Walker later recalled; NBC's *Huntley-Brinkley Report* was the top-rated national news program of the day.[84]

King was no less solicitous: "All the action began to center on the image projected from Birmingham: appearances replaced reality. King boasted at [one] mass meeting, 'After you saw *The Huntley-Brinkley Report* tonight, you saw some of the action that took place today,' as if the people in the audience had not been there."[85] He understood television's communicative potential, its ability to provide him with an "instant worldwide audience that would have been unattainable a decade earlier."[86] He complained about the indifference of the local white newspapers to the demonstrations in Birmingham: "The white man is trying to black out our movement. . . . Over the next few days we must make this movement 95% effective."[87] That meant creating enough excitement to attract the attention of journalists and especially television news. In *Why We Can't Wait* (1964), his personal account of the movement, King analyzed the media's ability to sway a complacent and distracted nation. Of the epical coverage of the March on Washington, he observed:

> If anyone had questioned how deeply the summer's activities had penetrated the consciousness of white America, the answer was evident in the treatment accorded the March on Washington by all the media of communication. Normally Negro activities are the object of attention in the press only when they are likely to lead to some dramatic outbreak, or possess some bizarre quality. The March was the first organized Negro operation which was accorded respect and coverage commensurate with its importance. The millions who viewed it on television were seeing an event historic not only because of the subject but because it was being brought into their homes.
>
> Millions of white Americans, for the first time, had a clear, long look at Negroes engaged in a serious occupation. For the first time, millions listened to the informed and thoughtful words of Negro spokesmen, from all walks of life. The stereotype of the Negro suffered a heavy blow. This was evident in some of the comment, which reflected surprise at the dignity, the organization and even the wearing apparel and friendly spirit of the participants. If the press had expected something akin to a minstrel show, or a

fig. 31
Fan
Evans Memorial Chapel
Saginaw, Michigan
ca. 1968
Collection Civil Rights Archive,
CADVC

DR. MARTIN
LUTHER KING, JR.

"LET THE WORLD SEE WHAT I'VE SEEN": EVIDENCE AND PERSUASION

brawl, or a comic display of odd clothes and bad manners, they were disappointed. A great deal has been said about a dialogue between Negro and white. Genuinely to achieve it requires that all the media of communications open their channels wide as they did on that radiant August day.[88]

King relied on the movement's media-driven visibility "to nationalize and internationalize the black struggle," insisting that its leaders and activists "capitalize on his charisma and media presence."[89] There was little of his public life that he would not make available to news cameras. In return, they transformed him into the movement's most recognizable icon (*fig. 31*).

In Birmingham, television news provided King with an important political weapon: a vivid, ongoing morality play that pitted segregationists against their benevolent victims. In the coming months, evening network news programs would switch from a fifteen- to a thirty-minute format, the result of their ability to produce stories more quickly and efficiently through the use of handheld cameras and satellite technology. The shift was fortunate for the movement: with fewer time restrictions, producers could cover the story of civil rights more frequently and in greater depth. The movement's dramatic, largely visual events made it "television's first recurring news story." It provided an unending stream of emotionally intense images that would enthrall viewers and keep them tuning in night after night.[90]

At the height of the Birmingham conflagration, television crews endeavored daily to capture those few seconds of footage that would most succinctly illustrate the urgency of the story they were reporting. Young journalists, such as R. W. "Johnny" Apple, from *Huntley-Brinkley*, and Dan Rather, from the *CBS Evening News*, pioneered a new way of reporting—directing TV cameras, conducting interviews, writing scripts, applying their own makeup. They operated under hostile and difficult conditions. Apple later recalled that Birmingham was more frightening and dangerous than many of the international war zones he covered. White civilians spat at him. Policemen awakened him in the middle of the night to search for narcotics in his hotel room.

The inventiveness of early TV news sometimes inspired bold civil rights coverage. Despite criticism to the contrary, this reporting was neither simplistic nor superficial. While network evening news programs such as *Huntley-Brinkley*, *CBS Evening News*, and *ABC News* could offer little more than brief reports, their tenacity in developing and broadcasting stories yielded an ongoing, serial analysis of the movement that was, at its best, sophisticated and focused. If long-form television documentaries rarely addressed civil rights—concentrating instead on international affairs and the Cold War—producers often turned to other formats, especially prime-time news series and interview programs, to analyze American race relations in depth.[91] On the evening of May 10, 1963, just hours after the

accords were announced, CBS News aired *Breakthrough in Birmingham*, a half-hour report on its weekly Friday news program, *Eyewitness (fig. 32)*. Through dramatic visual images, interviews, and provocative narration, the show offered an early and cogent analysis of the Birmingham campaign and its local and national implications.

Breakthrough in Birmingham subtly recasts the story as a clash between supporters of progress and advocates of the status quo, between the "the Negro disciples of nonviolence" and "segregationist forces." It opens with striking footage of white aggression—clips of a policeman choke-holding a black demonstrator, of barking and snapping German shepherds—and a breathtaking, one-minute pan of youthful demonstrators being menaced by water hoses. It features interviews with people sympathetic to the cause of civil rights, including King, James Baldwin, and a white Harvard sociologist, Thomas Pettigrew. (The title was taken from King's on-camera reference to recent events as a watershed for the movement, a "breakthrough in Birmingham.") Protesters are generally represented as peaceful and reasonable: after peaceful black churchgoers are shown singing "We Shall Overcome," for example, a female demonstrator comments: "If I'm going to spend my money in the stores, I think I should have the right to sit down and eat a sandwich in them."

Breakthrough is less generous to Birmingham's white establishment. Menacing white policemen impatiently tap nightsticks against their thighs or tug on the leashes of ferocious dogs. A local white newspaper editor dismisses both the protests and the accords, insisting that Birmingham's black citizens had achieved little more than a "Pyrrhic victory" that will embolden the champions of segregation. Referring to the city's attempt to quell rebellious African-Americans, a white male bystander remarks that it is his "wish" the police would "kill them all."

fig. 32
Eyewitness: Breakthrough in
Birmingham
May 10, 1963
Courtesy of CBS News Archives

Another man maintains that the "niggers" of Birmingham are being unduly influenced by outside agitators.

The concluding segment considers the question of whether the civil rights movement is devolving into a "new militancy." "The events in Birmingham have sent a chill through most Americans," says Charles Collingwood, the host of *Eyewitness*. He suggests that King and his supporters, while increasingly confrontational, are far tamer than the black Muslims and other extremists who might replace the civil rights leader if his efforts fail. Collingwood offers an implicit warning to white viewers: Ignore the needs and rights of African-Americans, and risk outright "racial war." His remarks are undeniably troubling, demonizing radical black leaders—earlier in the documentary, he cites allegations that Congressman Adam Clayton Powell, Jr., is a "demagogue and a racist"—and insisting that the focus in race relations rests primarily on the needs and security of white people.

But his sober words also place the onus where it belongs, on the millions of white Americans who heretofore have had little incentive to examine their own complicity in a racist society, whether in the Jim Crow South or in the supposedly liberal cities of the North. More than simply investigating the dilemma of race through the lens of white self-interest, the usual strategy of mainstream media of the period, *Breakthrough in Birmingham* implies that the interests of white people would be best served if they face up to their prejudices. As James Baldwin suggests in an on-camera interview, it is up to white Americans to assume moral responsibility for the crisis at hand:

> It is a matter of changing the attitudes of this country. Martin Luther King…cannot do for you what only you can do. It is your country, too. And what is happening to Martin, what is happening to all of the children of Birmingham, is being done in your name. You have no right, no right, not to know that. You have no right to pretend that Birmingham is in another country. It is not. It is here in Los Angeles. It is in New York. It is in Detroit.

The tone and content of the program appear more extraordinary when compared with *Life*'s May 17, 1963, report on the conflict, "They Fight a Fire That Won't Go Out." The photo-essay features eleven pages of striking black-and-white images by Charles Moore that document the event's brutality and urgency. Caption headings, picked out in bold type, further dramatize the images: "Pinned to Wall," "Caught in Open," "Attack Dogs," and "Face of Hatred." It is the last heading, however, that suggests a flagrant bias: the hate-filled face it describes belongs not to a white segregationist but to a black man soaked by a water jet (*fig. 33*).[92]

The article's unsympathetic view of the demonstrators—a position not shared by photographer Moore, who was "sickened" by the brutality of Bull Connor's troops—differs markedly from *Breakthrough in Birmingham*.[93] "The

Negro strategy of 'nonviolent direct action' invites . . . brutality," the unnamed author asserts at the outset, blaming African-American demonstrators for having "set an ominous precedent of provocation and reprisal."[94] "The Dogs' Attack Is Negroes' Reward," announces the title of another section of images, its judgmental text concluding: "This extraordinary sequence—brutal as it is as a Negro gets his trousers ripped off by Connor's dogs—is the attention-getting jackpot of the Negroes' provocation."[95] The only honorable solution to Birmingham's problems, the magazine implies, is for its black citizens to end their demonstrations: "Responsible Voice. Shouting through bullhorn, Rev. James Bevel tries to persuade Negroes to go home."[96] The text contains no quotations or comments of any kind from African-Americans, and gives the last word to Birmingham's white residents, in a section of solicitous interviews, "Query for Southern Whites: What Now?"

The contrast between the *Life* photo-essay and *Breakthrough in Birmingham* is telling, but mainstream periodicals were not always conservative in their civil rights reporting. Some, like the *New York Times*, were sometimes openly sympathetic to the cause of racial justice. Nor was broadcast news universally progressive. After a period of robust, edgy reporting, network news, fearful that its pro–civil-rights image, in the face of increasing racial violence and black militancy, was eroding its support among white viewers, grew more circumspect.[97] By 1965, the hour-long CBS News documentary *Watts: Riots or Revolt?*, for example, presented as undisputed fact the sociologist Daniel Patrick Moynihan's theory that the principal cause of the Los Angeles riots, and African-American violence in general, was the "breakup of the black family and the increasing number of female-headed households"—a position that unfairly stigmatized black women and disregarded the racism that was at the root of the problem.[98]

The idea that television was better at reinforcing "existing opinions" than changing minds—an idea that originated in a 1960 study by sociologist Joseph T. Klapper, then director of social research for CBS, on how the medium influences public opinion—had become for the industry a self-fulfilling prophecy.[99] But at least in the early 1960s, in nightly news broadcasts and extraordinary programs like *Eyewitness: The Albany Movement* (CBS News, 1962), *Crucial Summer: The Civil Rights Issue* (ABC News, 1963), and *Ku Klux Klan: The Invisible Empire* (CBS Reports, 1965; *fig. 34*), much of television news remained steadfast and aggressive in its race reporting, allowing compelling stories to reach millions of Americans. Like the horrific photos of Emmett Till that had jolted African-Americans into action eight years earlier, TV news coverage of the demonstrations in Birmingham—as well as other major civil rights events of the period—became a catalyst for all Americans.

Television news empowered the civil rights movement by providing "simplicity and a moral clarity to the confrontation between the bigotry

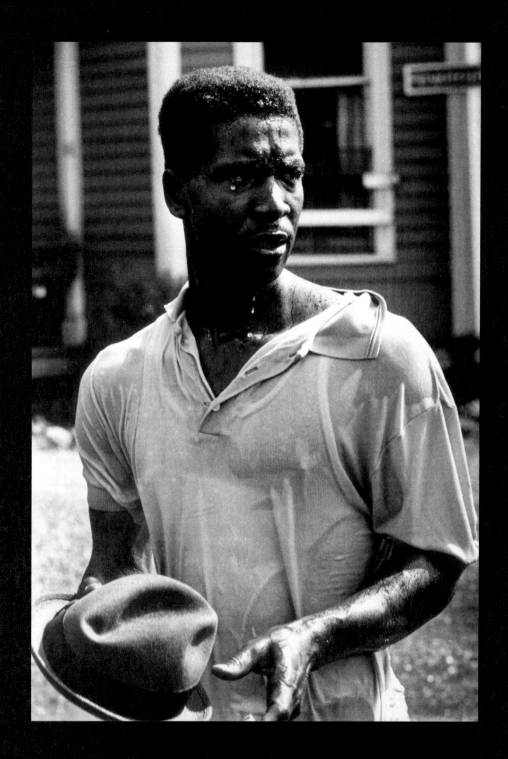

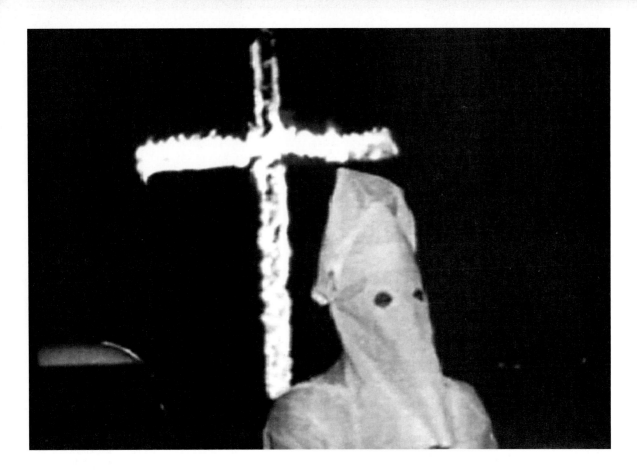

of segregationists and the determination of oppressed African Americans."[100] The shocking images it transmitted helped convince "white northerners of the depth of the racial conflict in the South and the intransigence of local officials."[101] In the weeks after the gripping broadcast reporting of Birmingham, "television's greatest hour," as civil rights leader Bayard Rustin later called it, public opinion surveys indicated for the first time that a majority of Americans believed that racism and segregation were the nation's most urgent problem.[102] Surveys tracked a decline in the perception of white Americans that the pace of change in race relations was too fast, and a sharp increase in support for laws guaranteeing voting rights, access to housing, and the desegregation of schools and public accommodations.[103]

The scenes from Birmingham also inspired concrete political action. President John F. Kennedy, who was slow to respond to the problem of civil rights for fear of alienating southern Democrats, met with his cabinet and advisors to discuss the repercussions of the conflagration. The president, made "sick" by the photos and TV footage he saw, feared more bloody conflicts.[104] He decided to press for major civil rights legislation. On June 11, he delivered a nationally televised address that condemned the unlawful use of violence against the citizens of Birmingham, proclaiming "more forcefully than any other American chief executive the immorality of segregation and discrimination."[105] "Are we to say

fig. 33
Charles Moore
Birmingham, Alabama
May 17, 1963
Collection Civil Rights Archive,
CADVC, Courtesy of
Charles Moore/Black Star

fig. 34
Ku Klux Klan: The Invisible Empire
1965
Courtesy of CBS News Archives

to the world—and much more importantly to each other," Kennedy asked, "that this is the land of the free, except for Negroes; that we have no class or caste system, no ghettoes, no master race, except with respect to Negroes?"[106]

Congress was no less swayed by the images of these momentous events. NBC correspondent Bill Monroe has argued that the Civil Rights Act of 1964, the landmark legislation proposed by President Kennedy a year earlier, "wouldn't have happened without TV."[107] Similarly, Ralph McGill, editor of the *Atlanta Constitution*, observed that television news "performed a magnificent service" by broadcasting pictures of Bull Connor and his dogs to millions of Americans, thereby creating a momentum forceful enough to "push the Civil Rights Act through Congress."[108]

Congressman John Lewis, leader of the 1965 Selma-to-Montgomery voting rights march—"Bloody Sunday," as it would come to be known—asserts that had it not "been for television on that day, we wouldn't have gotten the Voting Rights Act of 1965. The civil rights movement in this country owes a great deal to television."[109] On March 7, 1965, millions of Americans watched in astonishment as state troopers and local policemen savagely clubbed, trampled, and tear-gassed six hundred peaceful demonstrators attempting to cross the Edmund Pettus Bridge out of Selma. The journalist George Leonard recalls the galvanizing power of these nationally broadcast images, which brought thousands of sympathizers from across the country, black and white, to Alabama in support of the marchers:

> We were in our living room in San Francisco watching the 6 P.M. news. I was not aware that at the same moment people all up and down the West Coast were feeling what my wife and I felt, that at various times all over the country that day and up past 11 P.M. Pacific Time that night hundreds of these people would drop whatever they were doing, that some of them would leave home without changing clothes, borrow money, overdraw their checking accounts; board planes, buses, trains, cars; travel thousands of miles with no luggage; get speeding tickets, hitchhike . . . that these people, mostly unknown to one another, would move for a single purpose: to place themselves alongside the Negroes they had watched on television.[110]

That a nation could be inspired by the sheer, raw force of these images was a source of encouragement for civil rights leaders and activists. For them, television had emerged as a potent ally. For others, though, it was a locus of fear and loathing. Mainstream politicians and segregationists alike grew anxious about a medium they hardly understood, yet knew was extraordinarily influential. A political figure no less canny than Lyndon Johnson would feel compelled to resist

its uncompromising imagery. In 1964, the African-American activist Fannie Lou Hamer testified at the Democratic National Convention, before a national television audience, about being jailed and savagely beaten in Winona, Mississippi while on a voting rights crusade. Johnson was so concerned about the effect his support of the burgeoning movement would have on his southern white Democratic base that he interrupted Hamer's deposition with an emergency news conference.

Nowhere was there more dismay about television's civil rights coverage than in the Deep South. As early as 1956, state legislators in Louisiana accused the networks of employing the "communist technique of brainwashing for racial integration."[111] In August 1962, the *New York Times* reported that white people in Albany, Georgia, weary of national scrutiny and frustrated with what they believed was television's African-American bias, habitually referred to the networks as Afro Broadcasting Company, the Colored Broadcasting System, and the Negro Broadcasting Company.[112] They no doubt understood the power of television to expose the cruelty and vehemence of their prejudices. They no doubt also were resentful of its focus on the transgressions of one section of the country. As broadcasters homed in on a new breed of villain—the unreconstructed and brutal southern white bigot—they tended to overlook the more mundane, everyday reality of racial prejudice, whether the harsh restrictions of the Jim Crow South or the more subtle bias of the urban North. Several more years would pass before television began to pay attention to the millions of people who could not, or would not fathom their own involvement in the story of racism in the United States.

The country's image of the Negro,
which hasn't very much to do with the Negro,
has never failed to reflect with a kind of
frightening accuracy the state of mind of the country.
James Baldwin
"Notes for a Hypothetical Novel" (1960)

GUESS WHO'S COMING TO DINNER: BROADCASTING RACE

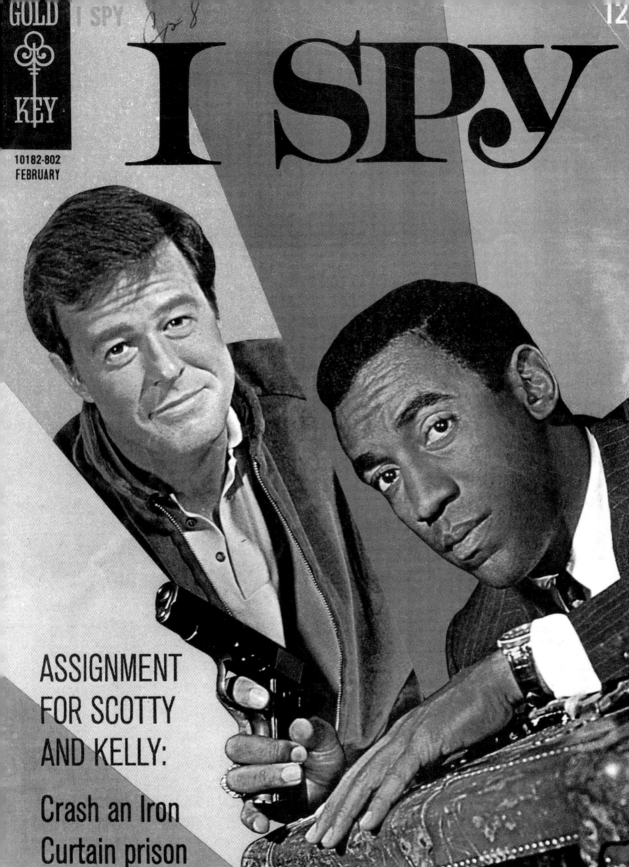

GOLD KEY

10182-802
FEBRUARY

I SPY

12

I SPY

ASSIGNMENT
FOR SCOTTY
AND KELLY:

Crash an Iron
Curtain prison
and smash
a frame-up!

In September 1968, National Broadcasting Company, promising "a new experience in television," debuted a situation comedy that offered viewers something not seen on the air since two controversial programs, *The Beulah Show* and *Amos 'n Andy*, were canceled in the early 1950s: a weekly, nationally broadcast series built around a contemporary African-American character.[1] The program was *Julia*. Its star was the acclaimed stage and screen actress Diahann Carroll, its producer and writer the respected Hollywood veteran Hal Kanter. The series centered on Julia Baker, a newly widowed nurse—her husband a casualty of the Vietnam War—and her young son, Corey (Marc Copage). The program followed their everyday lives in an integrated apartment building in Los Angeles and Julia's interaction with her colleagues in a corporate medical office headed by Dr. Morton Chegley (Lloyd Nolan), a curmudgeonly white physician.

What made the series "new," as NBC claimed, was its refusal to promote racial stereotypes or to mark its protagonist as intrinsically different from its white characters. Julia was intelligent, self-sufficient, well dressed, and beautiful, a far cry from the black servants and buffoons of 1950s television. She was an equal among equals, a woman deserving of the respect of her white friends and associates. Shortly after its premiere, *TV Guide* praised the comedy as "an honest portrait of a woman with love interests and realistic emotions, while showing with humor that Negroes face the same problems as everyone else—and then some."[2]

The show was a critical and ratings success, spawning a lucrative industry of memorabilia including dolls, lunch boxes, coloring books, and toys (*pl. 23*). The seventh most popular program in its premiere season, *Julia* reached a weekly average of more than 14 million homes. In a medium where black characters remained rare, the series was a source of admiration and pride for some African-Americans. *Ebony* lauded it, suggesting that it offered the black middle class a positive alternative to images of racial dissension and violence that were pervasive on national news programs.[3]

If *Julia* broke new ground, however, it did so in ways that would not intimidate white viewers. For one, the series isolated its protagonist from African-American culture and community—she was rarely depicted interacting with black friends or associates—while typically ignoring or downplaying her race. Julia's color was mostly irrelevant in an environment of obdurate whiteness and happy-go-lucky racial harmony, a world of accommodating white neighbors, friends, and colleagues.[4] Only in her love life was integration not allowable, her exclusively black boyfriends indicating the show's hesitancy to confront or even examine racial taboos.

In Julia's world, racism was mostly a thing of the past. When characters were portrayed as prejudiced (an uncommon occurrence), they were depicted as small-minded, out of touch, or antisocial, "not a part of the day-to-day

fig. 35 (previous page)
I Spy
February 1967
I Spy comic book cover image
provided by PRO
(Peter Rodgers Organization)

lives of Julia or her son."[5] Even when she perceived racism, Julia invariably came to the conclusion that she had misconstrued the situation. Predictably, she had little tolerance for black militancy. In one episode, she upbraids an African-American babysitter for her separatist beliefs, and praises the virtues of color-blindness and integration. References to race were usually made in an offhanded, humorous way meant to minimize its importance. Typifying this was Dr. Chegley's teasing retort when Julia informed him in their initial phone interview that she was black: "Have you always been black," he asked, "or are you just being fashionable?"[6]

Not surprisingly, civil rights advocates—like many black viewers—disapproved of the show for a number of reasons, from its lack of a male head of family to its unwillingness to tackle the problems faced by real African-Americans.[7] Kanter answered his critics by insisting that *Julia* was "escapist entertainment," and not "a civil rights show" or "a sociological document."[8] His defense was contradicted by his own widely published assertion that he was inspired to create *Julia* after hearing a speech by NAACP director Roy Wilkins on the problematic state of American race relations.[9] As NBC touted its social value and critics lauded it as "an idea born of one man's desire to serve humanity," the series was widely understood to be a show about race.[10] Adding to this impression was the political activism of its star: Carroll was an ardent and vocal supporter of the civil rights and black power movements.

In her landmark *Revolution Televised: Prime Time and the Struggle for Black Power*, the cultural historian Christine Acham argues that while *Julia* promoted itself as controversial and bold, it cynically assuaged the racial anxieties of white viewers. Obliterating the social realities of African-American existence, the show was able to render Julia "a safe black person whom America could embrace," and thus assure high enough ratings to attract profitable sponsors.[11] From the ease with which she excused white people's bad behavior to her lack of cultural specificity and racial pride, the character bore little resemblance to the outspoken civil rights advocates then ubiquitous on broadcast news programs. Beyond her race, Julia's vocation and work situation—as a selfless caregiver always deferential to her elderly white employer—to some extent undercut the idea that she was an equal among equals.[12] Notably, there was no more outspoken critic of the show's racial evasiveness than its star. In a *TV Guide* article published shortly after the series' premiere, Carroll charged that Julia's race was intentionally neutralized in order to appease white viewers. The character was, in the actress's words, a "white Negro" with "very little Negro-ness."[13]

The "white Negro" was not new to television. Three years earlier, NBC made a ratings splash with *I Spy* (1965–68), costarring the white actor Robert Culp and the popular black stand-up comedian Bill Cosby (*fig. 35*). The stylish hour-long weekly espionage drama followed the exploits of American secret agents

Kelly Robinson (Culp) and Alexander Scott (Cosby), posing as a professional tennis player and his personal trainer, respectively. It was the first national TV drama or comedy to feature an African-American actor in a nonmenial or derogatory leading role. (The dramatic series *Harlem Detective*, canceled in 1954 after one season, starred the black actor William Marshall as a plainclothes police officer, but was broadcast only locally on WOR-TV in New York City.)

As with *Julia*, the "black" character in *I Spy* was not defined racially; the role was so race-neutral that it "could have been played by a white man."[14] The show's producers insisted that it be "color-blind" and that its two lead characters be portrayed as equals. As Cosby later confirmed, the program avoided racial issues, and was thus freed from "having to impart a message each week and instead allowed . . . to succeed by emulating the conventions" of the popular espionage genre.[15] But unlike *Julia*, it was an important showcase for African-American performers, with guest appearances over its three-year run by Ivan Dixon, Eartha Kitt, Barbara McNair, Greg Morris, Diana Sands, Cicely Tyson, Leslie Uggams, and Nancy Wilson, among others.

In the end, *Julia*'s tranquil, whitewashed depiction of African-American life, despite its good intentions, was anachronistic, contrasting sharply with the pervasive images of racial violence and rebellion on local and national newscasts. Only months before the show premiered, the nation watched in horror as Martin Luther King, Jr., and Robert Kennedy were assassinated. Race riots scarred inner cities. Black militancy was on the rise. Racial frustrations were at their peak.

Even before *Julia*'s first broadcast, Robert Lewis Shayon, television critic for the *Saturday Review*, attacked it for a "plush, suburban setting" that had little to do with "the bitter realities of Negro life in the urban ghetto."[16] If the critic himself reduced the African-American experience to a stereotype—a wretched cityscape of poverty and suffering—his criticism was persuasive enough for Carroll to quote it in her autobiography. African-American viewers, too, spoke out against the show, flooding NBC with calls and letters. By 1970, Carroll herself had become one of *Julia*'s harshest detractors, publicly deriding it as a sellout and wondering whether the nation would ever accept a TV program that represented African-Americans as more than simplistic stereotypes or racially neutralized ciphers.[17]

The actress walked away from *Julia* after three seasons. But her brave political intervention, and her outspokenness about the show, did not end there. In 1974, she starred in the film *Claudine* (directed by John Berry), portraying an inner-city single mother fighting to make a better life for her children. *Claudine* was Carroll's answer to *Julia*. "Far from the highly made up and stylish Julia," writes Christine Acham, Claudine "was often pictured in a housecoat, tired after a long day of work."[18] With this modest and poignant film, the actress pushed the representation of black womanhood well beyond the cliché of the "white Negro." The effort

earned her an Academy Award nomination and the respect of civil rights advocates and millions of African-American moviegoers.

The "ghetto sitcoms" of the 1970s were prime-time television's answer to the racial neutrality and equivocation of *Julia* and *I Spy*. Set in the places like Chicago, Washington, D.C., and the Watts section of Los Angeles, these programs offered mainstream audiences a humorous view of working-class African-American inner-city life, whether from the vantage point of a barbershop, a high school, or a junkyard. *Sanford and Son* (NBC, 1972–77; *fig. 36*), the first mainstream situation comedy to feature a mostly black cast since *The Amos 'n Andy Show*, followed the exploits of a rambunctious junk dealer in Watts; *What's Happening!!* (ABC, 1976–79) centered on the antics of three underprivileged black teenagers in Los Angeles; and *Good Times* (CBS, 1974–79; *fig. 37*), the most politically conscious of the genre, was a domestic comedy set in a Chicago housing project.[19]

With predominantly black casts, these programs introduced millions of viewers to a mostly unknown generation of black entertainers. A few, like comedian Redd Foxx, the costar of *Sanford and Son*, had been regulars on the "Chitlin' Circuit" of the 1940s and 1950s, a string of vaudeville theaters and nightclubs, mostly in the eastern and southern United States, that featured black performers during a time of rampant racism and segregation.[20] Other

fig. 36
Sanford and Son
1972
(Redd Foxx, Demond Wilson)

fig. 37
Good Times
1974
(Jimmie Walker, Ralph Carter)

actors—such as John Amos and Esther Rolle (*Good Times*), Clifton Davis (*That's My Mama*, ABC, 1974–75), Whitman Mayo (*Sanford and Son*; *Grady*, NBC, 1975–76; *The Sanford Arms*, NBC, 1977), and Roxie Roker and Isabel Sanford (*The Jeffersons*, CBS, 1975–85)—came from the world of film, Broadway, or African-American repertory theaters, including the Negro Ensemble Company in New York.

Despite the presence and input of these performers, and scripts sometimes written by black writers, ghetto sitcoms offered a picture of African-American life that was as unrealistic and equivocal as the "white Negro" of *Julia* and *I Spy*. The tendency of these shows to identify blackness with poverty denied the presence, as well as the political and cultural clout, of a growing black middle class. In many cases, "ghetto" life in these comedies was a benign fantasy, a place where black folks were happy-go-lucky and where the effects of indigence and racism barely registered. These programs also reverted to stereotypes—the shiftless trickster (on *Sanford and Son*) or the lazy buffoon (on *Good Times*)—that drew protests from media activists and viewers who saw them as anachronistic in the wake of the civil rights movement and the black activism and militancy of the 1970s.

Good Times elicited some of the fiercest complaints, in spite of its attempts at social commentary. Created by the African-American team of writer

Eric Monte and actor Michael Evans, the show centered on the Evans clan, who lived in the derelict Cabrini-Green housing project: patriarch James (John Amos), unemployed but always looking for work, his wife, Florida (Esther Rolle), who struggled to keep the family together, and their three teenage children, Thelma (BernNadette Stanis), intelligent and driven to succeed, J. J. (Jimmie Walker), the elder son, an artist and high school dropout, and Michael (Ralph Carter), the militant youngest child, who speaks up about racism and advocates revolution.

The political messages of *Good Times* were mixed, vacillating between "uplifting images of the black community," commentary on racism and poverty, and the reworking of old racist stereotypes for comic effect.[21] Unlike *Julia*, the show featured a nuclear black family headed by two parents—a strong unit that endured in an urban environment beset by poverty, evictions, gang warfare, robberies, and muggings. In its early episodes, at least, it also refused to soft-pedal the topic of racism, treating it as a serious problem with dire social consequences. In one episode, Michael is suspended from school after he calls George Washington a racist and complains about the racial bias he perceives in his American history class. In another, two white FBI agents show up at the Evanses' apartment to interrogate Florida about the whereabouts of her nephew, a suspect in a bank robbery. Michael wonders aloud whether the men are searching as vigorously for the person who assassinated Medgar Evers—a sly reference to the government's failure to bring to justice the killer of the civil rights activist.[22]

As the series evolved, however, it became more dependent on stereotypes vulgar enough to compel its stars, Rolle and Amos, to quit in protest. Fading into the background were stories of the parents' stoicism and conscientiousness, the family's struggles with racism and poverty, and Michael's militancy and accomplishments. Replacing them were the antics of J.J., a character so popular that by the mid-1970s his trademark expression, "Dyn-o-mite," had become a household word. Wearing a perpetual toothy grin, his eyes bulging, his demeanor clownlike, J.J. was an updated version of the coon stereotype of minstrel shows, films (*The Birth of a Nation*), and early television (*Amos 'n Andy*). In contrast to his robust and honorable father or the bright and studious Michael, the bone-thin, barely literate J.J. was prone to lying and stealing. He personified the compromised black masculinity long employed to placate white anxieties about African-American power and self-possession—not surprisingly, in the case of *Good Times*, after the rise of black militancy that terrified and confused many. Negative images "have been quietly slipped in on us through the character of the oldest child," observed a frustrated Esther Rolle about the shift from celebration of the black family to a reliance on crude stereotypes for cheap laughs. "I resent the imagery that says to black kids that you can make it on the corner saying 'Dyn-o-mite.'"[23]

East Side / West Side
1963
(James Earl Jones)

The one-hour dramatic series *East Side / West Side* (CBS, 1963–1964), shot on location in New York City, was the outstanding exception to prime-time television's tendency to idealize urban poverty and minimize the deleterious effects of racism. Grappling with such controversial topics as inner-city blight and neglect, homelessness, bigotry, and drug addiction—and with plots that often remained unresolved at the end of each episode—the critically acclaimed program, produced by David Susskind, followed the troubling, everyday encounters of Neil Brock (George C. Scott), a social worker for the Community Welfare Service, a private agency in Manhattan. The show also featured Cicely Tyson as Brock's secretary, Jane Foster, the first recurring African-American character in a national dramatic television series. In one episode, about the invisibility of the urban poor, Brock writes a series of articles about ghetto life, only to find that no newspaper or magazine will publish them. One of the series' most startling and controversial installments—"Who Do You Kill?"—concerned a young African-American couple (Diana Sands and James Earl Jones) who, beset by job discrimination and poverty, must cope with the death of their baby daughter, mortally attacked by a rat in their Harlem tenement apartment (*fig. 38*). New York senator Jacob Javits praised the episode on the floor of Congress for "honestly and

sensitively" dealing with the "vital problems of job discrimination, housing conditions and the terrible cancerous cleavage that can exist between the Negro and the white community."[24]

In another episode, "No Hiding Place," Brock takes on an unscrupulous white realtor who, notwithstanding his disavowal of prejudice, stirs up the racial anxieties of seemingly tolerant white homeowners in order to keep an African-American couple out of their development. In the dramatic climax, the social worker challenges the double standards and hypocrisy of seemingly tolerant people who judge the applicants not for who they are but for the darkness of their skin and the level of their accomplishment: "We have a different yardstick for measuring Negroes, don't we? If he went to Harvard, if he plays golf, if he looks like a Boston gentleman and talks like a Philadelphia lawyer, why, fine. Let him be brown, only not too brown." "No Hiding Place" presented an uncompromising and unusual appraisal of racism in the North, a problem denied by many and usually overlooked by media fixated on the Jim Crow South.

The boldness and candor of *East Side/West Side* predictably drove away sponsors and viewers, and it was canceled after one season. But in its scant twenty-six installments, the series repeatedly tested the racial, ethnic, and economic tolerances of its white audience, to a degree unprecedented on prime-time television of the period. The vast majority of white Americans made it through the modern civil rights movement with little incentive to examine their racial beliefs and actions. Mainstream American culture rarely if ever identified whiteness as a race. Although it was represented everywhere—crowding out almost everything that was not white—it remained an unexamined state of mind and body. Civil defense films, such as *Medical Aspects of Radiation* (1950; *fig. 39*), *Cold War: The Challenge of Ideas, Part 1* (1961), and *The House in the Middle* (1954), depicted a vulnerable, surreal nation largely devoid of people of color. Government posters celebrated an America "where every boy can dream of being President" and "a fellow can start on the home team and wind up in the big league," goals apparently unavailable to the black children absent from the posters (*pl. 24*). Television sponsors continued to deliver their messages almost exclusively through the mouths of white actors and spokespeople. And situation comedies like *The Adventures of Ozzie and Harriet* (ABC, 1952–66), *Leave It to Beaver* (CBS, 1957; ABC, 1958–63), *Father Knows Best* (CBS, 1954–55, NBC; 1955–58; CBS, 1958–60), *Hazel* (NBC, 1961–65; CBS, 1965–66), and *The Brady Bunch* (ABC, 1969–74) celebrated the lily-white, Christian virtues of the American nuclear family.

When Hollywood broached the subject of white racism, it usually sidestepped all but the most virulent forms of southern bigotry—a limitation seen in films including *The Defiant Ones* (directed by Stanley Kramer, 1958), *Nothing but a Man* (Michael Roemer, 1964), and *In the Heat of the Night* (Norman Jewison,

fig. 39
Medical Aspects of Radiation
1950

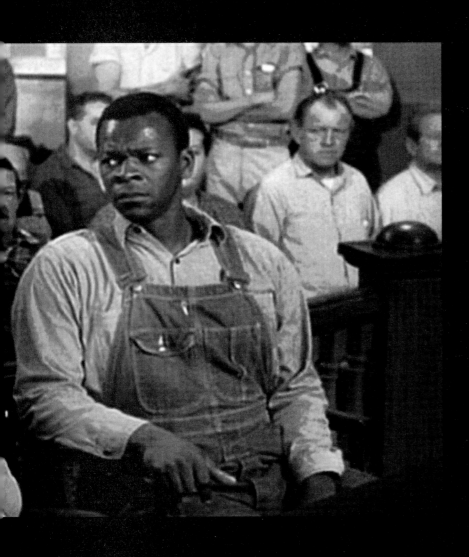

1967) and television dramas such as *The Autobiography of Miss Jane Pittman* (CBS, 1974) and the twelve-part miniseries *Roots* (ABC, 1977), adapted from Alex Haley's best-selling novel.[25] One of the most progressive race movies of its time, *To Kill a Mockingbird* (directed by Robert Mulligan, 1962; *fig. 40*), was no less geographically constrained. Based on the novel by Harper Lee, the film tells the story of Atticus Finch (Gregory Peck), a small-town Alabama lawyer and widower father, who passionately defends a black man (Brock Peters) wrongly accused of raping a white woman. *Mockingbird* made an important contribution to the public debate around race, both in the way it positioned the courageous and benevolent Finch as a role model for white Americans and in its blunt representation of prejudice. But by focusing its action on a time and a place in which segregation was at its most venomous and unchecked—the Depression-era South—the film, unintentionally or otherwise, distanced its predominantly non-southern audience from the problem that was all around but that few people would acknowledge.

Given the persistence of racism outside the Old Confederacy, this restriction was all the more problematic. As Jim Crow segregation flourished in the period after Reconstruction, white supremacist and Ku Klux Klan activities spread across the country. African-Americans were lynched in almost every state. After World War II, people of color continued to be denied access to fair housing, employment, and education in many urban and suburban communities in the North as well as the South. As blacks migrated to the cities of the North and Midwest, white residents fled to the suburbs, where they expected, indeed demanded, racial exclusivity. Levittown, a massive Long Island, New York, housing development built after World War II to accommodate returning veterans and their families, became a symbol of northern intolerance. The standard lease for a Levittown home in 1947 mandated that it could not "be used or occupied by any person other than members of the Caucasian race," not even the African-American soldiers who just a few years earlier had risked their lives protecting the country.[26] Employers as well as institutions of higher learning, from Ivy League schools of medicine and law to municipal community colleges, routinely blacklisted applicants of color. In their own way, these racist proscriptions were as damaging to African-American morale as legislated segregation. The deadly riots that erupted in Detroit, Los Angeles, Newark, and other cities in the mid-1960s put to rest the notion that the problem of race was an exclusively southern phenomenon.

This strife was only one sign that despite inroads made by the federal government and the media in exposing and dismantling the catastrophe of Jim Crow segregation, the nation as a whole was still in trouble. There is no question that race relations, and the plight of black people, had improved as a result of the civil rights movement. By the late 1960s, the U.S. Supreme Court had invalidated most forms of institutional segregation. A decade later, support in

fig. 40 (previous page)
To Kill a Mockingbird
1962
(Gregory Peck, Brock Peters)

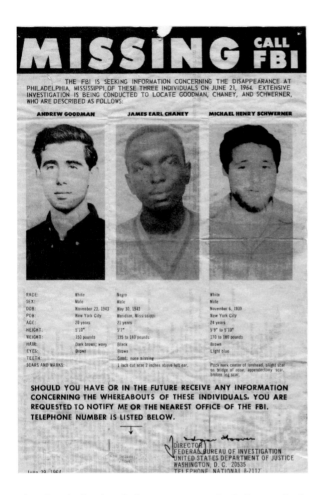

the South for legal discrimination had diminished considerably. The symbols of the Jim Crow regime—lynching, segregation signs, separate bathrooms, water fountains, and other public accommodations—were disappearing from everyday life. National public opinion was increasingly intolerant of racial bigotry. Concepts such as "diversity" and "pluralism" took hold, signaling a greater acceptance of racial and ethnic minorities in the culture at large.

The racial largesse of some white Americans, of course, went beyond mere tolerance. From the founding of the nation, progressive whites supported abolition, voted for antiracist politicians, and donated money and time to civil rights groups. Some challenged white denial about racism, holding themselves and others accountable for bigotry. This was nowhere more vivid, perhaps, than in *Killers of the Dream* (1949), Lillian Smith's candid memoir about the origins, causes, and effects of southern racism. And a few died for the cause, such as the white Jewish activists Andrew Goodman and Michael Schwerner, who, along with the African-American civil rights worker James Chaney, were murdered by Klansmen in Philadelphia, Mississippi, where they had gone in the summer of 1964 to investigate the burning of a black church (*fig. 41*).

Despite the increasing acceptance of the idea of civil rights in

fig. 41
Missing: Call FBI
June 29, 1964
Collection International Center of Photography, Anonymous Gift, 2005

mainstream society, however, the problem of racism continued as old-fashioned de jure segregation gave way to more subtle forms of prejudice. "Benign neglect" and discreet slights replaced epithets and murder. School administrators, real estate agents, and developers, marginally in compliance with the law, resorted to unspoken agreements and conspiracies of silence. Police officers invented new ways of harassing African-American motorists and pedestrians. Banks redlined entire neighborhoods. Waiters ignored black patrons. Teachers anticipated black failure or stupidity. Employers passed over black candidates. And large sectors of the population, whether compelled by unspoken agreement or by the fear of alienating their neighbors, aligned into de facto racial camps that played together, learned together, and lived together with little concern about government intervention.

The path from segregation to integration was fraught and uncertain for many white Americans. As abstract notions of racial harmony and justice gave way to the concrete reality of black equality, white people were forced to question the absolute social and cultural authority to which they were accustomed. Relinquishing this power was, unconsciously or not, a source of resentment and apprehension for many. Other factors, too, contributed to racial uneasiness: ignorance about the history, culture, and politics of a people long ignored and now empowered; dread of humiliation or retaliation at the hands of indignant African-Americans; fear that hidden prejudices might reveal themselves. This discomfort impelled many to avoid interracial contact, suppress or deny the feelings it elicited, or sublimate these feelings into unconscious, sometimes repellent behavior.

Notwithstanding the persistence of white anxiety around race, popular culture rarely challenged the millions of people who had escaped the rigorous media scrutiny previously reserved for white supremacists and redneck police chiefs. In the rare instance when racism outside of the South was examined, the result was cautious or unchallenging—a problem notable in *Guess Who's Coming to Dinner* (directed by Stanley Kramer, 1967; *fig. 42*), the Academy Award–winning movie starring Spencer Tracy and Katharine Hepburn as an affluent white San Francisco couple who consider themselves progressive, until their daughter brings home her black fiancé.

The film centers on a dinner party in the couple's elegant home, during which the interracial lovers—Joanna Drayton (Katharine Houghton) and Dr. John Wade Prentice (Sidney Poitier), a prominent African-American physician—meet their respective in-laws for the first time. The dinner unfolds as a series of polite conversations about the possibility and practicality of interracial marriage. The couple defends their relationship. Joanna's father opposes it. John's father (Roy Glenn) is similarly unenthusiastic, fearing that his son and Joanna will never be happy or safe in a racist society. As the rhetoric intensifies, and prejudices are demurely revealed, it is up to another guest, Mike Ryan (Cecil Kellaway), a

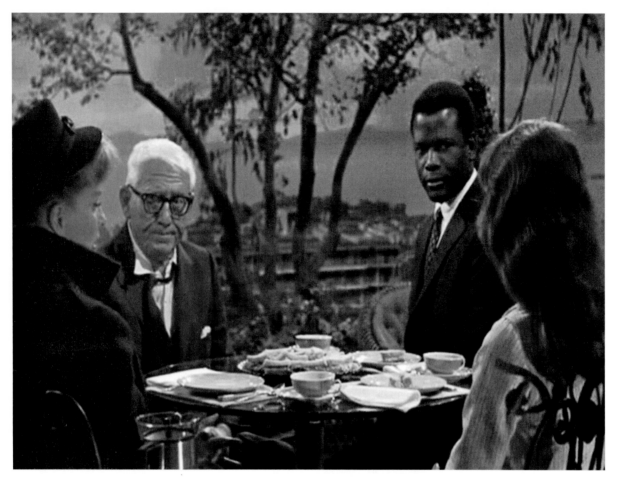

Catholic priest, to serve as arbitrator, benevolently counseling the young couple and preaching tolerance to their skeptical parents.

On one level, *Guess Who's Coming to Dinner* was progressive for its time, representing an interracial relationship—no less between a black man and a white woman—that both sets of parents come to accept by the film's end. Yet by refusing to address the ugly stereotypes and irrational fears at the heart of racism, of the liberal variety or otherwise, the film's open-mindedness goes only so far. Joanna's father, for example, never owns up to the prejudices behind his objections to her relationship. While Monsignor Ryan tries to pin him down—"It's amusing to see a phony liberal come face-to-face with his principles," he wryly observes— Mr. Drayton dwells on the potential dangers that the couple will undoubtedly confront in a racist society: "I wish I didn't have the feeling that they'll never make it," he confides to the priest.

The script goes out of its way to make its white audience comfortable, as well. The young doctor is depicted as exemplary and flawless, unquestionably free of the stereotypical drawbacks—poverty, anger, indolence— that might render a "lesser" black man unfit for Joanna and for many white viewers. The character's idealization, abetted by Poitier's dashing good looks and regal

fig. 42
Guess Who's Coming to Dinner
1967
(Katharine Hepburn, Spencer Tracy, Sidney Poitier, Katharine Houghton)

bearing, is almost absurd: a world-renowned globetrotting clinician, Dr. Prentice is Yale-educated, exquisitely dressed, well mannered, eloquent, and scrupulous to a fault; he refuses to sleep with his fiancé until they are married, and insists on paying for the long-distance phone call he makes while at the Drayton's.

The movie further distances itself from the subject of white racism by rendering the families' reactions—and their motivations—as equal. Both sets of parents initially respond to the couple with dumbstruck silence. Both fathers vehemently reject the relationship on the grounds that it is foolhardy and perilous. Both mothers hesitantly accept it because they want their children to be happy. The most irrational and intolerant reaction to the couple comes not from family but from the Draytons' outraged African-American maid (Isabel Sanford), who berates John for taking advantage of her naive ward and accuses him of being a "smooth-talking, smart-ass nigger." Ultimately, the film's gentility and tentativeness made it out-of-date at a time of increasing racial tensions, urban riots, and assassinations. Its take on American race relations was out of step with political reality. John's father warns his son about the illegality of interracial love—"In sixteen or seventeen states you'd be breaking the law, you'd be criminals," he says—but by the time of the movie's premiere, in December 1967, his words were no longer true. Six months earlier, the U.S. Supreme Court, in *Loving v. Virginia*, had invalidated all remaining anti-miscegenation laws.

It took four more years before the situation comedy *All in the Family* (CBS, 1971–79) succeeded where *Guess Who's Coming to Dinner* had failed, offering a candid and sustained exploration of urban white racism then unprecedented in mainstream culture. Based on BBC comedy series *Till Death Do Us Part* and produced by Norman Lear and Bud Yorkin, *All in the Family* centered on the antics of a middle-class, white family in Queens, New York: patriarch Archie Bunker (Carroll O'Connor), a blustering and chauvinistic loading-dock worker; Edith, his good-natured but scatterbrained wife (Jean Stapleton); and their live-in daughter, Gloria (Sally Struthers), and son-in-law, Mike Stivic (Rob Reiner), a liberal college student.

The show was unusual for its time, bluntly depicting racial bigotry in one of the North's supposedly most tolerant cities. Archie gave public voice to the mostly private intolerance of the millions of white urban and suburban Americans unhappy with the sweeping social reforms of the 1960s. Speaking for this "silent majority," as President Richard Nixon anointed them, Archie believed that the gains of African-Americans, Hispanics, and Jews—"coons," "spooks," or "spades"; "spics"; and "Hebes," as he called them—were being made at the expense of lower-middle-class white Christians. His frequent racial tirades were unprecedented in a medium that tended to appease its sponsors with comforting fantasies of middle-class family life, by and large free of hate, resentment, or ethnic difference.

As might be expected, many critics viewed the series with disdain or suspicion, often because of its hard-nosed and crude depiction of racism. Some felt that Archie was a "lovable bigot" who glorified prejudice. Others feared that his racial epithets hurt blacks, Jews, Hispanics, and other minorities. The *New York Times* panned *All in the Family* on the morning of its premiere, asserting that Archie's language and behavior were more shocking than funny, eliciting "self-conscious, semi-amused gasps" rather than genuine laughter.[27] Failing to achieve the producers' expressed goal of humorously presenting "familiar stereotypes" in order to reveal their absurdity, the paper dismissed it as unfunny, sensationalistic, and most of all, lacking "taste."[28]

The appeal for "taste"—no doubt, the kind of discretion that precluded *Guess Who's Coming to Dinner* from depicting all but the most banal pronouncements of racial animus—missed the point of Archie's unsettling diatribes: that racism, never tasteful or polite, was ugly, wounding, mindless, and in its most unbridled form, shocking. It could also be, in its irrationality and ludicrousness, absurdly, if painfully, funny. Breaking through the defensiveness that usually prohibited blunt depictions of intolerance in mainstream culture, the show's writers made Archie both the brunt of its jokes *and* accountable for his racism, especially through the vigilant monitoring of his more tolerant son-in-law and the people of color who crossed his path.

In one of the series' most celebrated episodes, "Sammy's Visit," Archie picks up the black Jewish entertainer Sammy Davis, Jr., in the cab he drives to make money on the side (*fig. 43*). When Davis leaves his briefcase in the car, and must drop by the Bunker home to retrieve it, Archie is gripped by racial panic. At once awestruck by the performer's fame and repulsed by the color of his skin, he nervously spouts offensive remarks. "Do you got any fried chicken in the kitchen," he asks Edith before their guest arrives, "'cause they like to snack on that." Within seconds after Davis walks through the door, Archie asks, "You being colored, well, I know you had no choice in that. But whatever made you turn Jew?" Recalling the performer's recent appearance on *The Tonight Show*, in which he greeted actress Raquel Welch with a peck on the cheek, Archie proclaims that he never thought he would "see the day when coloreds and whites would be hugging and kissing coast to coast. If God had meant us to be together," he confides in Davis, "he'd have put us together. But look what he done: He put you over in Africa. He put the rest of us in all the white countries."

The episode was extraordinary, not only for its frank depiction of racism, but also for its unwillingness to neutralize or mollify Davis's vulnerability as a black man. In the more realistic setting of *All in the Family*—as in everyday life—even a person as wealthy and famous as Davis was not immune to racial attack. Avoiding the affectations of the mythic "white Negro" or the latter-day

minstrelsy of *Good Times*, the entertainer played himself in a situation he often experienced in real life: confronting racism, explicit or otherwise. Unwilling to tolerate Archie's offensive remarks, Davis fights back, sarcastically taking apart the bigot's oft-repeated assertion that he is not prejudiced:

> Look, if you were prejudiced, Archie, when I came into your house, you would have called me a "coon" or a "nigger." But you didn't say that. I heard you clear as a bell. Right straight out, you said "colored." And if you were prejudiced, you would—like some people—close [your] eyes to what's going on in this great country that we live in. But not you, Archie, your eyes are wide open. You can tell the difference between black and white. And I have a deep-rooted feeling that you'll always be able to tell the difference between black and white. And if you were prejudiced, you'd walk around thinking that you're better than anybody else in the world. But I can honestly say, having spent these marvelous moments with you, you ain't better than anybody.

That Archie accepts this rebuke as a compliment was a testament to his stupidity and boorishness. That white Americans could see their own prejudices mirrored in his callow behavior was unprecedented. More than any other

program of its time, *All in the Family* shattered the illusion of racial harmony and equality advanced by prime-time television, a hermetic world devoid of the stories of racial conflict then dominating network news.[29]

If comedic and dramatic programs remained skittish about white racism throughout the period of the modern movement, another television format, the variety show, helped the cause of civil rights in another way: by serving as a consistent outlet for black entertainers. This commitment stood in contrast to, among other things, musical comedy film, a genre long dominated by white actors. Financial considerations invariably doomed movies with integrated casts. For decades, southern exhibitors refused to book movies that featured integrationist story lines and black actors. Censoring television programs proved more difficult. In 1956, the Louisiana state legislature attempted to officially prohibit the broadcasting of any show "in which members of the white and Negro races participate or which involve social contacts between members of both races."[30] The statute was unenforceable: to preview live telecasts was impossible; to refuse to broadcast recorded programs already sold to sponsors was to forfeit an appreciable source of income for local affiliates. "Trapped by technology and commerce," writes the cultural historian Thomas Doherty, "station managers in the Deep South telecast images of interracial amity they would never have countenanced in their hometown newspapers or at the local Bijou."[31]

As has been discussed earlier, the rise of television was concurrent with that of the civil rights movement. Both embraced a spirit of experimentation, learning from the past, but also learning as they went along. Less tethered to Hollywood's racist past, the young medium attracted many young, socially progressive producers, directors, and writers. Indeed, the Television Code, a set of ethical standards adopted by the National Association of Broadcasters in the 1950s, expressly forbade the depiction of "racial or nationality types . . . in such a manner as to ridicule . . . race or nationality."[32] Television was not a panacea, of course, as the timidity of most early prime-time dramas and situation comedies suggests. But the variety format—to a degree far greater than Hollywood films, or even the interpersonal lives of most Americans—regularly presented black and white performers interacting as equals.

"Here any man or woman, regardless of creed or color or station in life, can have a chance at the entertainment goal he seeks," proclaimed Ted Mack, the host of *The Original Amateur Hour* (Dumont/NBC/ABC/CBS, 1948–70).[33] Mack's sentiment did not accurately reflect the medium as a whole at the time, since actors of color remained rare in TV dramas and situation comedies well into the 1960s. A few dramatic anthology series from the 1950s—notably *Philco Television Playhouse* (NBC, 1948–55) and *Playhouse 90* (CBS, 1956–60)—were the major exceptions to this rule. By the late 1960s, the situation had changed

somewhat, with no fewer than thirty dramatic and comedic series featuring black actors in starring or recurring supporting roles.[34]

But Mack's assertion about his own show—as for many other variety programs, even in the early days of television—was more or less true. The genre afforded black entertainers a national venue to practice their craft at the highest level, in a context less threatening to white viewers. The first national prime-time broadcast ever written, produced, and performed by African-Americans was a jovial variety special that aired on NBC in February 1966. A one-hour musical celebration of Harlem, *The Strollin' Twenties* was conceived and produced by Harry Belafonte after reading Langston Hughes's memoir *The Big Sea* (1940). The actor cowrote the script with Hughes and employed a star-studded roster of black performers, including Diahann Carroll, Sammy Davis, Jr., Duke Ellington, Sidney Poitier, and Nipsey Russell.[35]

Over its twenty-three-year run on CBS, *The Ed Sullivan Show* (1948–71; *fig. 44*), television's most successful prime-time variety hour, was an early and reliable forum for African-American singers, actors, and comedians, despite Sullivan's ongoing battles with conservative sponsors.[36] A number of other variety and talk programs routinely booked black entertainers, such as *Arthur Godfrey and His Friends* (CBS, 1949–57), *The Dinah Shore Show* (NBC, 1951–62), *The Tonight Show* (NBC, 1954–present), *The Arthur Godfrey Show* (CBS, 1958–59), *Sing Along with Mitch* (NBC, 1961–64), and *The Mike Douglas Show* (syndicated, 1961–82). The networks also produced a handful of programs hosted by black performers but unable to build a sustainable nationwide audience: Nat King Cole (NBC, 1956–57), Sammy Davis, Jr. (NBC, 1966), Leslie Uggams (CBS, 1969), Diahann Carroll (CBS, 1976), and Richard Pryor (NBC, 1977). During the modern civil rights movement, only two national variety programs with African-American hosts became hits: *The Flip Wilson Show* (NBC, 1970–74) and *Soul Train* (syndicated, 1971–2006). The latter, produced and hosted by Don Cornelius, was essentially the black counterpart of *American Bandstand*.

If the variety show's imperative to enfranchise black entertainers was, in part, economic—a means to reach out to an increasingly prosperous black middle class—it also served the cause of civil rights by bringing accomplished African-American entertainers into millions of living rooms on a regular basis. By showing black and white performers interacting as equals, these programs represented the promise and desirability of integration. In their celebration of black achievement and excellence—just as W. E. B. Du Bois had urged the race to uplift itself by the example set by outstanding African-Americans, what he called the "talented tenth"—they helped instill pride in a people heretofore ignored, undervalued, or demeaned on television. "Television presentation must reflect the best," wrote the *Pittsburgh Courier* in 1954, because the "American Negro

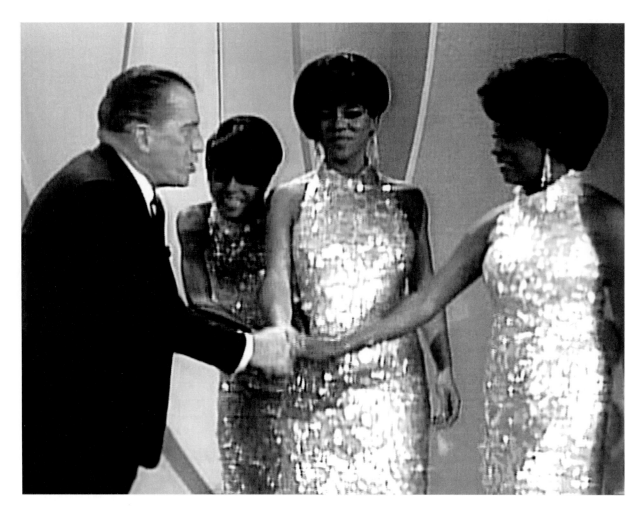

will get favorable publicity that he has never before enjoyed, and it will reflect credit upon the race."[37]

Still, there was a limit to the racial generosity of these shows. Their tendency to sidestep the issue of race, in one sense, made them little different from prime-time comedies or dramas. The subject was often irrelevant in a variety format, in which entertainers sang, danced, and clowned their way through light-hearted skits and musical numbers. *The Richard Pryor Show* was the one significant exception (*fig. 45*). This extraordinarily progressive and uncompromising program was cowritten by and starred the edgy Pryor, among the first African-American stand-up comedians to "speak candidly and successfully to integrated audiences using the language and jokes blacks previously only shared among themselves when they were most critical of America."[38] Pryor experimented with the variety format, pushing both dramatic and comedic content into the realm of uncompromising social commentary. In one skit, for example, he turned his formidable wit on the network itself, appearing emasculated in a bodysuit, genitals erased, and assuring viewers that he had given up nothing to get his own series. (The skit was deleted for broadcast by NBC.)

fig. 44
The Ed Sullivan Show
ca. 1966
(Ed Sullivan, The Supremes:
Diana Ross, Florence Ballard,
Mary Wilson)

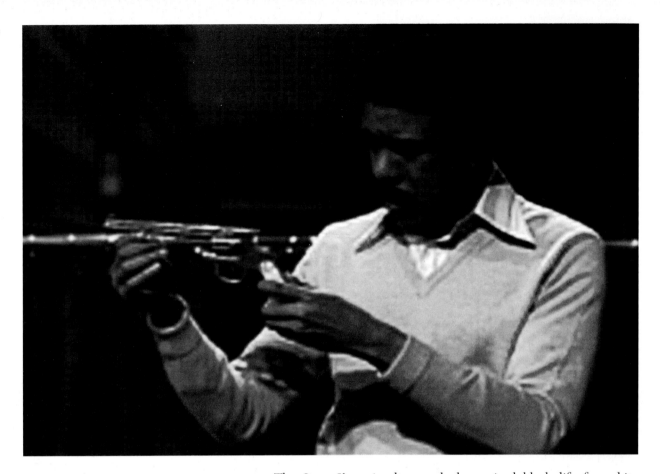

The *Pryor Show* simultaneously humanized black life for white audiences, and offered black viewers genuine and starkly realistic representations of themselves, often portraying the everyday reality of living with racism. Pryor resisted "the confines of television," creating "entertaining and insightful material . . . while targeting issues of concern for the African-American community."[39] Although the show was years ahead of its time—one skit went as far as to imagine the first black president, still vulnerable to the slights of white people unaware of or indifferent to his status—it was also politically radical and thus unsustainable on mainstream television. Heavily censored, the series was canceled after only four episodes.[40]

The short life of *The Richard Pryor Show* points to the profound inadequacy of mainstream popular culture in providing audiences—black and white—with a complex view of African-Americans. It is fair to say that the battle for racial uplift, while successful within the black community, had only qualified success in the mainstream. Throughout the modern civil rights movement, political activists and cultural figures alike agitated for change within popular culture and the media. But in an entertainment industry where as brilliant and confident an actress as Diahann Carroll was transformed into a passive "white Negro"—and where her insistence that her character in *Julia* wear a natural was perceived as radical—the potential for a revolution in black representation was limited at best.

EPILOGUE

IN OUR LIVES WE ARE WHOLE: THE PICTURES OF EVERYDAY LIFE

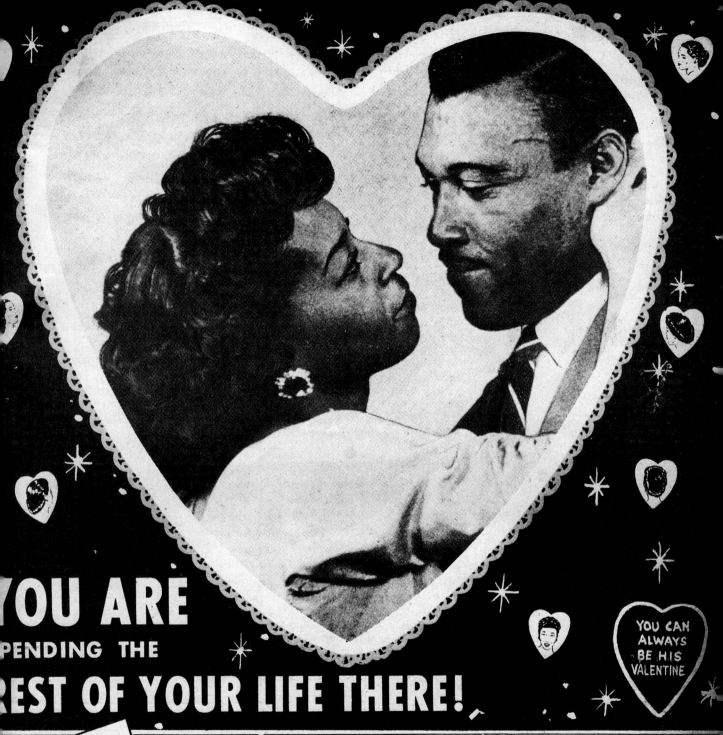

In an interview in 1966, the activist poet and writer Amiri Baraka, then known as LeRoi Jones, decried the absence of black subjects in mainstream popular culture. "All around black people are white man's images, especially on television and radio. You can't pick up anything without seeing the white man's life dramatized, the white man made a hero."[1] For Baraka, the central question of black representation was one of control: as long as white producers, writers, and directors were the gatekeepers of the broadcast industry, African-Americans would not see themselves presented realistically, or even routinely, in the media.

Baraka believed that only black cultural figures could rectify this problem: "If you give me a television station, we won't need a bloody revolution."[2] His words suggest an abiding paradox of African-American representation in the waning years of the civil rights movement: The very medium that had failed to enfranchise a people, despite its promise, could, in the right hands and with the right motivation, empower them. Since African-Americans played almost no role in producing, let alone dictating, the content of television, Baraka's observation is perhaps most telling in its negative and decidedly unoptimistic assessment of mainstream popular culture: that its portrayal of African-Americans was inevitably compromised and one-dimensional, because its depictions were shaped by the racial limitations and vulnerabilities of white people.

While neither Baraka nor any other black American of the period would run a national television network, the notion of black cultural autonomy and control was, and always had been, a vital aspect of the modern struggle for racial equality and justice. If the popular culture continued to offer a partial, fragmentary, or distorted view of black life, it was the goal of alternative representations to represent the full complexity and humanity of a people—to make visible, to paraphrase Ralph Ellison, that which had remained mostly invisible in the culture at large. "White America at the time did not know that we lived in a complete universe. In our private lives we *were* whole," observes the writer Thulani Davis. "We enjoyed a richness that the mainstream almost never showed, but that we took for granted just as white people did."[3]

It was black-owned and -operated media and cultural outlets, as well as the intervention of black artists, performers, writers, and filmmakers, that allowed African-Americans to see themselves in ways denied or forestalled in the wider culture. There was a broader imperative toward African-American self-expression in the 1960s and 1970s, a time when black artists, media, and businesses endeavored to seize control of the representation of race. As conventional women's publications such as *Harper's Bazaar*, *Glamour*, and *Vogue* unself-consciously clung to the ideals of white beauty (U.S. *Vogue* did not put a black model on its cover until Beverly Johnson was featured in 1974), periodicals like *Tan* and *Essence* celebrated the beauty, intelligence, talent, and aspirations of female African-Americans.[4]

fig. 46 (previous page)
Gold Medal
1957
Collection Civil Rights Archive,
CADVC. Gold Medal Hair
Products Inc.
www.GoldMedalHair.com

Black hairstyle and cosmetic companies reached out to women long ignored by companies invested in the virtues of white skin or blondness (*fig. 46*). Shindana Toys, a black-owned business founded in Los Angeles in 1968 as a division of the self-help organization Operation Bootstrap, mass-produced black dolls with "ethnically correct" features to countermand the harmful effects on African-American children of a market flooded with white- or dark-skinned dolls with Caucasian features (*pl. 25*). An increasingly active black publishing industry gave voice to African-American achievers, interests, culture, and history, stories that even as late as the 1970s rarely made it onto the pages of mainstream books, magazines, journals, and newspapers.

The venues for black cultural expression were many and varied. A new generation of black filmmakers challenged the stereotypical or compromised black characters then customary in Hollywood pictures. With calls for diversity growing, and a larger black middle class demanding to see itself represented, "social, political and economic pressures inside and outside . . . the commercial film industry played a pivotal role in creating" opportunities for black directors.[5] As early as 1969, Warner Brothers financed the production of Gordon Parks's drama *The Learning Tree*, a semiautobiographical, humanistic recounting of black life in Depression-era America. The film established Parks as the first black

fig. 47
Shaft
1971
(Richard Roundtree)

director of a major Hollywood studio film. His Oscar-winning hit *Shaft* (1971; *fig. 47*), about a suave private investigator in Harlem (Richard Roundtree), introduced the African-American action hero into mainstream cinema, a role until then reserved for white actors.

With the commercially viable *Sweet Sweetback's Baadasssss Song* (1971), whose protagonist triumphs over corrupt Los Angeles policemen bent on framing him for a murder he did not commit, Melvin Van Peebles expanded the limits of black male representation. This independent film, which no studio would produce, portrayed the almost unthinkable in mainstream popular culture: a tough African-American hero who stands up to white power and authority and wins.[6] Van Peebles saw his film as a political intervention, an antidote to decades of emasculated or docile characters. "For the Black man, Sweetback is a new kind of hero," the director commented shortly after the film's premiere. "For the White man, my picture is a new kind of foreign film."[7]

Despite the profitability of a handful of movies, such as *Shaft*, *Sweetback*, and *Super Fly* (directed by Gordon Parks, Jr., 1972)—often labeled "Blaxploitation" films by critics, both within and outside the black community, because of their violent content and lurid story lines—the commercial movie industry was hardly an accessible or important place for black cultural expression. Supporting projects with large budgets, and inevitably dependent on box-office revenues, the studios were generally risk-averse, and therefore unwilling to fund movies that could not attract a large national audience. Throughout the civil rights era, few race-related projects were green-lighted, and relatively few African-American performers appeared in Hollywood productions. In the 1970s, just as the civil rights movement was winding down, a new generation of black independent filmmakers emerged. Working outside of the studio system, these directors—in innovative works, such as Haile Gerima's *Child of Resistance* (1972) and *Bush Mama* (1979), Charles Burnett's *Killer of Sheep* (1977), Larry Clark's *Passing Through* (1977), and Julie Dash's *Four Women* (1975) and *Diary of an African Nun* (1977)—were committed to exploring black life on a personal and humanistic level, a point of view then unsustainable in Hollywood.[8]

From the late 1960s, African-American television programs began to appear on network affiliates and local stations across the nation. Produced, directed, written, and hosted mostly by black journalists and entertainers, these shows served a large regional black community and thus did not have to retain sponsors by attracting a chiefly white national audience. Freed from this restriction, they could give voice to a range of topics of specific interest to African-Americans. The revolution they proffered was one of cultural complexity, providing details, insights, and analysis of the lives of a people chronically stereotyped in mainstream popular culture.

These shows, airing in cities across the country, and diverse in their programming style, included, among many others: *Black Horizons* (Pittsburgh), *Black Perspectives on the News* (Philadelphia), *Cliff Alexander—Black on White* (Washington, D.C.), *Face to Face* (Seattle), *For You Black Women* (syndicated), *Haney's People* (Detroit), *Inside Bedford-Stuyvesant* (New York), *Job Man Caravan* (South Carolina), *Minority Matters* (Kansas City, Kansas), *Our People* (Chicago), *Say Brother* (Boston), and *Soul!* (New York).[9]

In New York City, newsman Gil Noble produced and hosted *Like It Is* (WABC, 1968–present), a weekly talk show on the local ABC affiliate. In the latter years of the movement, the show provided a forum for examining cultural, social, and political concerns to black people, and featured hard-hitting discussions about race relations, racism, and black power and militancy that had little or no outlet on network talk shows. Similarly, in Detroit, *Colored People's Time*, produced by the local PBS affiliate, served as the local counterpart to the pioneering series *Black Journal* (PBS, 1968–76), a nationally syndicated newsmagazine funded by the Corporation for Public Broadcasting and hosted by Lou House and William Greaves (and then by Tony Brown after 1970). One of the primary objectives of *Colored People's Time*, according to its producers, was to offer a local "alternative to the objectification and negative imagery of blacks" on national television.[10] The weekly newsmagazine, which interspersed short films with talk segments and skits, was a showcase for local black artists, actors, writers, directors, and producers and a forum for exploring social and cultural topics of importance to the African-American residents of Detroit. As Noble later observed about the significance of these local broadcasts, they constituted a "powerful mind-molding machine," engaging the black community with stories and discussions about "their very real problems, instead of preoccupying them with the problems of fictitious families of the soap operas and situation comedies."[11]

As the modern civil rights movement cleaved into integrationist and separatist factions in the 1960s—the former continuing to advocate nonviolence and white accommodation, the latter committed to black power, insurrection, and self-sufficiency—the role of visual culture reflected these differences. The Black Panther Party, one of the period's most radical political groups, argued that the African-American community needed to look inward, to its own people and institutions, for inspiration and empowerment. In the process, the Panthers were responsible for some of the most graphically innovative efforts to control the image of African-Americans.

Founded by Huey P. Newton and Bobby Seale in Oakland, California in October 1966, the organization initially advocated black nationalism and armed revolution, and hoped to achieve by force the racial equality it believed court-ordered integration and civil disobedience could not deliver. Challenging the

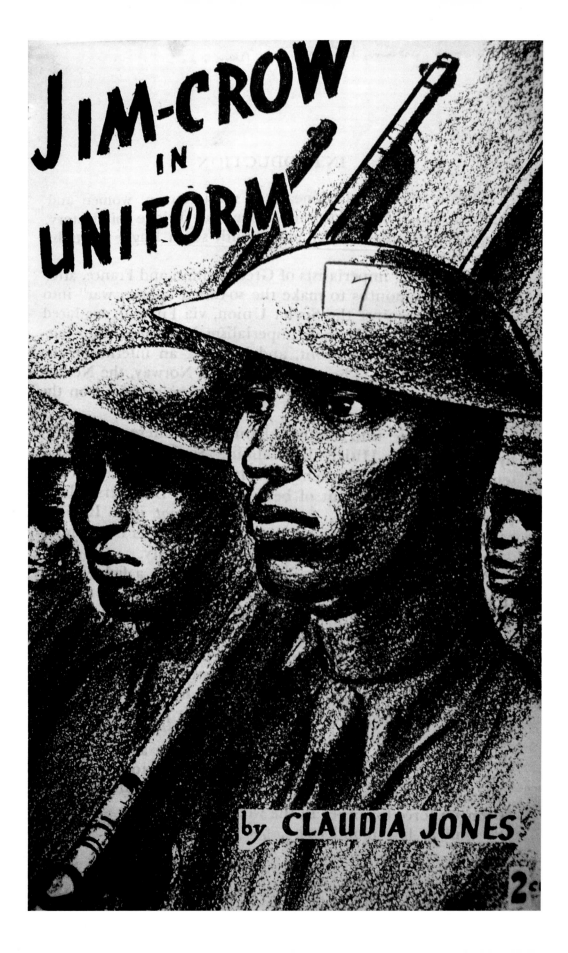

civil rights establishment, the Panthers were the first major black political group of their time to "broadcast their intention to fight back against those who sought to exploit them."[12] In 1967, California repealed the right to publicly bear firearms in California, and eventually party leaders were impelled to moderate their mission and tactics. Calls for armed insurrection gave way to community-based activism to improve the lives of black people. Through its "Survival Program," the party advocated, among other things, free health care, adequate housing, land ownership, community control of schools and police, and programs to end hunger, drug abuse, crime, and police brutality.

Central to this mission was a visual campaign designed to introduce Panther ideology directly into the black community. "Before a correct visual interpretation of the struggle can be given, we must recognize that Revolutionary Art is an art that flows from the people," observed Emory Douglas, the party's minister of culture. "It must be a whole and living part of the people's lives, their daily struggle to survive."[13] A commercial art student at the City College of San Francisco, Douglas joined the party in February 1967. His talent and social consciousness impressed Newton and Seale, and they soon appointed him the first art director of the organization's weekly newspaper, the *Black Panther*, a position he held until the party disbanded in 1980. The "most prolific and persistent graphic agitator in the American Black Power movements," Douglas served as the "master craftsman" of the Panthers' visual identity—designer, illustrator, political cartoonist, and mentor to young artists.[14]

Douglas's imagery reflected the party's evolving social agenda. Early iconography echoed its militancy, a pictorial vocabulary replete with slick armed revolutionaries, clad in the Panther uniform of black beret, black leather jacket, and sunglasses; gun toting mothers with babies; and snorting potbellied pigs, the party's symbol for police officers, politicians, and other establishment types (*pl. 26*). In his later work, Douglas was more likely to celebrate black pride or meditate on urgent social concerns. One image from 1973 depicts a worn out black laborer, above him a dire observation: "Few Black Folks die of old age—Few have the time, and none get the opportunity." Another, from 1971, juxtaposes the smiling face of a black child—red rays radiating from his head, classroom images reflected in his eyeglasses—with a more hopeful slogan: "We Shall Survive Without a Doubt" (*pl. 26*).

Douglas's graphic style suggests a number of art historical influences, from African textiles and Cuban and American propaganda broadsides (*fig. 48*) to muckraking caricatures by the nineteenth-century French artist Honoré Daumier and the socially conscious paintings and prints of the African-American artists Elizabeth Catlett and Charles White (*fig. 49*). It also owed much to commercial advertising, employing bold color, repetitive and striking

fig. 48
Jim Crow in Uniform
1940
Collection Civil Rights Archive, CADVC

fig. 49
Charles White
"The Negro Mother"
by Langston Hughes
ca. 1952
The Charles White Archives
Collection Civil Rights Archive, CADVC

iconography, and snappy catchphrases. Douglas's visual "branding" of the party—beginning with its distinctive logo, the silhouette of a slinking panther—resulted in imagery so seductive and iconic that mainstream graphic designers and advertising agencies copied it.[15] (The derisive term "radical chic," coined by Tom Wolfe, originally referred to the enthrallment of the white cultural elite with the Panthers, an attraction, Wolfe alleged, that had more to do with the party's stylishness and cool than its revolutionary politics.)[16] As the artist and theorist Colette Gaiter writes:

> The Panthers were adept at creating recognizable signifiers and icons that identified their members and eventually represented their ideology. Some ubiquitous elements of the "brand," which constantly appeared in the paper, were black berets, leather jackets, military-style machine guns, and the Panther logo. "This is what the revolution looks like" was the message. The revolution would not be televised, so Douglas visualized it with his art and work for the paper, communicating specific instructions through his images.[17]

The success of the Panther brand depended to a great extent on its reach. The party's sophisticated visual campaign, which benefited also from the work of artists and graphic designers trained by Douglas, was intended not for the elitist world of the museum, but for the spaces and institutions of everyday life, the black neighborhood. Its target audience included the millions of impoverished men and women demoralized by a steady diet of negative media stereotypes. Its objective was to "incite the disenfranchised to action, portraying the poor with genuine empathy, not as victims but as outraged, unapologetic, and ready for a fight."[18] "Art for the people's sake," was Douglas's expressed ambition, whether distributed through a weekly newspaper, brochures, or political buttons (*pl. 27*), or plastered onto "the walls of the ghetto; in storefront windows, fences, doorways, telephone poles and booths, passing buses, alleyways, gas stations, barbershops, beauty parlors, Laundromats, [and] liquor stores."[19]

The Panthers' visual orientation accorded with the broader struggle for civil rights. But its view of the substance or purpose of this imagery was not always in sync with other factions, groups, and organizations. Many civil rights leaders actively reached out to white America, for example, while the Panthers rebuffed this strategy as a form of appeasement. A 1967 essay by Eldridge Cleaver, excoriating the NAACP for just this reason, was illustrated by Douglas's *Bootlickers Gallery:* photographs of Martin Luther King, Jr., and other civil rights leaders collaged onto a drawing of a black man prostrate before President Lyndon Johnson's cowboy boots.

Black Panther ideology mirrored that of a broader black power movement that spurned the civil rights establishment, refused to depend on

mainstream media and institutions, and advocated cultural and political self-determination. The Black Arts Movement, a group of outspoken writers, artists, designers, producers, performers, and editors, represented the cultural voice of black power. Founded in 1965 by Amiri Baraka, partly in response to the assassination of Malcolm X earlier that year, the Black Arts Movement called for a singularly African-American expression supported by a network of local organizations. As the poet Larry Neal has observed, the Movement was "radically opposed to any concept of the artist that alienates him from his community," insisting that the production, content, and distribution of art be inextricably bound to the reality of daily life.[20]

The Black Arts Movement boldly rejected the idea of cultural integration, arguing that African-American life was already full, rich, complex, and complete. It wanted neither the acceptance nor the support of white America: in appeasing or allowing itself to be co-opted by white-identified culture, black culture risked losing its uniqueness and resonance. By the late 1960s, Movement artists and writers offered an alternative to mainstream depictions—from progressive plays mounted by local black theater companies, such as Ed Bullins's *The Devil Catchers* (New Lafayette Theater, New York, 1970) and Sonia Sanchez's *The Bronx Is Next* (Theater Black, New York, 1970), to the activist literary journals *Floating Bear*, *Umbra*, and *Yugen*.

Although the political leader central to the rise of the black power movement—Malcolm X—was a strong champion of cultural self-determination, he was not beyond using "any means necessary," including the mainstream media, to achieve his goals (*pl. 28*).[21] The national spokesman for the Black Muslim religious group, the Nation of Islam, Malcolm rejected many of the objectives of the establishment civil rights movement. He was a fierce opponent of Martin Luther King, Jr., and his advocacy of civil disobedience, integration, and interracial dialogue. When persecuted by racial oppression, Malcolm X argued, black Americans must not see themselves as victims, and should fight aggressively, even responding to brutality with violence, to maintain their freedom and independence. He was one of the most media-savvy black leaders of the period, "intensely interested" in using radio, television, magazines, and newspapers to spread the ideology of Islam and black nationalism.[22] By the time of his assassination, in February 1965, he had appeared on scores of television and radio programs, arguably more than any other civil rights figure including King.

Malcolm X was able to take advantage of journalists' fascination with him and the religion he represented. His fierce rhetoric provided print, radio, and television with an ongoing and incendiary story that could capture the attention of their audiences. The Nation of Islam, through the voice of its national spokesman, likewise offered editors, producers, and reporters a

dramatic counterpoint to King and the establishment movement. Malcolm became the media's "angel of darkness," a leader unafraid to condemn white people and always poised to "launch a sensational, rhetorical attack" against King, the "angel of light."[23] Through this comparison, implicit or overt, outlets sympathetic to the cause of civil rights were able to position King as a reasonable alternative to black extremism, and thus allay the fears of white readers, listeners, and viewers apprehensive about the movement for black equality and justice.

But white people were not Malcolm's principal target audience. He was interested, instead, in tapping into the anger of African-Americans fed up with the segregation or racism they experienced on a daily basis. Many blacks at the time would not accept the Nation of Islam, because of its religious orientation, its fundamentalism, its cultural insularity, or its political extremism. But as a 1963 poll by *Newsweek* concluded, a sizable portion of the African-American community—more than a third by the magazine's estimate—was "resigned to the possibility that they may have to fight their way to freedom."[24] Media outreach constituted an important part of Malcolm's effort to reach these people. He publicized and contributed to the illustrated weekly newspaper *Muhammad Speaks*, created by the Nation of Islam's leader, Elijah Muhammad, in 1961, and helped build a national syndicate of Muslim-owned radio stations. A keen steward of his own and the religion's visual representation in the media, Malcolm often carried a camera to record Black Muslim activities, and even set up the shots of photojournalists assigned to cover the group.[25]

As part of this media campaign, Malcolm also sought out media and institutions controlled by white people but with which blacks regularly engaged. While newsmagazines were sometimes reluctant to cover the Black Muslims, television was often more solicitous. Thomas Doherty explains how Malcolm was able to turn the new medium into a powerful, albeit often unwitting accomplice:

> Malcolm X's arrival on the national scene was concurrent not only with the renascent civil rights movement, but with a series of pivotal shifts in the nature of television journalism: the consolidation of three-network hegemony in the late 1950s, the extension of nightly newscasts from fifteen minutes to thirty minutes in September 1963, and the high renaissance of the prime-time television documentary. Telegenic and quick-witted, Malcolm courted the networks like a smitten suitor, and relished his verbal duels with patrician white broadcasters. As the critic Shelby Steele noted, Malcolm X spoke in sound bites before the term was invented, and used blunt street talk to punch through the fog of pretense, politeness, and euphemism on television.[26]

The charismatic leader mastered television, crafting every aspect of his own camera persona—from his elegant dark suits and ties to his urbane speaking style—to emphasize his physical attractiveness, intelligence, and rhetorical gifts. (In a meticulously detailed passage in *The Autobiography of Malcolm X*, he describes the changes he made in outward appearance, from clothing to hairstyle, to transform himself from Nebraska country boy and small-town Michigan teenager to Boston "home boy," and finally to national political and religious figure.)[27] By carefully studying television and its format—and building on insights he had learned from radio—he developed "techniques and tactics through which he could control" the programs on which he appeared.[28] Malcolm habitually interrupted the introductory comments of talk-show hosts, as a way of "establishing that he, not the host, was in control."[29] He spoke forcefully and insistently, refusing to stop until he delivered the exact and complete message he wished to convey. Rarely raising his voice or demonstrating any sign of anger or agitation, he remained coolly in charge of rhetoric designed to affirm within the African-American community the justness and urgency of his cause.

Many in the New York metropolitan area, a region with a large African-American population, first heard this rhetoric in detail in July 1959, when the thirty-four-year-old minister was featured in a controversial five-part television series about black extremism, *The Hate That Hate Produced*, presented by the nightly half-hour program *News Beat* (WNTA, Newark; *fig. 50*). The series, moderated by *News Beat* host Mike Wallace with interviews conducted by the African-American journalist Louis E. Lomax, focused on the teachings and beliefs

fig. 50
News Beat
(The Hate That Hate Produced)
1959
(Mike Wallace)

of the Nation of Islam, its role in the African-American community, and Malcolm's emergence as one of its most influential leaders.

Billed as a "study of the rise of black racism, of a call for black supremacy among a small but growing segment of the American Negro population," *The Hate That Hate Produced* excoriated the Black Muslims. Asserting that they espoused a "gospel of hate that would set off a federal investigation if it were preached by southern whites," Wallace assured viewers that the religion's militancy rendered it unacceptable to most "sober-minded Negroes." On one level, the program dispassionately documented the group's lifestyle, from its strict religious education and moral code to its consortium of Muslim-owned-and-operated businesses. On another, Wallace's commentary portrayed a demonic religion bent on violent rebellion and the ruthless denunciation of the white man. "Let no one underestimate the Muslims," he cautioned before one of many clips of Elijah Muhammad and Malcolm X and other Nation of Islam leaders professing that white people were the embodiment of evil.

Despite its decidedly negative tone, the program afforded Muslim leaders the opportunity to be seen and heard over the din of their media accusers, at a time when black political figures, even the most conservative, had little access to mainstream television. Lomax's extensive, thoughtful, and nonjudgmental interviews with Muslim leaders and sympathizers—especially the solicitous and telegenic Malcolm X—neutralized to some extent Wallace's sensationalistic commentary, counterbalancing it with forcefully delivered, meticulously crafted messages intended primarily for the ears of black viewers. Even Wallace could not ignore Malcolm's rhetorical genius: "He is a remarkable man," the journalist admitted in one of the segments, his praise affirmed by interviews with other black leaders, including the popular Harlem Congressman Adam Clayton Powell, Jr., who called the minister "a very brilliant man."

If Malcolm was a persuasive advocate for the Nation of Islam, his biography provided *News Beat* with a ready-made and compelling story—one that underscored for disaffected black viewers the moral fortitude and efficacy of the Muslim lifestyle. In his introduction to a lengthy excerpt of Lomax's dialogue with Malcolm, Wallace invokes his transformation from criminal to religious leader:

> A man who by his own admission was once a procurer and dope peddler, he served time for robbery in the Michigan and Massachusetts state penitentiaries. But now he is a changed man. He will not smoke or drink. He will not even eat in a restaurant that houses a tavern. He told *Newsbeat* that his life changed for him when the Muslim faith taught him no longer to be ashamed of being a black man.

The controversy surrounding *The Hate That Hate Produced* would also prove useful to the Nation of Islam. After the weeklong broadcast, *News Beat*

received numerous protest letters and phone calls, many condemning the program for giving free airtime to the dissident group. Ten days later, WNTA rebroadcast the series on a single evening, with "additional filmed sequences" that had been omitted from the earlier broadcast and a post-screening discussion among more accommodating black leaders, such as Jackie Robinson, who was now a columnist for the *New York Post*, and Roy Wilkins, executive secretary of the NAACP.[30] The media uproar, in the nation's most populous TV market, gave the religion higher visibility—regular news coverage, a flurry of television appearances for Malcolm X, and a segment on the Emmy Award–nominated documentary *Walk in My Shoes*, broadcast nationally on ABC's *Close Up!* in 1961. Such media appearances underscored the extent to which the right message efficiently and broadly communicated through the right outlet could reap enormous political dividends. The strategy helped build membership in the Nation of Islam from 500 in 1952 to 30,000 in 1963, and allowed its leaders to influence African-American public opinion for decades to come.

In 1969, the Chicano artist and activist Rupert Garcia designed a poster that brought full circle the question of the representation of people of color in the period of the modern civil rights movement (*pl. 29*). The work presents a Pop Art rendering of a grinning, dark-skinned cook, complete with white coat and red bowtie, serving up a bowl of hot soup. At first glance, the poster brings to mind mid-twentieth-century icons of black servitude, "empty vessels" such as Beulah and Aunt Jemima, into which, to quote Thulani Davis, "Americans, black and white, inserted their fantasies about black people."[31] If these characters hovered in the representational limbo between slavery and full equality in which African-Americans then found themselves, in Garcia's poster they are transformed into a symbol of defiance, self-determination, and resistance: the man wears a toque, an indication that he is a professional chef and not a domestic, and emblazoned below him are the words "No more o' this shit."

In the same year, the African-American artist Elizabeth Catlett published a lithograph, *Negro Es Bello II (Black Is Beautiful)*, that serves as a conceptual pendant to Garcia's poster (*pl. 30*). The lithograph juxtaposes two masklike faces with a grid of matching decals bearing the Black Panther logo and the words "Black is beautiful." In both words and images, it proclaims its resistance to a century and a half of white-identified popular culture designed to keep African-Americans in their place by insisting that they were not beautiful. The campaign for racial uplift through positive images—the "pride of race and lineage and self . . . for Life lit by some large vision of beauty and goodness and truth," as W. E. B. Du Bois described it in 1904—reached its apex sixty years later, when the slogan "Black is beautiful" became the rallying cry of a cultural movement committed to undoing the negative stereotypes that continued to imperil black self-esteem.[32] This crusade took many

forms, from the thriving market in goods related to black pride to the popularity of natural hairstyles meant to counter the notion that only "straight" hair, not "kinky," was attractive and desirable.[33]

The most powerful and sustained vehicle for black self-representation and celebration, however, did not require the cooperation of the media. Far from the stage sets of Hollywood and the advertising agencies of Madison Avenue—and even the boardroom of Johnson Publishing Company and the meeting halls of the Nation of Islam—a simple, ever-present device was stoking a quiet visual revolution: the snapshot camera. By taking pictures of themselves, African-Americans could participate in their own image-making and thus provide what a century of mainstream culture would not: the ongoing confirmation of their humanity, complexity, beauty, and cultural and intellectual authority. They were able to reap the advantages of a modern technology for seeing and recording reality that granted to individuals—rich or poor, of any race, in almost any context or location—the incontrovertible right to represent themselves (*pls. 31 and 32*).

If the question of "control over images" was for African-Americans, as the writer bell hooks observes, one of "equal access," the snapshot camera helped to alter the balance of power.[34] In 1888, George Eastman marketed the first Kodak camera, a relatively uncomplicated and inexpensive device. Over the next decade, Eastman Kodak, through aggressive advertising, sold 1.5 million units in the United States. In 1900, Kodak introduced the Brownie camera, which sold for just one dollar, an apparatus so stripped down and easy to use that it was at first marketed specifically to children. After World War I, when the rationing of film ended, and it was plentiful again, the use of personal cameras took off, and by World War II they were a ubiquitous and central part of American family life, black and white.

For African-Americans, snapshots were particularly indispensable—a pleasurable, inexpensive, and uncomplicated method for controlling self-representation and challenging stereotypes. The camera was also a political instrument: "Shot spontaneously, without any notion of remaking black bodies in the image of whiteness," writes hooks, "snapshots gave us a way to see ourselves, a sense of how we looked when we were not 'wearing the mask,' when we were not attempting to perfect the image for the white supremacist gaze."[35]

Snapshot photography offered Americans—black and white—the opportunity to "experiment with the ways [their] private and public selves might be planned and performed."[36] The rise of its popularity during the first half of the twentieth century coincided with the increasing importance of motion pictures, newsreels, and pictorial magazines in American life. The culture was becoming saturated with images of actors, politicians, and other celebrities—pictures that served as models and inspiration for everyday snapshots. "People were learning

by doing," writes the critic and curator Marvin Heiferman, "testing out facial expressions, postures, seductive looks and poses, and sometimes exaggerated gestures, all with the goal of mastering their distinctive snapshot personae and looks."[37]

This mastery was important for the average American, yet it was even more crucial for black people in search of pictures that could countermand a popular culture rife with racist imagery. If white Americans had models in media awash with obsequious portrayals of white fame, people of color often made pictures in opposition to their regressive characterization in the culture at large. The cultural mainstream offered a public view of black life that was eminently simplistic, stereotypical, and fragmentary, made for the consumption of and inevitably tempered by the racial anxieties of the nation's white majority. Their own snapshots allowed African-Americans to represent the full breadth and nuance of their private lives.

So consequential were these photographs that they became part of a greater strategy of image gathering and display. Even before the snapshot camera became a constant and vital element of African-American life, a national network of black studio photographers, often working in difficult economic and social circumstances, produced images that could, as Angela Davis writes, "expose and condemn the evolving visual mythology of racism"[38] Already in the late nineteenth century, before the widespread use of personal snapshots and home movie cameras, these studios were principal sources of local black imagery.[39]

In the early twentieth century, the Washington, D.C., studio of Addison Scurlock started to document and celebrate the local African-American community and record the rapid changes in an important black urban center (*fig. 51*). Commissioned by businesses, organizations, churches, families, and individuals, Scurlock and his colleagues captured weddings, baptisms, graduations, sporting events, protests, galas, store openings, and visits of dignitaries. But it was portraiture that solidified the studio's reputation as one of the nation's leading black establishments. Its subjects were both famous—Marian Anderson, Duke Ellington, Ralph Bunche, Mary McLeod Bethune and Muhammad Ali— and unknown. As the snapshot camera became widely used, black photo studios declined in the civil rights era, but they did not entirely disappear. Continued by his sons Robert and George, Scurlock's studio remained in business until the 1990s.

In many homes, pictures were juxtaposed in arrangements on walls or on mantels as "altars," studio portraits commemorating the dead, snapshots celebrating the history, activities, triumphs, and celebrations of family and community. These shrines were essential to the formation of a "sense of self and identity as a family"—documentation meant to affirm and augment oral memory,

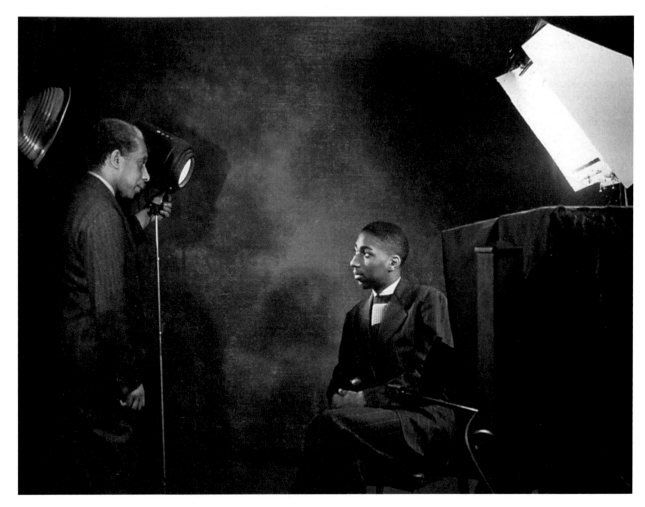

fig. 51
Addison N. Scurlock at work
making a portrait in his studio,
900 U St. N.W., Washington, D.C.
ca. 1957
Scurlock Studio Records,
Archive Center,
National Museum of American
History, Smithsonian Institution

like maps guiding a people "through diverse journeys."[40] Bell hooks observes about
her own childhood experiences:

> We would stand before the walls of images and learn the impor-
> tance of the arrangement, why a certain photo was placed here
> and not there. The walls were fundamentally different from photo
> albums. Rather than shutting images away, where they could be
> seen only by request, the walls were a public announcement of
> the primacy of the image, the joy of image making. To enter black
> homes in my childhood was to enter a world that valued the visual,
> that asserted our collective will to participate in a non-institution-
> alized curatorial process.[41]

Memories like this illustrate what a decisive role pictures played in the lives of
African-Americans. Whether it was the photographer Ernest Withers recording for
posterity the tragedy of Emmett Till's murder; the editors of the *Crisis, Life, Look,* or
Ebony publishing pictures of black achievers; Dr. King or Malcolm X relying on the
evidentiary power of photographs or television news footage to convey deeper, more
troubling truths about bigotry; or an African-American parent taking snapshots at a

child's graduation, the modern struggle for racial justice esteemed the inspirational and persuasive authority of pictures.

In this light, the word *modern* in the phrase "modern civil rights movement" denotes more than a historical era. The movement's pictorial orientation suggests the degree to which it capitalized on the "modernist visual revolution"—the ongoing transformation in the nature of seeing and recording reality that began in the nineteenth century and had come to define contemporary life at the dawn of the twentieth.[42] From increasingly fast and economical printing methods to the invention of the still, motion picture, and television cameras, new technologies radically altered people's expectations about and interaction with pictures. Innovations helped to engender a supremely visual society defined and shaped by the rapid proliferation of and public hunger for mechanically reproduced images. Through this succession of technological developments, the sanctity of written language gave way to the dominance of the image: the evidentiary weight of photography transcended that of the printed word, film supplanted the novel as the dominant storytelling medium; and television replaced newspapers and magazines as the most trusted venue for news and information.[43]

The modern struggle for racial justice and equality, more than any other American political cause before it, adopted this cultural transformation, learning from it and adapting its lessons to a life-or-death crusade. As the civil rights leader Roger Wilkins noted, years after the movement had ended, the "greatest power" for African-Americans during the era "turned out to be what it had always been: the power to define reality where blacks are concerned."[44] Visual culture would be indispensable in this endeavor, helping define an alternative reality compelling enough to shock a nation out of its denial and inspire an oppressed people to overcome the limitations that society had imposed on them.

Sometimes this reality played out on a vast national stage. The startling footage of southern white aggression and black suffering galvanized the country night after night on television screens. Sometimes it appeared on the pages of Negro newspapers and magazines—images of strivers and achievers and martyrs, rousing pride or activism in the African-American community. Sometimes it was evident in a humble snapshot, no less powerful in its ability to edify and motivate. In each case, this reality was constructed not out of brick or flesh or words but out of pictures—millions of points of light, millions of potent weapons that forever changed a nation.

ACKNOWLEDGMENTS

This volume is indebted to the pioneering work of the following colleagues in race studies, literary criticism, and art and cultural history, most of whom are also friends: Christine Acham, Courtney Baker, Donald Bogle, Manthia Diawara, Mary L. Dudziak, Glenn T. Eskew, Colette Gaiter, Ann Eden Gibson, Vicki Goldberg, Thelma Golden, Jennifer A. González, Michael D. Harris, bell hooks, Steven Kasher, Wayne Koestenbaum, Rosalind E. Krauss, Aldon D. Morris, Toni Morrison, Maria Phillips, Richard Powell, Marlon Riggs, Irving Sandler, Allan Sekula, Lowery Stokes Sims, Susan Sontag, Maren Stange, Brian Wallis, and Cornel West. Additionally, I have called upon a remarkable group of consultants, who have served as readers of this book or as advisors for the project as a whole: Elizabeth Alexander, Emily Bernard, Carrie Bickner, Lonnie G. Bunch III, Merry Foresta, Henry Louis Gates, Jr., Diane M. Lee, Kriste Lindenmeyer, David Roediger, Jacqueline Serwer, Michele Wallace, and Deborah Willis. My friend Thulani Davis provided the brilliant foreword to this book as well as generous and immensely perceptive commentary on the manuscript.

The Center for Art, Design and Visual Culture, University of Maryland Baltimore County, co-organizing institution of this project, of which this book is a part, has been my academic home for the past eighteen years. David Yager, formerly its Executive Director and now Dean of Arts at the University of California Santa Cruz, has been a good friend and wise advisor as well as a tireless supporter of *For All the World to See*. Director Symmes Gardner supervised the project with magnanimity and good spirit, advocating for it both within and outside of the university. Project Coordinator and Registrar Sandra Abbott rigorously followed through on all aspects of its organization with dedication and grace. Business Manager Janet Magruder vigilantly attended to its myriad financial details. William John Tudor prepared the exhibition for travel and provided an exceptional design for its Baltimore venue. Staff members Melanie Feaster, Natalia Panfile, and Renée van der Stelt made important contributions along the way. The outstanding work of my research assistant, Graca McKenney, was marked at every turn by her keen intelligence, creativity, cheerful spirit, and resourcefulness.

I am honored to have as the institutional partner for this project the National Museum of African American History and Culture, Smithsonian Institution. Its Director, Lonnie G. Bunch III, generously embraced the project from its inception, providing ongoing support and guidance. I have been most fortunate to work with another friend, NMAAHC Chief Curator Jacquelyn D. Serwer, on all aspects of the project's planning, content, and organization. I would also like to thank the following for their significant input: Kinshasha Holman Conwill, Deputy Director; Rex M. Ellis, Associate Director for Curatorial Affairs; Michèle Gates Moresi, Curator of Collections; Paul Gardullo, Museum Curator; Lynn F. Chase, Project Manager; and Esther J. Washington, Director of Education.

Generous foundational support went far in making this project possible, including grants from the National Endowment for the Humanities, the Trellis Fund, the National Endowment for the Arts, Communities Foundation of Texas, Inc., St. Paul Travelers Corporation, Maryland State Arts Council, and the Baltimore County Commission on Arts and Sciences. Clay Lewis, Senior Program Officer at the NEH, was particularly helpful in his meticulous and insightful reading of our successful Planning and Implementation grant applications. Betsy Karel, Chairperson of the Board of Directors of the Trellis Fund, played an early and decisive role in supporting this project. CBS News Archives, Ed Sullivan/ SOFA Entertainment, and the Sullmark Corporation provided additional support, in the form of research footage and film stills for this book as well as clips for the exhibition. At CBS News, I would especially like to thank Linda Mason, Senior Vice President of Public Affairs; Daniel DiPierro, Executive Director of the CBS News Archives; and Ann M. Fotiades, Sales Manager of the archives.

A project of this magnitude would not have been possible without the encouragement and support of the following friends and family: Joanne Leonhardt Cassullo, Katherine Dieckmann and Brian Wallis, Melanie Falk, Ronald and Frayda Feldman, Alvin Hall, Willis Hartshorn and Patricia Martin, Brian Heiferman and Helen Treloar, Ronald Heiferman and Judy Miller, Barbara Kruger, Barbara Buhler Lynes, Steve Miller, Elizabeth Sacre, Amy Schewel, Marilyn Schmertzler, Shirley Verrett and Louis LoMonaco, Michele Wallace, and Patricia J. Williams. I am grateful to Mason Klein for offering incisive ideas about this project as well as for his friendship and vigilant support over the past thirty years. Therese Lichtenstein, in daily conversations, has served unfailingly as sensitive and encouraging friend and wise counsel.

I greatly appreciate the support of my agent Faith Childs, whose brilliance as advocate for and reader of my work went far in making *For All the World to See* possible. My editor at Yale University Press, Christopher Rogers, has been an unwavering and sage champion of this project, almost from its inception. Also at Yale University Press, Laura Davulis, associate editor, offered important guidance in the preparation of the manuscript and the accompanying illustrations; Jenya Weinreb, managing editor, handled all aspects of the book's production with rigor, intelligence, and grace. Editor Anna Jardine once again demonstrated her thoroughness, brilliance, and extraordinary ear for language. Charlotte Carter, managing editor at CADVC, meticulously shepherded the editorial process from

start to finish. My friend Michael Sittenfeld offered wise editorial guidance. Franc Nunoo-Quarcoo and Emily Sara Wilson created a brilliant—indeed breathtaking—design for this volume. My dialogue with Franc over the past fifteen years, often in relationship to the ten books we have completed together, has been edifying and generative.

My spouse, Marvin Heiferman, has been there in every way. His magnanimity, patience, love, and wisdom have sustained me in this project as they do in our life together.

Finally, I would like to acknowledge the debt of this nation to the brave men and women who fought for racial justice and equality in the period of the modern civil rights movement. It is to them that this book is dedicated.

Maurice Berger

NOTES

INTRODUCTION

1 Richard Wright, 12 *Million Black Voices* (New York: Viking, 1941), 124.

2 Gordon Parks, *A Choice of Weapons* (New York: Harper & Row, 1966), 45.

3 Ibid.

4 Ibid., 178.

5 Ibid., 230.

6 bell hooks, "In Our Glory: Photography and Black Life," in Deborah Willis, ed., *Picturing Us: African American Identity in Photography* (New York: New Press, 1994), 46.

7 For an early and important attempt to examine the relationship between visual images within the struggle for and against civil rights, see Mary L. Dudziak, *Cold War Civil Rights: Race and the Image of American Democracy* (Princeton, NJ, and Oxford: Princeton University Press, 2000).

8 Ralph Ellison, "Brave Words for a Startling Occasion" (January 27, 1953), in John F. Callahan, ed., *The Collected Essays of Ralph Ellison* (New York: Modern Library, 1995), 151.

9 Frederick R. Karl, "The Fifties and After: An Ambiguous Culture," in Josephine G. Hendin, ed., *A Concise Companion to Postwar American Literature and Culture* (Malden, MA: Blackwell, 2004), 40.

10 Wyatt Walker, as quoted in Aldon D. Morris, "A Man Prepared for the Times: A Sociological Analysis of the Leadership of Martin Luther King, Jr.," in Peter J. Albert and Ronald Hoffman, eds., *We Shall Overcome: Martin Luther King, Jr., and the Black Freedom Struggle* (New York: Pantheon, 1990), 53.

11 Susan Sontag, *Regarding the Pain of Others* (New York: Farrar, Straus and Giroux, 2003), 26.

IT KEEPS ON ROLLIN' ALONG

1 The first screen version of *Show Boat*, a silent movie, opened in 1929.

2 Richard Wright, *12 Million Black Voices* (New York: Viking, 1941), 11.

3 Paul Robeson, as quoted in Hazel V. Carby, *Race Men* (Cambridge, MA, and London: Harvard University Press, 1998), 80.

4 W. E. B. Du Bois, "As the Crow Flies," *Amsterdam News* (October 11, 1941); repr. in Herbert Aptheker, ed., *Newspaper Columns by W. E. B. Du Bois*, vol. 1 (White Plains, NY: Kraus-Thompson, 1986), 389.

5 Robert M. Entman and Andrew Rojecki, *The Black Image in the White Mind: Media and Race in America* (Chicago and London: University of Chicago Press, 2001), 1–4.

6 For an analysis of how these prototypes operate, see ibid., 60–62.

7 Walter Camp, as quoted in "Top College Football Players of All Time: No. 85—Paul Robeson," www.collegefootballnews.com.

8 Sterling Stuckey, "Paul Robeson Revisited," *New York Times Book Review*, October 21, 1973, 13.

9 Calvin C. Hernton, "And You, Too, Sidney Poitier!" in *White Papers for White Americans* (New York: Doubleday, 1966); repr. in *Reporting Civil Rights*, part 2: *American Journalism, 1963–1973* (New York: Library of America, 2003), 466.

10 Carby, *Race Men*, 83.

11 For more on Brown's analysis, which first appeared in his pioneering essay "Negro Character as Seen by White Authors" (1933), see Henry Louis Gates, Jr., "The Face and Voice of Blackness," in Maurice Berger, ed., *Modern Art and Society: An Anthology of Social and Multicultural Readings* (New York: HarperCollins, 1994), 51–52.

12 Sidney Poitier, as quoted in Aram Goudsouzian, *Sidney: Man, Actor, Icon* (Chapel Hill and London: University of North Carolina Press, 2004), 179.

13 Entman and Rojecki, *The Black Image in the White Mind*, 3.

14 Donald Bogle, "Black Beginnings: From *Uncle Tom's Cabin* to *The Birth of a Nation*," in Valerie Smith, ed., *Representing Blackness: Issues in Film and Video* (New Brunswick, NJ: Rutgers University Press, 1997), 14.

15 Elizabeth Shepley Sergeant, "The Man with His Home in a Rock: Paul Robeson," *New Republic*, March 3, 1926, 40.

16 Tore Hallonquist, "What We Have Learned About Documentary and Educational Programs" (CBS Research Department, Program Analysis Division, 1957), as quoted in Michael Curtin, *Redeeming the Wasteland: Television Documentary and Cold War Politics* (New Brunswick, NJ: Rutgers University Press, 1995), 227.

17 For more on the issue of "double consciousness," see W. E. B. Du Bois, *The Souls of Black Folk* (New York: New American Library, 1969), 45–48.

18 Hernton, "And You, Too, Sidney Poitier!" 470.

19 The film historian Ed Guerrero has written of the irrational and contradictory feelings that stoked white people's fascination with and trepidation toward black men, a "love-hate obsession" that for decades insinuated itself into commercial films. See Guerrero, "The Black Man on Our Screens and the Empty Space in Representation," in Thelma Golden, ed., *Black Male: Representations of Masculinity in Contemporary Art* (New York: Whitney Museum of American Art, 1994), 181. In his essay, Guerrero argues that many of these conceits in film continued into the 1990s.

20 Hernton, "And You, Too, Sidney Poitier!" 470. For more on this issue, see Sander Gilman, "Black Bodies, White Bodies: Toward an Iconography of Female Sexuality in Late Nineteenth-Century Art,

Medicine, and Literature," *Critical Inquiry* 12, no. 1 (Autumn 1985), 204–42.

21 Hernton, "And You, Too, Sidney Poitier!" 475.

22 Hattie McDaniel, the first black actor to win an Academy Award, was the star of the *Beulah* radio show. She appeared as Beulah in the first six episodes of the television program's third season, but was forced to leave after suffering a heart attack and a stroke. McDaniel died in 1952 at age fifty-seven. Her episodes of *Beulah* were broadcast only after the show went into syndication.

23 The cast of *The Beulah Show* included William Post, Jr., as Harry Henderson; Ginger Jones (1950–52) and June Frazee (1952–53) as Alice; Clifford Sales (1950–52) and Stuffy Singer (1952–53) as Donnie; Percy Harris (1950–51), Dooley Wilson (1951–52), and Ernest Whitman (1952–53) as Bill Jackson; and Butterfly McQueen (1950–52) and Ruby Dandridge (1952–53) as Oriole.

24 Gerald R. Butters, Jr., "Nobody Asks Me the Questions: *Beulah* and the Moynihan Report," *Cercles* 8 (2003), 38.

25 "Resolutions from the 1951 National Convention of the N.A.A.C.P.," *Crisis* 58 (August/September 1951), 478–79.

26 For more on *Julia*, see *Guess Who's Coming to Dinner: Broadcasting Race* in this volume.

27 Audrey Shuey, Nancy King, and Barbara Griffith, "Stereotyping of Negroes and Whites: An Analysis of Magazine Pictures," *Public Opinion Quarterly*, Summer 1953, 281–87. Fifteen years later, in 1968, the study was duplicated: While black adults were present in only two percent of the ads analyzed, more than fifty-five percent of them were shown as entertainers, sportsmen, students, clerics, businessmen, and other

professionals. See Keith Cox, "Changes in the Stereotyping of Negroes and Whites in Magazine Advertisements," *Public Opinion Quarterly*, Winter 1969–70, 603–6.

28 Entman and Rojecki, *The Black Image in the White Mind*, 162. Although the quotation refers to television commercials, it is equally applicable to print ads.

29 For more on Pepsi's relatively early outreach to the "Negro market," see Stephanie Capparell, *The Real Pepsi Challenge: The Inspirational Story of Breaking the Color Barrier in American Business* (New York: Wall Street Journal Books/Free Press, 2007).

30 For more on this, see Shuey et al., "Stereotyping of Negroes and Whites," 281–87; Cox, "Changes in the Stereotyping of Negroes and Whites in Magazine Advertisements," 603–6; Carl E. Block, "White Backlash to Negro Ads: Fact or Fantasy," *Journalism Quarterly* 49, no. 2 (Summer 1972), 258–62; James D. Culley and Rex Barnett, "Selling Blacks, Selling Women," *Journal of Communication* 26, no. 4 (Autumn 1976), 160–74; and Philip H. Dougherty, "Frequency of Blacks in TV Ads," *New York Times*, May 27, 1982, D19.

31 Nat King Cole, as quoted in Anita Gates, "The Story of a King Who Wasn't Always Treated Like Royalty," *New York Times*, May 17, 2006, E8.

32 Whitney M. Young, Jr., as quoted in Philip H. Dougherty, "The Negro Makes a Start in Commercials," *New York Times*, October 13, 1968, F16.

33 Michael D. Harris, *Colored Pictures: Race and Visual Representation* (Chapel Hill and London: University of North Carolina Press, 2003), 92.

34 Elizabeth O'Leary, *At Beck and Call: The Representation of Domestic*

Servants in Nineteenth-Century American Painting (Washington, DC: Smithsonian Institution Press, 1996), 5.

35 W. E. B. Du Bois, *Black Reconstruction in America* (New York: Russell & Russell, 1962), 700. For more on this, see Maurice Berger, *White Lies: Race and the Myths of Whiteness* (New York: Farrar, Straus & Giroux, 1999), 164–68.

36 Harris, *Colored Pictures*, 84.

37 For a detailed account of the origins and evolution of the Aunt Jemima trademark, see ibid., 81–106.

38 Grace Elizabeth Hale, "'For Colored' and 'For White': Segregating Consumption in the South," in Jane Dailey et al., eds., *Jumpin' Jim Crow: Southern Politics from Civil War to Civil Rights* (Princeton, NJ: Princeton University Press, 2000), 166.

39 Harris, *Colored Pictures*, 84.

40 Ibid., 88.

41 The paragraphs on Aunt Jemima are indebted to Michael Harris's outstanding analysis, ibid., 81–106. For another important discussion, see Maurice Manring, *Slave in a Box: The Strange Career of Aunt Jemima* (Charlottesville: University Press of Virginia, 1998).

42 B. A. Botkin, ed., *Lay My Burden Down: A Folk History of Slavery* (New York: Delta, 1989), 143.

43 See, for example, Mike Thelwell, "Fish Are Jumping an' the Cotton Is High: Notes from the Mississippi Delta," *Massachusetts Review* (Spring 1966); repr. in *Reporting Civil Rights*, part 2: *American Journalism, 1963–1973*, 477.

44 Botkin, *Lay My Burden Down*, 143.

45 Ibid.

46 The African-American poet and critic Melvin B. Tolson, in an early and important essay on *Gone With the Wind*, argued that the film was a thinly veiled apology for southern racism and the Ku Klux Klan. See "*Gone With the Wind* Is More Dangerous

than *Birth of a Nation*," in Robert M. Farnsworth, ed., *Caviar and Cabbage: Selected Columns by Melvin B. Tolson from the* Washington Tribune. *1937–1944* (Columbia: University of Missouri Press, 1982); repr. in Phillip Lopate, ed., *American Movie Critics: An Anthology from the Silents Until Now* (New York: Library of America, 2006), 140–43.

47 For a discussion of the role of minstrelsy in American culture, see W. T. Lhamon, Jr., *Raising Cain: Blackface Performance from Jim Crow to Hip Hop* (Cambridge, MA, and London: Harvard University Press, 1998).

48 For an important discussion of this signage, see Elizabeth Abel, "American Graffiti: The Social Life of Segregation Signs," *African American Review* 42, no. 1 (Spring 2008), 20–35.

49 Hale, "'For Colored' and 'For White,'" 177.

50 Mary L. Dudziak, *Cold War Civil Rights: Race and the Image of American Democracy* (Princeton, NJ, and Oxford: Princeton University Press, 2000), 49. My reading of *The Negro in American Life* is indebted to Dudziak's text.

51 Dudziak observes: "By setting forth the history of the evil slave past, and contrasting past with present, the pamphlet asked the reader to marvel at the progress that had been made. The reader was asked not to view American race relations in isolation. Rather, 'it is against this background that the progress which the Negro has made and the steps still needed for the full solution of his problems must be measured.' With the shameful past as a benchmark, race relations in the early 1950s could certainly be seen as an improvement." See ibid., 50.

52 Ralph Ellison, "Introduction" (1982), *Invisible Man* (New York: Vintage, 1995), xv.

THE NEW "NEW NEGRO"

1 Bilbo advocated the deportation to Africa of American blacks and openly praised Adolf Hitler on the floor of the Senate.

2 "*Song of the South* Picketed, Line at the Palace Protests Disney Portrayal of Negro," *New York Times*, December 14, 1946, 18.

3 Karl F. Cohen, *Forbidden Animation: Censored Cartoons and Blacklisted Animators in America* (Jefferson, NC, and London: McFarland, 1997), 61.

4 Adam Clayton Powell, Jr., as quoted in Steven Watts, *The Magic Kingdom: Walt Disney and the American Way of Life* (New York and Boston: Houghton Mifflin, 1997), 276–77.

5 "Needed: A Negro Legion of Decency," *Ebony*, February 1947, 36.

6 Walter White, NAACP press release, November 27, 1946, as quoted in Cohen, *Forbidden Animation*, 60–61.

7 White became aware of the project in 1944, reading about it in an article by Hedda Hopper, one of Hollywood's most revered gossip columnists.

8 Walter White, telegram to *Parents*, January 9, 1947, as quoted in Cohen, *Forbidden Animation*, 66.

9 In addition to the activities of the NAACP, newspapers routinely covered the local demonstrations of unaffiliated groups.

10 Such positive messages, if they were intended at all, would hardly have been appealing to Harris's adoring southern white readers, long accustomed to primitive and animalistic stereotypes of black people.

11 James Snead, *White Screens, Black Images: Hollywood from the Dark Side* (New York and London: Routledge, 1994), 86.

12 For more on this process, see Cohen, *Forbidden Animation*, 62–66, and Watts, *The Magic Kingdom*, 277–80.

13 Bosley Crowther, "Spanking Disney," *New York Times*, December 8, 1946, 85.

14 For a critical reading of these campaigns as censorious, see Donald Liebenson, "Should 'Dated' Films See the Light of Day," *Los Angeles Times*, May 7, 2003, E4.

15 "White Regrets Film," *New York Times*, November 28, 1946, 45.

16 Woodrow Wilson, as quoted in Milton Kleg, *Hate, Prejudice and Racism* (Albany: State University of New York Press, 1993), 19.

17 B. Joyce Ross, *J. E. Spingarn and the Rise of the NAACP, 1911–1939* (New York: Atheneum, 1972), 38.

18 As quoted in "NAACP v. 'The Birth of a Nation,'" *Crisis* 72, no. 2 (February 1965), 96.

19 Ibid.

20 Walter White, as quoted in Jill Watts, *Hattie McDaniel: Black Ambition, White Hollywood* (New York: HarperCollins, 2005), 244. White's idea originated in a 1937 article in the *Crisis* by Edgar Dale, a professor of education at Ohio State University, which argued that stereotyping was a "powerful 'monopoly' of the media that could be best challenged by an African-American agency modeled on the Jewish Anti-Defamation League." For more on the Hollywood Bureau, see Thomas Cripps, "'Walter's Thing': The NAACP's Hollywood Bureau of 1946—A Cautionary Tale," *Journal of Popular Film and Television*, Summer 2005, 116–25.

21 For more on *Beulah*, see *It Keeps On Rollin' Along: The Status Quo* in this volume. *Amos 'n Andy*, replete with black dialect and degrading plots, resonated with vulgar black character types— a dim-witted Uncle Tom; a crooked, scheming businessman; a dithering, listless janitor; and a nosy, loud-mouthed Mama.

22 After its final release in 1986, Disney essentially banned the film in the United States, prohibiting its distribution in theaters or as a home movie. The embargo continues today.

23 For more on this, see Cohen, *Forbidden Animation*, 68–69.

24 Donald Bogle, *Toms, Coons, Mulattoes, Mammies & Bucks* (New York: Continuum, 1993), 136. Bogle's pioneering book was first published in 1973.

25 Production Code Administration memo to Disney, August 1, 1944, as quoted in Cohen, *Forbidden Animation*, 65.

26 Production Code Administration memo to Disney, December 13, 1944, as quoted in Cohen, *Forbidden Animation*, 65.

27 Lena Horne, as quoted in Clayton R. Koppes and Gregory D. Black, "Blacks, Loyalty, and Motion-Picture Propaganda in World War II," *Journal of American History* 73, no. 2 (September 1986), 392.

28 Disney Studio press office, as quoted in an article in *People's Voice*, January 25, 1945, and reprinted in Cohen, *Forbidden Animation*, 65.

29 Organizers planned to sell five million of the coins at one dollar each to raise money to build the monument and its park. Sales were tepid, however. While the U.S. Mint struck more than three million pieces over five years, it eventually melted more than half of these coins.

30 Du Bois argued that Washington's view of education was "acquiescence in second-class citizenship on the part of the Negro people in return for white support of vocational education and assurance of more or less menial employment." See W. E. B. Du Bois, *The Autobiography of W. E. B. Du Bois: A Soliloquy on Viewing My Life from the Last Decade of Its First Century*

(New York: International, 1968), 428.

31 For more on the Carver–Washington coin, see R. S. Yeoman, *A Guide Book of United States Coins* (Racine, WI: Golden Books, 1997), 229.

32 Moses Fleetwood "Fleet" Walker is credited with being the first African-American to play professional baseball at the major-league level, making his debut in May 1884. His career in the majors ended within a year, after an injury. Jimmy Claxton was the first black player to appear on a baseball card and the first African-American in professional baseball in the twentieth century. He pitched in two games for the Oakland Oaks of the Pacific Coast League in 1916. At the time, he was thought to be American Indian; he was released after his race was discovered. He later played in the Negro leagues.

33 Michael Oriard, *King Football: Sport and Spectacle in the Golden Age of Radio and Newsreels, Movies, and Magazines and the Weekly and Daily Press* (Chapel Hill and London: University of North Carolina Press, 2001), 317.

34 Sarah Palfrey, "Preview: Forest Hills—Althea Gibson," *Sports Illustrated*, September 2, 1957, 28.

35 Patrick B. Miller and David K. Wiggins, "Introduction," in Miller and Wiggins, eds., *Sport and the Color Line: Black Athletes and Race Relations in Twentieth-Century America* (New York and London: Routledge, 2004), x.

36 Editorial, *Cleveland Plain Dealer*, August 22, 1948, 17.

37 John Hoberman, *Darwin's Athletes: How Sport Has Damaged Black America and Preserved the Myth of Race* (New York: Mariner Books/Houghton Mifflin, 1997), 30.

38 Jack Olsen, "Pride and Prejudice," *Sports Illustrated*, July 1, 1968, as quoted in ibid.

39 Eldridge Cleaver, *Soul on Ice*

(New York: McGraw-Hill, 1967), 92.

40 Cassius Clay, as quoted in "The Dream," *Time*, March 22, 1963, 79.

41 For more on the boxer's early political passion, see Muhammad Ali with Richard Durham, *The Greatest: My Own Story* (New York: Random House, 1975), 32–36.

42 "The Dream," 78.

43 Ibid., 79.

44 Miller and Wiggins, "Introduction," xi.

45 Ibid.

46 For more on this, see Bill L. Weaver, "The Black Press and the Assault on Professional Baseball's 'Color Line,' October 1945–April 1947," *Phylon* 40, no. 4 (Fourth Quarter, 1979), 303–17.

47 Editorial, *Pittsburgh Courier*, November 29, 1945, as quoted in ibid., 307.

48 Aldon D. Morris, *The Origins of the Civil Rights Movement: Black Communities Organizing for Change* (New York: Free Press, 1984), xii.

49 Ibid., 5.

50 Ibid.

51 Ibid., 13.

52 For more on the "Double V" campaign and its effect on professional sports and the African-American media, see Weaver, "The Black Press and the Assault on Professional Baseball's 'Color Line,'" 304–5.

53 W. E. B. Du Bois, "A Proposed Negro Journal," unpublished essay (1905), as quoted in Anne Elizabeth Carroll, *Word, Image, and the New Negro: Representation and Identity in the Harlem Renaissance* (Bloomington and Indianapolis: Indiana University Press, 2005), 22.

54 Du Bois remained editor of the *Crisis* until 1934, when he resigned from the NAACP, because he was unwilling to advocate racial integration in all aspects of life, a position adopted by the organization.

55 W. E. B. Du Bois, "Opinion," *Crisis* 1, no. 1 (November 1910), 7.

56 The magazine made this announcement in an advertisement in its fourth issue. For more on the vital role of illustrations in the *Crisis*, see Carroll, *Word, Image, and the New Negro*, 15–54.

57 For more on the interrelationship of these two types of images and stories, see Carroll's perceptive analysis, ibid., 15ff.

58 W. E. B. Du Bois, "Editing *The Crisis*," *Crisis* 58 (March 1951); repr. in Sondra Kathryn Wilson, ed., *The Crisis Reader: Stories, Poetry, and Essays from the N.A.A.C.P.'s Crisis Magazine* (New York: Modern Library, 1999), xxviii.

59 "Harlem on Our Minds," *Critical Inquiry* 24, no. 1 (Autumn 1997), 10.

60 Carroll, *Word, Image, and the New Negro*, 16.

61 Ibid.

62 W. E. B. Du Bois, *Dusk of Dawn: An Essay Toward an Autobiography of a Race Concept* (New Brunswick, NJ, and London: Transaction, 1984), 271. This book was originally published in 1940.

63 Du Bois, "Editing *The Crisis*," xxix.

64 John H. Johnson, as quoted in Gene N. Landrum, *Profiles of Black Success: Thirteen Creative Geniuses Who Changed the World* (Amherst, NY: Prometheus, 1997), 203.

65 James C. Hall, "On Sale at Your Favorite Newsstand: *Negro Digest / Black World* and the 1960s," in Todd Vogel, ed., *The Black Press: New Literary and Historical Essays* (New Brunswick, NJ, and London: Rutgers University Press, 2001), 196.

66 The editors and publisher of *Negro Digest* eventually supported a harder editorial line. The *Digest* went on hiatus in 1951, returning a decade later, in June 1961. By the mid-1960s, the magazine emerged as an important critic of American racism, supporting the writing of many outspoken black writers. In May 1970,

the *Digest* underwent yet another metamorphosis, changing its name to *Black World* and aligning itself with the Black Power movement. The magazine was discontinued in 1976. For more on the political aspirations of *Negro Digest / Black World*, see ibid., 192–99.

67 John H. Johnson with Lerone Bennett, Jr., *Succeeding Against the Odds: The Inspiring Autobiography of One of America's Wealthiest Entrepreneurs* (New York: Warner Books, 1989), 156.

68 Ibid.

69 John H. Johnson, as quoted in "Remembering John H. Johnson, 1918–2005," *Jet*, August 29, 2005, 12.

70 Ibid.

71 Landrum, *Profiles of Black Success*, 209.

72 "Backstage," *Ebony* (November 1945), as quoted in Maren Stange, "Photographs Taken in Everyday Life: *Ebony*'s Photojournalistic Discourse," in Vogel, *The Black Press*, 207.

73 Hall, "On Sale at Your Favorite Newsstand," 194.

74 For a cogent analysis of *Ebony*'s visual strategies, see Stange, "Photographs Taken in Everyday Life," 207–27.

75 Earl Graves, Sr., as quoted in "Remembering John H. Johnson, 1918–2005," 12.

76 Johnson, as quoted in ibid.

77 By 1960, ten percent of African-Americans were middle class. By contrast, twenty percent of the total white population was middle class by 1920. For more on the emergence of the black middle class, see Mary Pattillo-McCoy, *Black Picket Fences: Privilege and Peril Among the Black Middle Class* (Chicago and London: University of Chicago Press, 1999), 17–25.

78 Henry Louis Gates, Jr., *Colored People: A Memoir* (New York: Vintage, 1995), 19, 23.

79 Stange, "Photographs Taken in Everyday Life," 216.

80 For more on *Life*'s racial attitudes, see ibid., 215–20.

81 Kenneth Clark, as quoted in David Faigman, *Laboratory of Justice: The Supreme Court's 200-Year History to Integrate Science and the Law* (New York: Times Books, 2004), 179. Clark reported that black children, as a result of their experience with discrimination, segregation, and stereotypes, routinely suffered from poor self-esteem, feelings of inferiority, confused self-image, hostility, and resentment.

82 bell hooks, "In Our Glory: Photography and Black Life," in Deborah Willis, ed., *Picturing Us: African-American Identity in Photography* (New York: New Press, 1994), 46.

83 Roger Wilkins, "White Out," *Mother Jones* (November 1992); repr. in Richard Delgado and Jean Stefanic, eds., *Critical White Studies: Looking Beyond the Mirror* (Philadelphia: Temple University Press, 1997), 659–60.

84 Susan Sontag, *Regarding the Pain of Others* (New York: Farrar, Straus & Giroux, 2003), 21–22.

85 Vicki Goldberg, *The Power of Photography: How Photographs Changed Our Lives* (New York: Abbeville, 1991), 34.

86 Jean Prouvost, *Paris-Soir*, May 2, 1931, as quoted in ibid.

87 Walter Lippmann, *Public Opinion* (New York: Macmillan, 1922), 92.

88 Johnson with Bennett, *Succeeding Against the Odds*, 156.

89 The Old Taylor commission was based on a project begun by Hardison in 1963, a series of bronze portrait busts titled *Negro Giants in History*.

"LET THE WORLD SEE WHAT I'VE SEEN"

1 Mamie Till Bradley, as quoted in Stephen J. Whitfield, *A Death in the Delta: The Story of Emmett Till* (New York: Free Press, 1988), 40.

2 Mamie Till Bradley, as quoted in Clenora Frances

Hudson, *Emmett Till: The Impetus for the Modern Civil Rights Movement* (Ann Arbor, MI: UMI, 1993; Ph.D. dissertation, University of Iowa, 1988), 300.

3 Mamie Till Bradley, as quoted in Clenora Hudson-Weems, *Emmett Till: The Sacrificial Lamb of the Civil Rights Movement* (Troy, MI: Bedford, 1994), 302.

4 Mamie Till-Mobley and Christopher Benson, *Death of Innocence: The Story of the Hate Crime That Changed America* (New York: Random House, 2003), 142.

5 Courtney Baker, "Emmett Till, Justice, and the Task of Recognition," *Journal of American Culture* 29, no. 2 (June 2006), 113.

6 Till-Mobley and Benson, *Death of Innocence*, 139.

7 Baker, "Emmett Till, Justice, and the Task of Recognition," 113.

8 Mamie Till Bradley, speech at NAACP rally, Cleveland, September 18, 1955, as quoted in Jacqueline Goldsby, "The High and Low Tech of It: The Meaning of the Lynching and Death of Emmett Till," *Yale Journal of Criticism* 9, no. 2 (1996), 245.

9 Till-Mobley and Benson, *Death of Innocence*, 139.

10 John H. Johnson with Lerone Bennett, Jr., *Succeeding Against the Odds: The Inspiring Autobiography of One of America's Wealthiest Entrepreneurs* (New York: Warner Books, 1989), 240.

11 Baker, "Emmett Till, Justice, and the Task of Recognition," 118.

12 Till-Mobley and Benson, *Death of Innocence*, 142.

13 Ibid.

14 Vicki Goldberg, *The Power of Photography: How Photographs Changed Our Lives* (New York: Abbeville, 1991), 61.

15 Ibid., 34.

16 Ibid., 19.

17 See Shaila Dewan, "How Photos Became Icons of the Civil Rights Movement," *New York Times*, August 28, 2005, A12.

18 First quotation: Charles Diggs, as quoted in Juan Williams, *Eyes on the Prize: America's Civil Rights Years, 1954–1965* (New York: Viking Penguin, 1987), 49; second quotation: Diggs, letter to Vicki Goldberg, March 28, 1990, as quoted in Goldberg, *The Power of Photography*, 202.

19 For more on this relationship, see Fredrick C. Harris, "It Takes a Tragedy to Arouse Them: Collective Memory and Collective Action During the Civil Rights Movement," *Social Movement Studies* 5, no. 1 (2006), 37–38; and Whitfield, A *Death in the Delta*, 87–91.

20 Clayborne Carson et al., eds., *The Papers of Martin Luther King, Jr.*, vol. 4 (Berkeley: University of California Press, 2000), 369.

21 Harris, "It Takes a Tragedy to Arouse Them," 24.

22 The other events were the Supreme Court decision in *Brown v. Board of Education*; the murder of three Mississippi civil rights workers (1964); the passage of the Civil Rights Act (1964); the killing of Viola Liuzzo (1965); the voting rights march in Selma, Alabama (1965); and the shooting of James Meredith (1966).

23 Harris, "It Takes a Tragedy to Arouse Them," 26.

24 Ibid., 32. For more on the long-lasting political effects of the Till case, see Clenora Hudson-Weems, "Resurrecting Emmett Till: The Catalyst of the Modern Civil Rights Movement," *Journal of Black Studies* 29, no. 2 (November 1998), 179–88.

25 Joyce Ladner, statement from the conference "We Shall Overcome: Recalling the Civil Rights Struggles of the '50s and '60s," Brookings National Issues Forum, January 11, 2000, as quoted in Harris, "It Takes a Tragedy to Arouse Them," 36.

26 Shelby Steele, "On Being Black and Middle Class," *Commentary* 85, no. 1 (January 1988), 45.

27 Muhammad Ali with Richard Durham, *The Greatest: My Own Story* (New York: Random House, 1975), 34–35.

28 For an early study of the role of African-American photographers in the struggle against racism and segregation, see Deborah Willis and Howard Dodson, *Black Photographers Bear Witness: One Hundred Years of Social Protest* (Williamstown, MA: Williams College Museum of Art, 1989).

29 For comprehensive discussions of civil rights photography, see Steven Kasher, *The Civil Rights Movement: A Photographic History, 1954–68* (New York: Abbeville, 1996); and Julian Cox, *Road to Freedom: Photographs of the Civil Rights Movement, 1956–1968* (Atlanta: High Museum of Art, 2008).

30 Kasher, *The Civil Rights Movement*, 16.

31 Mary King, as quoted in ibid., 16.

32 Kasher, *The Civil Rights Movement*, 16.

33 Ibid.

34 Ibid.

35 One exhibition—*US*, a project documenting African-American life— opened in 1967 at the Countee Cullen branch of the New York Public Library in Harlem.

36 Allan Sekula, "On the Invention of Photographic Meaning," in Victor Burgin, ed., *Thinking Photography* (London: Macmillan, 1982), 87.

37 Roland Barthes, *Mythologies*, trans. Annette Lavers (New York: Hill & Wang, 1957), 116.

38 Roland Barthes, *Camera Lucida: Reflections on Photography*, trans. Richard Howard (New York: Hill & Wang, 1981), 26.

39 The portfolio was sold at the march for one dollar, to help defray the event's cost.

40 Gene Roberts and Hank Klibanoff, *The Race Beat: The*

Press, the Civil Rights Struggle, and the Awakening of a Nation (New York: Alfred A. Knopf, 2006), 150.

41 Armistead Scott Pride, "The Negro Newspaper in the United States," *Gazette: International Journal of the Science of the Press* 2 (1956), 141–43, as quoted in ibid., 150.

42 Kasher, *The Civil Rights Movement*, 13.

43 Martin Luther King, Jr., as quoted in Aldon D. Morris, *The Origins of the Civil Rights Movement: Black Communities Organizing for Change* (New York: Free Press, 1984), 251.

44 Blacks made up forty percent of Birmingham's population of 350,000.

45 Kasher, *The Civil Rights Movement*, 91.

46 Diane McWhorter, *Carry Me Home: Birmingham, Alabama: The Climactic Battle of the Civil Rights Revolution* (New York: Simon & Schuster, 2001), 308.

47 James Luther Bevel, as quoted in Morris, *The Origins of the Civil Rights Movement*, 260.

48 Robert F. Kennedy, as quoted in Andrew Michael Manis, *A Fire You Can't Put Out: The Civil Rights Life of Birmingham's Reverend Fred Shuttlesworth* (Tuscaloosa: University of Alabama Press, 1999), 370.

49 Malcolm X, as quoted in ibid.

50 Martin Luther King, Jr., *Why We Can't Wait* (New York: New American Library, 1964), 86.

51 Fred Shuttlesworth, address to student protesters at Sixteenth Street Baptist Church, Birmingham, May 2, 1963, as quoted in Manis, *A Fire You Can't Put Out*, 369.

52 Ibid., 371.

53 Bull Connor, as quoted in "Dogs, Kids, and Clubs," *Time*, May 10, 1963, 37.

54 Glenn T. Eskew, *But for Birmingham: The Local and National Movements in the Civil Rights Struggle* (Chapel Hill and London: University of North Carolina Press, 1997), 3.

55 Martin Luther King, Jr., "Negro Leaders' Statements on Birmingham Accord,"
New York Times, May 11, 1963, 8.

56 For more on the conflict between King and Shuttlesworth, see Eskew, *But for Birmingham*, 292–97, and Manis, *A Fire You Can't Put Out*, 381–90.

57 Eskew, *But for Birmingham*, 296.

58 As Eskew observes (ibid.), Shuttlesworth enlisted King's support because he believed that the two men could work together "in a local campaign to achieve the nonnegotiable demand for an end to racial discrimination in the district." He understood that the local demonstrations would have national implications and hoped that King's prestige, and financial resources, would encourage his crusade to dismantle institutional racism in Birmingham. But unlike King, Shuttlesworth was unwilling to "sacrifice local progress … in exchange for federal intervention" and nationwide publicity. See Manis, *A Fire You Can't Put Out*, 384.

59 Wyatt Walker, as quoted in David J. Garrow, *Bearing the Cross: Martin Luther King, Jr., and the Southern Christian Leadership Conference* (New York: William Morrow, 1986), 264.

60 McWhorter, *Carry Me Home*, 375.

61 Wyatt Walker, as quoted ibid.

62 Kasher, *The Civil Rights Movement*, 93.

63 Jacob Javits, as quoted in Goldberg, *The Power of Photography*, 208.

64 Albert C. Persons, *Sex and Civil Rights: The True Selma Story* (Birmingham, AL: Esco, 1965), 19, 28.

65 Ibid., 21.

66 Ibid., 19.

67 Ibid., 18.

68 Kevin Glynn, *Tabloid Culture: Trash Taste, Popular Power, and the Transformation of American Television* (Durham, NC, and London: Duke University Press, 2000), 21.

69 Goldberg, *The Power of Photography*, 218.

70 Aldon D. Morris, "A Man Prepared for the Times: A
Sociological Analysis of the Leadership of Martin Luther King, Jr.," in Peter J. Albert and Ronald Hoffman, eds., *We Shall Overcome: Martin Luther King, Jr., and the Black Freedom Struggle* (New York: Pantheon, 1990), 46.

71 For more on TV coverage of the March on Washington, see Mary Ann Watson, *The Expanding Vista: American Television in the Kennedy Years* (Durham, NC: Duke University Press, 1994), 107–9.

72 Performers included Marian Anderson, Harry Belafonte, Marlon Brando, Diahann Carroll, Ossie Davis, Sammy Davis, Jr., Bob Dylan, Lena Horne, Paul Newman, and Sidney Poitier.

73 Jack Gould, "Television and Civil Rights: Medium Demonstrates Importance as a Factor in the Campaign to Achieve Racial Integration," *New York Times*, September 8, 1963, X15.

74 Ibid.

75 "Television Broadens Racial Understanding," *Pittsburgh Courier*, March 13, 1954, 18.

76 Glynn, *Tabloid Culture*, 21.

77 See ibid., 20–21.

78 Doris A. Graber, *Processing Politics: Learning from Television in the Internet Age* (Chicago and London: University of Chicago Press, 2001), 21.

79 Ibid.

80 Ibid.

81 Kasher, *The Civil Rights Movement*, 13.

82 Rodger Streitmatter, *Mightier than the Sword: How the News Media Have Shaped American History* (Boulder, CO: Westview, 1997), 186.

83 Andrew Young, "And Birmingham," *Drum Major*, Winter 1971, 25, as quoted in McWhorter, *Carry Me Home*, 374.

84 Wyatt Walker, as quoted in ibid., 330.

85 Martin Luther King, Jr., as quoted in Eskew, *But for Birmingham*, 272–73.

86 Morris, "A Man Prepared for the Times," 47.

87 King, as quoted in Eskew, *But for Birmingham*, 225.

88 King, *Why We Can't Wait*, 124.

89 Morris, "A Man Prepared for the Times," 54.

90 Richard B. Kielbowicz and Clifford Scherer, "The Role of the Press in the Dynamics of Social Movements," in Kurt Lang and Gladys Engel Lang, eds., *Research in Social Movements: Conflicts and Change*, vol. 9 (Greenwich, CT, and London: JAI, 1986), 83.

91 Of the paucity of long-form documentaries (one hour or longer) on civil rights, Christine Acham writes: "In actuality, from 1959 to 1964, only 11 of the 147 documentaries of the flagship documentary series [*CBS Reports*, *NBC White Paper*, and ABC's *Close Up!*] . . . dealt with civil rights, the majority targeting an international agenda." See Christine Acham, *Revolution Televised: Prime Time and the Struggle for Black Power* (Minneapolis and London: University of Minnesota Press, 2004), 31.

92 "They Fight a Fire That Won't Go Out," *Life*, May 17, 1963, 32.

93 For more on Moore's view of Birmingham, see McWhorter, *Carry Me Home*, 373.

94 "They Fight a Fire That Won't Go Out," 29.

95 Ibid., 30.

96 Ibid., 33.

97 On the drop-off in aggressive civil rights reporting in the mainstream media, see Paul Good, "The Meredith March: One Year Deeper into Frustration," *New South* (Summer 1966); repr. in *Reporting Civil Rights*, part 2: *American Journalism 1963–1973* (New York: Library of America, 2003), 495–515.

98 Acham, *Revolution Televised*, 35.

99 Joseph T. Klapper, *The Effects of Mass Communication: An Analysis of Research on the Effectiveness and Limitations of Mass Media in Influencing the Opinions, Values, and Behavior of Their Audiences* (New York: Free Press, 1960), 15.

100 Streitmatter, *Mightier than the Sword*, 186.

101 Dennis Chong, *Collective Action and the Civil Rights Movement* (Chicago and London: University of Chicago Press, 1991), 191.

102 Bayard Rustin, as quoted in McWhorter, *Carry Me Home*, 374.

103 For more on these surveys, see Chong, *Collective Action and the Civil Rights Movement*, 191–93.

104 John F. Kennedy, as quoted in Robert Dallek, "A Slow Road to Civil Rights," *Time*, July 2, 2007, 55.

105 Jimmie Lewis Franklin, *Back to Birmingham: Richard Arrington, Jr., and His Times* (Tuscaloosa and London: University of Alabama Press, 1989), 51.

106 John F. Kennedy, as quoted in Goldberg, *The Power of Photography*, 209.

107 Bill Monroe, as quoted in Streitmatter, *Mightier than the Sword*, 186.

108 Ralph McGill, as quoted in ibid.

109 John Lewis, as quoted in ibid., 190.

110 George B. Leonard, "Midnight Plane to Alabama: Journey of Conscience," in Clayborne Carson et al., eds., *The Eyes on the Prize Civil Rights Reader: Documents, Speeches, and Firsthand Accounts from the Black Freedom Struggle* (New York: Penguin, 1991), 214.

111 See Thomas Doherty, *Cool War, Cool Medium: Television, McCarthyism, and American Culture* (New York: Columbia University Press, 2003), 73.

112 Hedrick Smith, "Segregation Stronghold: People of Albany, Ga., Long to Escape National Attention over Racial Turmoil," *New York Times*, August 16, 1962, 18.

GUESS WHO'S COMING TO DINNER

1 National Broadcasting Company press release, as quoted in Richard Warren Lewis, "The Importance of Being Julia," *TV Guide*, December 14, 1968, 27.

2 Ibid., 26.

3 See *Ebony*, November 1968, 57–62.

4 For an early critique of television's whitewashing of black characters, see John Oliver Killens, "Our Struggle Is Not to Be White Men in Black Skin," *TV Guide*, July 25, 1970, 6.

5 Christine Acham, *Revolution Televised: Prime Time and the Struggle for Black Power* (Minneapolis and London: University of Minnesota Press, 2004), 118.

6 For more on *Julia*'s strategies of racial evasion, see ibid., 117–25.

7 On the negative responses to *Julia*, see Robin R. Means Coleman, *African American Viewers and the Black Situation Comedy* (New York: Garland, 1998), 88–91; and J. Fred MacDonald, *Blacks and White TV: Afro-Americans in Television Since 1948* (Chicago: Nelson-Hall, 1983), 116–18.

8 Hal Kanter, as quoted in Lewis, "The Importance of Being Julia," 27.

9 See, for example, ibid., 24.

10 Unnamed critic, as quoted in ibid., 27.

11 Acham, *Revolution Televised*, 119.

12 Coleman, *African American Viewers and the Black Situation Comedy*, 90.

13 Diahann Carroll, as quoted in Lewis, "The Importance of Being Julia," 28.

14 MacDonald, *Blacks and White TV*, 110.

15 John Cooper, "I Spy." *Encyclopedia of Television*, Museum of Broadcast Communications, http://www.museum.tv/archives/etv/I/htmlI/ispy/ispy.htm. Nevertheless, Cosby at the time saw a political dimension to his role: "Negroes like Martin Luther King and Dick Gregory; Negro groups like the Deacons and the Muslims—are all dedicated to the cause of civil rights, but they do their job in their own way. My way is to show white people that Negroes are human beings with the same aspirations and abilities that whites have." See "*I Spy*: Comedian Bill Cosby Is the First Negro Co-Star in TV Network Series," *Ebony*, September 1965, 66.

16 Robert Lewis Shayon, as quoted in Diahann Carroll, *Diahann: An Autobiography* (Boston: Little, Brown, 1986), 144.

17 See, for example, Carroll's outspoken criticism of the show in Carolyn See, "I'm a Black Woman with a White Image," *TV Guide*, March 14, 1970, 26–30.

18 Acham, *Revolution Televised*, 126.

19 For an important discussion of the ghetto comedy, its historical roots, and social and cultural implications, see ibid., 85–109, 126–42.

20 The circuit included theaters such as the Apollo and the Fox (Detroit), the Howard (Washington, D.C.), the Regal (Chicago), and the Royal (Baltimore).

21 Acham, *Revolution Televised*, 133.

22 Evers's murderer, Byron De La Beckwith, was freed in 1964 after all-white juries deadlocked in two successive trials in Mississippi. Thirty years later, on February 5, 1994, he was retried and convicted of the killing.

23 Esther Rolle, as quoted in Louie Robinson, "Bad Times on the *Good Times* Set," *Ebony*, September 1975, 35–36. The actress's advocacy was evident as early as the show's prepro-duction. The original script called for the character of Florida to be a single mother. Rolle insisted that the family have a father as a condition of her joining the cast.

24 Jacob Javits, as quoted in Mary Ann Watson, *The Expanding Vista: American Television in the Kennedy Years* (Durham, NC: Duke University Press, 1994), 64–65.

25 While *Roots* was well received by critics and audiences alike, its premiere on national television in 1977, just as the modern civil rights movement was coming to an end, places it outside of the purview of this book.

For more on the miniseries, see Lauren R. Tucker and Hemant Shah, "Race and the Transformation of Culture: The Making of the Television Miniseries *Roots*," *Critical Studies in Mass Communication* 9, December 1992, 325–36.

26 The clause was dropped in 1948 after the U.S. Supreme Court, ruling on another case, declared such restrictions "unenforceable as law and contrary to public policy." For more on this, see Bruce Lambert, "At 50, Levittown Contends with Its Legacy of Bias," *New York Times*, December 28, 1997, A24, 26.

27 Fred Ferretti, "TV: Are Racism and Bigotry Funny?" *New York Times*, January 12, 1971, 70.

28 Ibid.

29 My ideas on the mainstream media's resistance to confronting racism outside the Deep South in the period of the civil rights movement are indebted to Marlon Riggs's film *Color Adjustment* (1991). The documentary traces televi-sion's complex—and often contradictory—relationship to American race relations, focusing on the ways TV dramas and situation comedies either perpetuated or resisted racial myths and stereotypes, as well as the way most programs avoided the question of racism within more politi-cally liberal or moderate communities.

30 Louisiana statute, as quoted in Thomas Doherty, *Cold War, Cool Medium: Television, McCarthyism, and American Culture* (New York: Columbia University Press, 2003), 73.

31 Doherty, *Cold War, Cool Medium*, 73.

32 Television Code, as quoted ibid., 74.

33 As quoted in Doherty, *Cold War, Cool Medium*, 72.

34 These shows, in addition to *I Spy* and *Julia*, included *Barefoot in the Park* (ABC, 1970–71), *Daktari* (CBS, 1966–69), *Hogan's Heroes*

(CBS, 1965–71), *Ironside* (NBC, 1967–75), *The Mary Tyler Moore Show* (CBS, 1970–77), *Mission: Impossible* (CBS, 1966–73), *The Mod Squad* (ABC, 1968–73), *N.Y.P.D.* (ABC, 1967–69), *Peyton Place* (ABC, 1964–69), *Room 222* (ABC, 1969–74), *Star Trek* (NBC, 1966–69), and *The Young Rebels* (ABC, 1970–71).

35 For more on *The Strollin' Twenties*, see Aram Goudsouzian, *Sidney: Man, Actor, Icon* (Chapel Hill and London: University of North Carolina Press, 2004), 244–45.

36 The *Pittsburgh Courier* commented: "[*The Ed Sullivan Show*], from its beginning, back in 1948, offered opportunities without restriction to persons of talent. It is always true that Sullivan presents Negro entertainers as an integral part of his show, knit well into the whole proceedings, with never a hint of bias." As quoted in Doherty, *Cold War, Cool Medium*, 73.

37 *Pittsburgh Courier* editorial, 1954, as quoted in ibid., 71. The preceding paragraphs on the African-American presence on television variety shows are indebted to Thomas Doherty's definitive analysis, ibid., 70–80.

38 Bishetta D. Merrit, "Richard Pryor," *Encyclopedia of Television*, Museum of Broadcast Communications, http://www.museum.tv/archives/etv/P/htmlP/pryorrichar/pryorrichar.htm.

39 Acham, *Revolution Televised*, 157.

40 For more on *The Richard Pryor Show*, see ibid., 143–69.

EPILOGUE

1 Stewart Smith and Peter Thorn, "An Interview with LeRoi Jones" (1966), in Charlie Reilly, ed., *Conversations with Amiri Baraka* (Jackson: University of Mississippi Press, 1994),

17.

2 Ibid., 18.

3 Thulani Davis, in conversation with the author, April 21, 2009. This chapter is indebted to Davis's insightful ideas about the fragmentary nature of mainstream black representation and its relationship to the work of black cultural activists, artists, and performers committed to producing a richer and more holistic view of blackness.

4 Donyale Luna was the first black model to appear on the cover of a major American women's magazine, *Harper's Bazaar*, in 1965. Throughout the 1960s and 1970s such appearances were extremely rare, and even newsworthy, as in the case of Beverly Johnson.

5 William R. Grant IV, *Post-Soul Black Cinema: Discontinuities, Innovations, and Breakpoints, 1970–1995* (New York and London: Routledge, 2004), 31.

6 For more on this film, see ibid., 27–43. Also see Ed Guerrero, *Framing Blackness: The African American Image in Film* (Philadelphia: Temple University Press, 1993), 86–111.

7 Melvin Van Peebles, as quoted in Brad Darrach, "Sweet Melvin's Very Hot, Very Cool Black Movie," *Life*, August 13, 1971, 61.

8 See Toni Cade Bambara, "Reading the Signs, Empowering the Eye: *Daughters of the Dust* and the Black Independent Cinema Movement," in Manthia Diawara, ed., *Black American Cinema* (New York and London: Routledge, 1993), 120.

9 Most of these shows premiered in the late-1960s. A few continue to be broadcast to the present day.

10 "*Colored People's Time*: The Making of a Rioter, CPT 5," *Matrix*. http://matrix.msu.edu/~abj/videofull.php?id=52.

11 Gil Noble, *Black Is the Color of My TV Tube* (Secaucus, NJ: Lyle Stuart, 1981), 125.

12 Sarah Valdez, "The Revolution Will Be Visualized," *Art in America*, June/July 2008, 106.

13 Emory Douglas, "Position Paper #1 on Revolutionary Art" (unpublished, 1968), n.p. For more on Douglas's aesthetic philosophy and role in the party, see St. Clair Bourne, "An Artist for the People: An Interview with Emory Douglas," in Sam Durant, ed., *Black Panther: The Revolutionary Art of Emory Douglas* (New York: Rizzoli, 2007), 199–205.

14 For an analysis of Douglas's methods, techniques, and aesthetic philosophy, see Colette Gaiter, "What Revolution Looks Like: The Work of Black Panther Artist Emory Douglas," in Durant, *Black Panther*, 93–109.

15 The Panther symbol was based on the logo of the Lowndes County Freedom Organization in Alabama.

16 The focus of Wolfe's derisive take on "radical chic" was the composer Leonard Bernstein and the infamous, celebrity-filled party fund-raiser he threw in his lavish Park Avenue apartment in 1970. See Tom Wolfe, *Radical Chic and Mau-Mauing the Flak Catchers* (New York: Farrar, Straus & Giroux, 1970).

17 Gaiter, "What Revolution Looks Like," 94.

18 Jessica Werner Zack, "The Black Panthers Advocated Armed Struggle: Emory Douglas' Weapon of Choice? The Pen," *San Francisco Chronicle*, March 8, 2007, E1.

19 Douglas, "Position Paper #1 on Revolutionary Art," n.p. Douglas elaborated on his view of art's role in society in an address delivered at Fisk University in 1972, "Art for the People's Sake." For more on this talk, see Valdez, "The Revolution Will Be Visualized," 108.

20 See Neal, "The Black Arts Movement," in Addison Gayle, Jr., ed., *The Black Aesthetic* (New York: Doubleday, 1971), 257.

21 See, for example, the minister's speech at a rally of the Organization of Afro-American Unity, New York, June 28, 1964, quoted in Malcolm X, *By Any Means Necessary: Speeches, Interviews, and a Letter by Malcolm*, ed. George Breitman (New York: Pathfinder, 1970), 35–36.

22 Komozi Woodard, *A Nation Within a Nation: Amiri Baraka (LeRoi Jones) and Black Power Politics* (Chapel Hill: University of North Carolina Press, 1999), 59.

23 Algernon Austin, *Achieving Blackness: Race, Black Nationalism, and Afro-Centrism in the Twentieth Century* (New York: New York University Press, 2006), 61.

24 William Brink and Louis Harris, *The Negro Revolution in America* (New York: Simon and Schuster, 1963), 73. For more on this poll and its implications, see Christopher B. Strain, *Pure Fire: Self-Defense as Activism in the Civil Rights Era* (Athens, GA, and London: University of Georgia Press, 2005), 79–82.

25 The photographer Eve Arnold has recounted Malcolm's meticulous direction of her shots for *Life* magazine. See Eve Arnold, *Flashback! The 50s* (New York: Alfred A. Knopf, 1978), 118. For a comprehensive account of the scores of photographers who took pictures of the Muslim leader, helping to broaden his visualization within high and low culture, see Thulani Davis, *Malcolm X: The Great Photographs* (New York: Stewart, Tabori and Chang, 1993).

26 Thomas Patrick Doherty, "Malcolm X: In Print, On Screen," *Biography: An Interdisciplinary Quarterly* 23, no. 1 (Winter 2000), 32.

27 For more on this, see Helen Bradley Foster, *New Raiments of Self: African American Clothing in the Antebellum South* (Oxford: Berg, 1997), 245–47.

28 Henry J. Perkinson, *Getting Better: Television and Moral*

Progress (New Brunswick: Transaction, 1996), 54.

29 Ibid.

30 For more on the documentary and its reception, see Doherty, "Malcolm X," 29–48; and Adam J. Banks, *Race, Rhetoric, and Technology: Searching for Higher Ground* (New York and London: Routledge, 2005), 49–51.

31 Thulani Davis, in conversation with the author, April 15, 2009. These ideas are richly explored in Davis's unpublished paper "Blackface Imagery During the Post-Reconstruction Era."

32 W. E. B. Du Bois, "Credo," *Independent*, no. 57 (October, 6, 1904), 787. For an important examination of positive imagery and African-American empowerment, see bell hooks, *Rock My Soul: Black People and Self-Esteem* (New York: Atria, 2003).

33 For discussions on the relationship among African-Americans, advertising, and consumer culture, see Robert Weems, "The Revolution Will Be Marketed: American Corporations and Black Consumers During the 1960s," *Radical History Review* 59 (1994), 94–107; and Jason Chambers, *Madison Avenue and the Color Line: African Americans in the Advertising Industry* (Philadelphia: University of Pennsylvania Press, 2007).

34 bell hooks, "In Our Glory: Photography and Black Life," in Deborah Willis, ed., *Picturing Us: African American Identity in Photography* (New York: New Press, 1994), 46.

35 Ibid., 50–51.

36 Marvin Heiferman, "Now Is Then: The Thrill and the Fate of Snapshots," in Heiferman, *Now Is Then: Snapshots from the Maresca Collection* (New York: Princeton Architectural Press, 2008), 46.

37 Ibid.

38 Angela Davis, "Underexposed: Photography and Afro-American History," in Valencia Hollins Coar, ed., *A Century of Black Photographers, 1840–1960* (Providence: Museum of Art, Rhode Island School of Design, 1983), 27.

39 A very partial list includes: James Presley Ball (Minneapolis), Florestine Perrault Collins (New Orleans), Andrew T. Kelly (Atlanta), Calvin Littlejohn (Fort Worth), Paul Poole (Atlanta), Richard S. Roberts (Columbia, South Carolina), Marvin and Morgan Smith (New York), Addison Scurlock (Washington, D.C.), A. C. Teal (Houston), James Van Der Zee (New York), and Ellie Lee Weems (Jacksonville).

40 hooks, "In Our Glory," 52.

41 Ibid., 50.

42 Jonathan Crary, *Techniques of the Observer: On Vision and Modernity in the Nineteenth Century* (Cambridge, MA, and London: MIT Press, 1990), 2.

43 For more on these phases, see Martin Jay, "Scopic Regimes of Modernity," in Hal Foster, ed., *Vision and Visuality* (Seattle: Bay Press, 1988), 3–27. For an excellent introduction to the subject of visual culture's primacy within modernism, see Antonio Somaini, "On the 'Scopic Regime,'" in *Leitmotiv*, no. 5 (2005–6), 25–38.

44 Roger Wilkins, "White Out," *Mother Jones* (November 1992); repr. in Richard Delgado and Jean Stefancic, eds., *Critical White Studies: Looking Behind the Mirror* (Philadelphia: Temple University Press, 1997), 660.

INDEX

S